MW01389064

WOMEN · THE GODDESSES OF WISDOM

The Journey of Womanhood

*Kathy & Rich
Enjoy reading the books!*

David G. Eigen, Ph.D.

WOMEN · THE GODDESSES OF WISDOM

The Journey of Womanhood

David G. Eigen, Ph.D.

GENDER STUDIES INSTITUTE PRESS™

Women—The Goddesses Of Wisdom

Copyright ©2010 by David G. Eigen.

All rights reserved. Printed in the United States of America. No part of this book may be used or reproduced in any manner whatsoever without written permission except in the case of brief quotations embodied in critical articles and reviews. For information address
The Gender Studies Institute, Inc., 280 Madison Avenue, Suite 912, New York, NY 10016-0801.

FIRST EDITION

ISBN 978-0-9797399-8-9

Library of Congress Control Number: 2009912372

Cover and Interior Design: Audria Gardner
www.bookdesignbyindigo.com

Author's Note to Women

Women, my commitment to you is to provide a new understanding of *Self*, a *Self* that has been masked over, denied, made wrong, or less-than by the patriarchal teachings; and then to offer a healthy expansive replacement for these unevolved role models.

As it stands, women are taught to be victims and often blame men for their predicaments and for not providing them with the true partnerships they desire. But what women don't see is that they are full participants in a dance in which both men and women are trapped. It is so easy to blame the other sex, but one's own role in the dance is just as important to know as our partner's. In fact, it's more important, but is the most overlooked.

Our responsibility is to fully know *Self*, not just our self-centered wants and desires. Each partner has the power to change the dance in which they participate. This power must be used for the betterment of all, and self-knowledge is THE most important element. Entering into a relationship without this is futile at best, yet ever so common.

The initiation into wisdomhood requires you to take on and balance your inner masculine essence with the feminine, using its intentional nature to focus the unlimitedness of the feminine. The challenge is how to remain feminine while doing so. Then women will be ready to participate in a new dance, one that they may even set the tone for. May I have this dance?

Author's Note to Men

Men, just as your heritage is to be The Gods of Love, women's heritage is to be The Goddesses of Wisdom. This book is required reading if you want to understand women. Yes, that is possible; in fact, it is easy. However, to make it easy a man must understand, accept, and incorporate his inner feminine... without being feminized. Then you will easily understand women, not as aliens from another planet, but as emotional beings you can relate to.

To implement this, it is important that you read *Men—The Gods of Love*. This aspect of the masculine totality has been made wrong and shameful by our conditioning, and this limits us.

Presently, neither gender truly understands the other, and many misunderstandings exist. I promise, you will gain a whole new understanding of yourself, as well as of women, when you read both books; and you will be able to feel fulfilled inside, instead of just finding distraction after distraction, or accumulating possessions as outer replacements for inner fulfillment. Then you will be joining the dance as the powerful loving leaders you are.

Contents

Introduction	13
Bluebeard	21
1: Bluebeard, Eros, and In the Garden	21
Eros And Psyche	26
In The Garden	27
2: Possibilities	29
Possibility One	29
Possibility Two	31
3: The Fairytale Princess and Other Illusions	35
The Fairytale Princess	35
Playing House	36
A Starving Soul	38
4: The Barter System	43
The Art Of The Deal	43
Addictions	46
Feminine Balance	48
The Material Girl	49
5: Narcissism	51
Vanity, Thy Name Is Woman	51
To Hell And Back	51

 Trance Exposed ... 55
 Venus And Hercules .. 56
 The Six Sticks ... 58
 Caricature Of Self ... 59

6: Being Female ... 61
 First, Let's Look at Both Sexes' Attributes. 61
 No, Maybe, Try Harder ... 62
 Truth .. 66
 Directing The Masculine ... 66
 Wisdom 101: Communication 70
 Sex ... 72
 The Invisible Woman .. 74

7: Grief, Anger And Rage ... 77
 Grief, Anger And Rage ... 77
 Boundaries ... 78
 Rage .. 81
 The Crescent Moon Bear .. 81
 Patriarchal Control ... 88

8: "It's All About ME!" ... 91
 Maturity ... 91
 Narcissism And Body Image ... 92
 Emotionalism .. 92
 Estrogen: The Loaded Gun .. 94

9: Secrets and Lies ... 99
 Emotional Strength .. 99
 Emotional Weaponology .. 101

Contents

 Withholding ...103
 The Bad Boy And Desire ..105

10: Men ..107
 Hero ..111
 Understanding Wounded Men113
 Testosterone ..116
 The Savior Codependent ..119

11: The Man in the Womb ..123

12: Initiations ...131
 The Red Tent ...133

13: Basic Training ..137
 Tasks: Developmental ..138

14: Midlife ..143
 The Critical Component ..145

15: The Dark Queen ...147
 The Masculine Energy In Women147
 What Are We Made Of? ..150
 The Patriarchy ...151
 The Driving Force ...151
 Shadow: Bringing Light Into Darkness154
 Primordial Wellspring ...155
 The Nature Of Repression ...156

16: What Is She Made Up Of? ...161
 Sugar And Spice And Everything Nice—And A Lot More. ..161

Body And Soul .. 161
The Mind .. 166
Paradox .. 166
Male Attributes: Mental .. 168
Female Attributes: Emotional ... 168
Male And Female Attributes ... 169

17: Feminine Courage .. 171
Feminine Courage ... 171
Forgiveness .. 173
Stages Of Forgiveness ... 174
Falling Together .. 175
Constructs ... 177
"A Woman's Prerogative" ... 178

18: Father ... 179
Personal Stories ... 179
Nancy K. — Thirties ... 180
Lisa D. — Thirties ... 181
Natasha R. — Fifties ... 183
Mary C. — Fifties .. 183
Kimberly L. — Sixties ... 184

19: Loving Struggle? .. 187
Codependency ... 189
Codependent Indicators ... 191
The Way Out ... 194
Innocence .. 195

Contents

20: This Thing Called Love .. 197
 Benchmarks .. 199
 So What Is Love? ... 200
 Love Is All Around Us, Isn't It? ... 205
 Mothers .. 208
 Vulnerability ... 209
 Eros Reconnected .. 211
 A Little Homework ... 215

21: Divine Feminine ... 217
 Purpose .. 219
 Children As Purpose ... 219
 Women As Intermediaries ... 221

22: The Sacred Offering .. 227

Bibliography .. 231

Introduction

Women have asked me how I, as a man, can write about women? First of all, please know that men are not from another planet, even if you have entertained this thought. Nor are we all heartless animals, though some may appear to be. Men and women are actually mirror images of each other—opposite sides of the same coin. We each contain elements of the other. Yet, we still regard each other as mysteries because we remain unaware of our common elements within. In fact, we have all been taught to disconnect from, deny, and even reject these shared elements by our male-as-dominant, patriarchal society. Therefore, our inner rejected parts become outer mysteries, keeping us separate from our outer opposites—men or women.

These mysteries are nothing more than our conditioned blindness. They are not truly known by anyone. Some people know how to manipulate and move within the present system, thinking of themselves as the "keepers of the mysteries." But they are still a part of this system; their perceptions, too, are colored by the very system they move within. As for the rest of us, most are clueless, just trying to get by day-to-day.

Our heritages are therefore beyond our reaches. There is something almost supernatural about these mysteries that causes us not to question, learn, or rock the boat. We get comfortable, acquiesce, roll over, and play dead. This is unfulfilling, naturally. In my life, this way of existing became unworkable, and I dared break the taboo to ask the question, "What the hell is really going on here?"

I decided to stop accepting the "truths" about my opposite's inscrutability—truths that I had been taught were reality. Not all women are crazy, as I had at one time thought, and I can learn to live with them.

My accepting this required that I also accept responsibility for my own blindness and unaware actions. This was uncomfortable at first, to say the least. I was facing the unknown. Men, myself included, dont like the unknown. Truth be told, I was afraid of it. But as a man, I couldn't acknowledge this because men are not supposed to be afraid or uncertain, are they? So continuing my questioning became even more unattractive. However, I had already arrived at the place of having no other choice; I had to explore this unknown. I needed to learn what was truth and what was illusion. Pandora's box was being opened consciously.

The first thing I learned was that we, as men and women, are not the acts we put on, the roles we play, nor the beliefs we hold. However, most of us do believe that we are indeed these things, and we believe the same of others as well.

So now what? The old adage, "know thyself," was never more pertinent. Every man has an inner feminine energy that he needs to be aware of and come to know. My first book, *Men—The Gods of Love*, explores and explains this. I talk about the necessity for men to accept and balance their inner feminine feeling energy, and in doing so, men will gain the insight needed to understand those mysterious creatures—women. Men can then reclaim their own inner selves, demonstrated by their opposites, their mirror images. Because women are seen as the embodiment of emotions, and men in our society are taught that emotions are wrong and cannot be trusted in themselves, women have become inscrutable mysteries, not to be trusted. Men are taught to blind themselves from their own feelings, or what I refer to as their "inner feminine."

As a man, I no longer reject my inner feminine; in fact, I celebrate her. Her wisdom, expansiveness and intuitiveness are priceless. This doesn't mean I feel like a woman, only that I feel. This has allowed me to see the reality of women and beyond the illusions that I was taught and many women promote and hide behind.

Women—The Goddesses of Wisdom unveils the masculine energy inside all women. This veil, created and promoted by our patriarchal society,

Introduction

hides a woman's inner masculine from herself, as well as from others. I believe it is time to really get naked—as in the naked truth. Discovering one's truth is the only way to find out who we really are on the inside. Don't worry; you won't have to run around naked. But you will need to remove the veil of illusions in order to gain self-knowledge.

Knowledge is power. This is an ancient truism. Keeping knowledge secret, as a source of power, is not a new concept. Men have been keeping knowledge from women for centuries, usually in regards to money, material, and power. I offer this possibility: on an unconscious level, women have been keeping knowledge of the feminine emotions to themselves to retain their power. By keeping men in the dark, women can enjoy the manipulative benefits of men remaining "clueless." Using sex, emotional innuendo, and other expressions of the manipulative "arts" superficially provides benefits, which equate to many as security, like marriage, kids, and material goodies.

A wise woman would do the opposite because she would want a man to know her, to see her and understand who she really is. She would realize that this is the only way to create true partnership. But how can she create this when most men seem to be so clueless? Would she be willing to give up the advantage her manipulative abilities allow her?

Women become the masters of illusion so they can get what they want from men—money and security—while men only care to attempt to grasp the feminine up to the point that they too get what they want from women—sex and companionship. Illusions beget illusions, and that's what these are based in, but none fill the soul. What a twisted predicament sacred union has been transformed into.

"It's all about looks," proclaimed my oldest daughter to me in a discussion at age fourteen. There is truth contained in her statement. Women learn early on that looks equate to what rapidly becomes an addicting "drug"—attention. Women seem to ignore the fact that this attention from men is most often sexually based and go on to berate men for being animals. This hasn't stopped women from hungering for attention, however.

Women—The Goddesses Of Wisdom

I gained a further understanding of the feminine when I saw a T-shirt that declared, "It is all about me!" Women can be great, wise, loving beings, while at the same time narcissistic, shallow, egocentric, and superficial. Could this be a paradox being played out before our eyes? Yes, and these typical extremes create a fire inside women called the "tension of the opposites."

Men see the outward appearance of this fire, this tension in women, as chaotic emotionality. Sometimes we get burned by these flames, and sometimes we stoke them. This is just a part of the dance we do with each other. These insights, along with my own reclaiming of my inner feminine feeling side, and over one thousand client hours with women have given me a perspective on what women have been taught to be and not to be. Perhaps my female readers may find this man's perspective of the feminine to be insightful.

On the whole, I love and trust women, though I can't say that this was always true for me. Why? Because I simply did not understand them. I was clueless. They seemed illogical, emotional, chaotic, contrary, self-centered, spiteful, and deeply vengeful. "Hell hath no fury like a woman scorned." Tell me something I didn't know—inherently. But as I awoke to my own living in a glass house, I learned not to throw any more stones and set out to discover who and what women really are.

I realized this journey would be similar to that of my first book. In that work, I revealed the male-as-dominant group role model, which is the illusion of masculinity programmed into men by our patriarchal society. I then brought to light the truth about what men really are—The Gods of Love. It follows that the Patriarchy must have taught women lies and illusions about whom they are too, just as it had men, and this has obscured the truth about women—that they are indeed The Goddesses of Wisdom. This is the premise of what you are about to experience in the following pages as we begin this journey into an understanding of the feminine.

Introduction

Women are the mirror images of men, and men are the mirror images of women; yet, our souls contain elements of both. These "mirrors" are our windows with which we can peer into our inner natures. These inner natures need to be understood, accepted, and added to who we are without losing our primary identities.

Denying any part of ourselves is like denying that we have two legs and using only one. It makes for an unnecessarily challenging journey. A woman must realize that she is not only made up of multidimensional feelings and senses, but also of certain mental aspects considered to be masculine, like linear ordering and structuring. She must learn to utilize this masculine part of her being to ground herself and focus her power. Just as the feminine within a man is actually an important part of his power, the masculine within a female is an important part of her power. These are the unexpressed aspects of our souls—the psyche within psychology.

Psyche means soul. Unfortunately, all of our dictionaries have the definition incorrect thanks to Freud. Psychology is not the study of the mind, as he believed; it is the study of the soul.[1] So what we really need is to delve into our souls, which includes our minds. Freud said that the soul was a creation of the mind. I believe just the opposite is true; the mind is a creation of the soul, as is every aspect of our being.

So many of our perceptions have become twisted and distorted. A woman, like her male reflection, her counterpart, has been taught to distrust those opposites she sees "through the looking glass, darkly." Men appear to her as shallow, clueless beings lacking in compassion. Because men often seem to want women only for sex, it occurs to some women that they are not highly valued as beings. Having had this distrust instilled within, women have learned to fear and repress their own masculine parts, viewing them as wrong, in much the same way men judge their inner feminine essence as wrong. The consequence of these inner decisions is the lessening of both women's Selves and men's Selves.

1 Mialos (me-ah-los) means mind in Greek. Mialogy is the correct word for the study of the mind.

In the ancient world, the Gods of Love—Eros, Amor and Cupid—were portrayed as masculine, while the Gods of Wisdom—Minerva, Athena and Sophia—were seen as feminine. What is required of a man to be a God of Love? He has balanced ALL of his aspects, including his feelings, or inner feminine. It is his capacity for love that gives him his greatest power, not his mind. This is the maturation of the masculine realized. The same holds true for women. Mature women have learned to balance their masculine inner nature with their feminine, not to reject it. These models are not what we see in today's modern society.

I have had two great teachers who have taught me quite a lot about women. They are my daughters. Both are teenagers as I write this. Sometimes I would wonder if my teenagers were in fact alien replacements. I have been known to declare, "Who are you, and what have you done with my daughters?" Their reply, "Dad, get over it!"

So, how could they be my teachers? As I watched them learn and grow, I asked them questions about their developing concepts of life and of themselves. I was amazed, surprised, and shocked at times. It certainly caused the further development of my own parenting muscles. My girls generously provided lots of opportunities for this.

I soon realized that some of the less-than-evolved concepts my daughters were developing and acting upon were also apparent in many adult women. These women had never let go of their immature teenage behaviors, and now, as adults, were continuing to express themselves through these immature behavioral models. Many of these immature, unbalanced behaviors are used to judge women as inferior to men in our patriarchal society.

Just as many boys physically become men while continuing their boyish thinking, women are not immune to continuing their girlish beliefs into physical adulthood. These beliefs combine to create patterns of self-constructed realities, called constructs. *Constructs* are illusions, but they are also working models for our behaviors—not healthy ones, of course.

Introduction

These illusions are based on a lack of maturity. Maturity is the balancing and healing of all aspects of our Selves, which allows for the expression of the whole Self. This is the place from where feminine wisdom springs forth—the whole Self—and it is empowered by a woman's masculine inner aspect. Illusion has no place in this wholly expression of Self.

How has our present thinking been formulated, and who has taught it to us? The following three stories, though vastly different in appearance, illustrate the common myths that have been passed down from our ancestors. It is critically important for us to recognize the threads that connect them all and to gain an understanding of their shared essences and true meanings.

Remember, constructs are only illusions, but society teaches us the most powerful ones. Myths are more than simply entertaining stories; in fact, in the past, they were the primary teaching tools. Codified and set down on paper, they became religious doctrine. We first need to understand how these have influenced us, and then we must decide if we wish to accept their influence. Using the light of conscious reason (the combination of thinking and feeling), we must exercise our ability to discern.

Discernment is defined as the ability to grasp and comprehend what is obscure, the power to see what is not evident to the average person. It is time for us to practice this skill.

CHAPTER 1

Bluebeard, Eros, and In the Garden

Bluebeard

Many years ago, in a land far, far away, there lived a large beast of a man with blue-black hair and beard. He was called Bluebeard. Some say he was one of the magi, possessing magical powers. He had an eye for women, but his luck in relationships was less than magical. In fact, his wives kept dying from this disease or that. He was further cursed by his blue beard. It made him look fearfully ugly, so much so that women would withdraw from him. Luckily for him, he was a wealthy man and could entice many women so inclined.

In this land, there was an old widow who lived in a small neat home with her three beautiful daughters. His Blueness desired one of the daughters in marriage, not necessarily having a preference for which one, but none of the three would have him. So in an attempt to win their affections, Bluebeard arrived at their home one day with bejeweled horses draped in gold ribbons and bells to invite the three daughters, along with their mother and any others they chose, to one of his country houses. They accepted his invitation and stayed for a whole week.

Their time was filled with parties, hunting, fishing, dancing, feasting, and mirth. Each night they stayed awake late to hear his fabulous tales that engaged their imaginations. They began to think that perhaps he was not as bad as he had been made out to be; however, there was still that blue, blue beard. The youngest sister began to entertain the notion

that his beard was not really so blue. After all, he was a very entertaining gentleman. In fact, the more she thought about him, the more his blueness diminished, and she started to find him almost desirable. The thought of living in riches in a castle was not too awfully difficult to appreciate either.

One thing led to another, and she eventually agreed to become Mrs. Bluebeard. She learned quickly to appreciate her new lifestyle. In the dark, her new husband was not so hard to appreciate as well.

One day the not-so-Bluebeard told his wife that he must leave on a business trip for some weeks. "I don't want you to feel alone in my absence, so why don't you ask your family and friends to visit you in the castle?"

"How sweet," she thought.

"Have fun and feasts; give them any gifts you wish, for we have more than enough," he told her. A very altruistic sentiment it was, and this moved her.

Before he left, he gave her a ring full of keys. "These unlock the storerooms that contain the strongboxes that hold my wealth, both gold and silver; these other keys lead to rooms filled with caskets of jewels and precious spice. You may open any door you'd like, except for the room that this little key opens. This you must not use!"

Without requesting an explanation for this last directive, she promised to follow his instructions exactly as he had expressed them. He then embraced her and went on his way.

Her family came at once. They spent their time as directed, feasting and making merry; but eventually, the subject of the keys came up. This was her family asking, so she told them all the details. Her sisters' excitement could not be contained; they longed to look upon the treasures inside those storerooms.

The youngest sister thought, "Well, he did tell me I can open any door I wish, except for the one." So, the three sisters proceeded to run

throughout the castle, looking into every room, finding them filled with fine and luxurious articles beyond their limited imaginations.

Then, they came to a small door in the dungeon that the small key fit. Bluebeard's new wife paused to think about her husband's instructions and worried what unhappiness might await her if she disobeyed. But how could anyone resist such temptation? Her sisters were insistent; after all, they had not made Bluebeard any promises, had they? This instruction they could giddily ignore.

She took the little key and opened the door. Her sisters pushed passed her and went in to inspect the room first. They came running out quickly, obviously upset. She entered and saw that the floor was stained with blood, and there were piles of dismembered bodies of dead women arranged against the walls. These were Bluebeard's previous wives! She started to hyperventilate and ran from the room, slamming the door and locking it.

After having regained her breath, she went upstairs to her chamber to recover but could not stop trembling. She then observed that the key was stained with blood. She tried to wipe it off, but the blood would not come off. In vain she washed the key, even rubbing it with soap and sand. However, the blood remained, as this was a magical key that she could never get clean.

Unluckily for his wife, Bluebeard returned from his journey that very same evening. He had received a message on the road informing him that the affair he went to handle was settled. Mrs. Bluebeard did all she could to convince her husband that she was pleased about his early return. Inside, though, she was trembling.

The next morning he asked her for the keys, which she gave him, but with one missing. Naturally, he noticed. "Where is the little key?" he asked?

She quick-wittedly replied, "I left it upstairs upon the table by the bed, so as to not use it."

"Fail not," commanded Bluebeard, "to bring it to me at once."

After several bouts of conversation, she was forced to bring him the key. Bluebeard looked upon the key and said to his wife, "Why is there blood on the key?"

"I do not know," cried the poor woman, paler than death.

"You do not know?" replied Bluebeard. "I very well know. You used it, did you not? Your fate, my lady, for this disobedience is to join the other ladies you saw there in that room!"

Upon hearing this, she threw herself at her husband's feet and begged his forgiveness, vowing to never again be disobedient. She would have melted the most hardened of hearts, so beautiful and sorrowful was she, but Bluebeard had no heart! She had missed that detail during their courtship.

"You must die, madam," said he, "at once!"

"Since I must die," she answered quickly, looking upon him with eyes full of tears, "give me some time to say my prayers and goodbyes to my sisters."

"I will give you one hour, but not one moment more!" replied Bluebeard.

When she was alone, she called out to her sisters, "Go up to the top of the tower and see if our brothers are coming. They promised me that they would come today. If you see them, give them a sign to make haste!"

The hour passed quickly, and Bluebeard, holding a great saber in his hand, bellowed to his wife, "Come hither instantly, or I shall come up and get you and all with you!"

"One moment longer, if you please," said his wife.

"I do not please. Come down now," replied Bluebeard, "or I will be forced to come up and get you all!"

"I am coming," answered his wife, and then she cried to her sisters, "Do you not see anyone coming?"

One replied, "I see a great cloud of dust approaching us."

"Is it our brothers?"

"I grow impatient!" cried Bluebeard.

"One moment longer," replied his wife.

Then a sister said, "We see two horsemen, but they are still a great way off."

"Oh, thank God," replied the poor wife joyfully. "Make a sign for them to hurry!"

Then Bluebeard yelled out so loud that the stones of the house rumbled. His wife came down, and threw herself at his feet, in tears, with her hair about her shoulders.

"This means nothing," said Bluebeard. "You must die for your actions!" Then, taking hold of her hair with one hand, and lifting up the sword with the other, he prepared to strike off her head. The poor lady, looking at him with dying eyes, asked him to afford her one little moment to recollect herself.

"No, no," he said. "Commend yourself to God," and again he raised his sword to strike.

At this very instant the two horsemen entered. Drawing their swords, they ran directly at Bluebeard. He knew them to be his wife's brothers, and both were soldiers. The two brothers pursued and overtook him before he could get out. They ran their swords through his body and left him dead. The newly widowed wife, almost as dead as her husband, could not get up to welcome her brothers.

Bluebeard had no heirs, so his wife became mistress of all his estate. She made use of one part of it to marry her sisters to fine young, but poor, gentlemen who had loved them a long while. Another part went to buy Captains' commissions for her brothers, and the rest she used to marry herself to a very worthy gentleman, who made her forget the ill time she had passed with Bluebeard.

Would you say the moral of this story is "Curiosity killed the cat?" Perhaps, but we will explore this later. First, another story.

Eros And Psyche

Eros rescues Psyche from being married off to Death in this ancient Greek myth. Eros' mother, Aphrodite, was jealous of Psyche and the attention she was given, so she arranged her end. But her son disobeyed her and carried Psyche off to his heavenly abode in secret. He gave her everything she could ever wish for, except a fully present husband. She did not know his true identity and was only permitted to spend time being loved by him in the darkness. She was not to see him, ever. These were the terms to which she had clearly agreed.

Psyche was lonely during the days and asked her nightly lord and lover if her sisters could be allowed to visit her. After her repeated requests, he finally agreed and brought them to her. They loved her abode, but were not happy that her new husband refused to show himself, even after giving her a heavenly lifestyle and the enjoyment of his loving embraces.

They said to her, "What if he is a monster, snake, or evil wizard, or worse?"

She resisted these possibilities, but the sisters would not let up, sowing the seeds of doubt. Slowly, this doubt began to grow. Like a slow poison, it cast a shadow over her heaven. So, she decided she would take the forbidden look at her husband. And she would be ready if he was indeed a monster.

That evening he came to her as he always did in the dark, and they embraced for a long time. When he drifted off into sleep, she went and got the oil lamp she had hidden along with a knife. She lit the lamp and walked over to him with the knife at the ready, just in case. When she saw him for the first time, she realized that he was the God of Love himself. She fell totally in love with him, all doubts gone, but as she did she accidentally spilled some hot oil from the lamp onto him, burning him.

Eros awoke with a cry of pain. A cry in heaven is heard by all, especially by one's own mother. Aphrodite came at once, and seeing how she was duped by her own son, took him to her abode and had Psyche cast out of heaven.

This great and long story continues with Psyche needing to accomplish four superhuman tasks in order to win Eros back and prove her loyalty. Later, we will discuss one of these tasks in depth. For now though, I wish only to draw a comparison between this tale and Bluebeard's story. Next, we must visit the Garden.

In The Garden

Once upon a time, in a land called Eden, there was a young couple named Adam and Eve. You've probably heard of them, yes? Good, so I don't need to lay too much groundwork. Naturally, they were living in a heaven on earth and had everything. Nothing was denied them, except one thing: the fruit of the Tree of Wisdom that held all knowledge of good and evil. They were not to eat of this fruit, "lest ye die," said the Lord God!

That statement holds a lot of weight, you must admit. Both agreed to the plan, and they enjoyed their days and nights running around naked and childlike and did whatever they pleased—total freedom, with no responsibilities whatsoever! Oh, I almost forgot. There was one responsibility: that fruit they agreed not to eat. Commitments are a responsibility, aren't they? Commitments to God, well...

Okay, you probably know there was this unsavory oppositional character who suggested to them that they should, of course, taste the banned fruit. According to the story, Eve gave into curiosity first and decided to give it a try. She took a bite, and then offered it to Adam, who had been watching as she took the first bite but had not stopped her. He then took a bite too, and God got angry and cast them both out of Eden. They were to fully exercise responsibility for their lives and

actions now, as punishment. And the human race has resented responsibility ever since.

Now, let's examine the similarities among these three stories. What are the common threads shared by all? Think about what these stories suggest to you about women. Before you begin the next chapter, I highly recommend you contemplate their meanings, so that you can identify your own inner beliefs regarding women. After doing so, please read on.

Chapter 2

Possibilities

There are two possible conclusions one can reasonably draw from reading the three stories contained in the previous chapter.

Possibility One

When a woman makes a commitment, she will not live up to this commitment because she will be easily swayed by her emotional dictates—her "curiosities"—and, therefore, cannot nor should be trusted.

I am not saying this is necessarily the correct conclusion; however, you need to understand how a conclusion like this could be drawn from these stories. Even if this is not your own opinion, trust me: there are men who believe this to be true of most, if not all, women.

This conclusion has implications regarding women's trust of one another. Sadly, I have heard from many women that they do not trust other women. This train of thought developed from darkness, an opposing force to the light of wisdom that seeks to deny wisdom by making it look like something undesirable or simply wrong. Remember, wise people are hard to manipulate and control. This is much like men being told in our patriarchal society that their feelings are wrong and shameful, instead of a great and necessary part of their humanness.

An example of this opposing force is a woman using or withholding sex to manipulate a man. This happens because sex is basically the only

outlet a man is allowed for the expression of his emotional needs, so he places an extremely exaggerated level of importance on it. If a man were balanced—allowed to talk about his feelings as a woman is—he would have his needs fulfilled appropriately. It would not be all about sex. A man could state that he's lonely, afraid, or in need of a hug. This sharing of self—this intimacy or in-to-me-see—is a man becoming a greater man, not a lesser one.

A woman would not then be able to use the "sex card" to manipulate a man nearly as easily. This could be perceived as a loss of power by the woman's dark side. This darkness would rebel and seek to emasculate this man in defense. In response, he would either roll over and play dead, rebel in macho anger, or leave. All the while, this woman would be blaming everything on whom she is projecting her darkness upon—the man.

Naturally, this is dysfunctional and counterproductive to connection and love. This is, however, the scenario that actually occurs time and time again in many relationships.

Now what is not evident, what is in fact hidden, is how and why this conclusion is actually the planned and desired outcome; and it carries through as a theme in all the previous stories.

Planned and desired? By whom?

The Patriarchy, our patriarchal belief system, this male-as-dominant belief system dictates that women must be subservient and controlled and that they cannot be trusted. Men must take care of women, protect them, and provide for them because women are weaker, less capable, emotionally chaotic, and less competent. In the past, and still in some parts of the world today, women are considered as children, treated like property, and money must be paid by their families to another family for taking on through marriage the burden of wife-care (like childcare). This is called a dowry.

Just imagine yourself living with a Bedouin tribe in the deserts of the Middle East a few thousand years ago. You are living in a very male-

as-dominant society. If you live there today, not much has changed. Its stories would seek to teach its viewpoints and exclude other possibilities, violently. So women became the ones that could not be trusted and were used as the scapegoat on which all manner of evil could be blamed. In fact, this has been so successful a campaign that many women believe it about themselves and act it out.

These thoughts have been woven into our myths and religious texts, and the fact that women are emotional and chaotic before they mature lends credence to this premise. For proof of this, just look at the average teenage girl, and remember that five thousand years ago, she was married in her early teens, if she was lucky. She was also lucky to live to the age of thirty and had little time to develop maturity. Schools didn't exist, and women were often excluded from the only teaching tools they might have received, which were from the retelling of the myths, the tribal teaching stories. Maturity, or wisdom, was unattainable under these conditions.

Possibility Two

Following the reasoning of Marissa Pinkola Estes, Ph.D., contained in her thought-provoking book, *Women Who Run With the Wolves*, I offer this understanding of the meaning of all three stories.

The female in all three stories is told she is free to live a heavenly lifestyle, but is she? An immature woman is easily lured with promises of an easy lifestyle with various benefits like increased security, social stature, power, glamour, or a taste of the forbidden fruit. Reason is not an important factor in her choices. She lives by the doctrine, "I feel; therefore, I am." So if it feels good, do it... right? From the outside, this looks like the woman has chosen to live life as an emotional whirlwind, and this is judged as wrong, weak, and even crazy. Along with all the emotions, the feminine is demeaned.

In our society, even similar behaviors that both sexes exhibit are judged differently. Women are called nosy or snooping, while men are

called inquiring; women are curious, men investigative. The Patriarchy intentionally places a negative connotation on the feminine version of these characteristics. Why? To lessen the value of feminine insight and intuition. This is an attack on feminine wisdom.

In real life, a woman must question what she feels and then follow her instincts. This is an inherent component of her wisdom. The Patriarchy, however, wants to keep these feminine characteristics in the dark, as a matter of power and control. Hidden knowledge is power, and if you don't have it, then blinding another to her inherent power, through techniques of subterfuge and deception, is strategic.

Examples of this are seen in the actions of the male antagonists within each of the three stories. It is the same with the trickster, who is also called the great deceiver, Satan. His only power is deception. In effect, he opposes our movement toward connection through convincing suggestions that we accept as true. He has stopped us without really doing anything. He affects the paradigm of existence, the group role model, in the same way. The oppositional force is the definition of the word Satan. Christian mythology gave him horns and great power, which he doesn't have nor doesn't, have nor need. We become his allies in our fear, arrogance, and blindness. I just hate that… because I recognize it in me.

Back to feminine questioning, Dr. Estes said, "Asking the proper question is the central action of transformation—in fairy tales, in analysis, and in consciousness. The key question causes germination [activation, growth, and development] of the consciousness. The properly shaped question always emanates from a curiosity about what stands behind. Questions are the keys that cause the secret doors of the psyche to swing open."

By asking the right questions, we can expand the width and breadth of our awareness and from this develop our capacity for wisdom. This is how we cut through illusion.

So, according to Possibility Two, these ancient tales contain quite a bit of misogyny, the hatred of women, or at least hatred of the wisdom

contained within women. Perhaps the Patriarchy fears this wisdom or feels inferior to it, like a boy would to his mother? We will need a clear understanding of how and why this thinking was developed in order to neutralize these beliefs and develop our own awareness of eons-old programming.

Chapter 3

The Fairytale Princess and Other Illusions

The Fairytale Princess

Once upon a time, (again) in a land far, far away, lived a beautiful princess. She was besieged or imprisoned by a wicked stepmother, or was it a horrible dragon? Then again, it might have been the evil king, sorcerer, witch, or some other horrible dark creature. Whatever kept her from her happiness is immaterial; suffice it to say, it was an opposing force.

Then HE (hero, knight, woodsman, naive youth, prince, etc.) saw her. He could have been the toad that she refused to kiss, too. Anyway, he fights the good fight against all odds, wins as all good fairytales assure us, and rescues her from her unhappy imprisonment. This hero must be a wonderful hero, protector and provider, and therefore, will also be a perfect husband, right? She wants to believe that he is really a prince, even though he smells a little like a toad. In gratitude, she gives him her kingdom, and they go off and, and, and… dare I say it… live happily ever after. Oh, the stuff dreams are made of.

Of course, it's just a fairytale, right? How could it hurt to entertain with a fairytale? They're just cute, harmless stories told to children. We are unaware, however, that they actually become the rudiments of our inner programming: our belief systems by which we create the foundations of our lives.

Imagine a life built upon a foundation made up of clouds, not rooted in the terra firma of conscious reality. I bet you can. These fairytales are

supposed to be heralds of hope. Yet, they actually concretize, or set in stone, our hopelessness. Our hoping for an outer happiness denies that happiness is already within us, waiting to be developed and claimed; thereby, we've excluded it.

There is a difference between looking for happiness in illusions and creating conscious realities. They may appear similar, but creating a life based in illusions never fulfills one in the long run. You will find yourself with the vague sense that you are "but an actor on a stage," all too often, I think. So let's chase the clouds away, illuminate what's not real, and plant our feet on solid ground. Then we can feed the seeds planted consciously and germinate wisdom and fulfillment.

Playing House

I remember as a child hearing these tales and thinking that, on the one hand, I liked them, and I wanted the princess, of course! On the other hand, though, these stories were scary. Why scary? Because the happy couple always went off into the sunset to live happily ever after despite having just met and not knowing each other at all.

As I grew up, I decided that the answer must be that somehow magically through "love" the couple connects, grows into an understanding of each other, and develops a deep abiding love as they play house. A quick review of our fifty-percent divorce rate should enlighten us on love's illusionary nature.

Both fairytale partners accept their parts in this play of consciousness and act them out. Even their "love" is mostly nothing more than a heated rush with their codependent needs being fully activated and at play. How could they possibly have developed a relationship that goes deeper than "I think you are hot, and I don't want to be alone?" They just met under stress and need. These are not healthy ingredients for a successful romantically connected relationship.

Unlike children playing house, who are allowed to retreat to their real home after a few hours of play, you in the fairytale relationship remain trapped in the playhouse, thinking it is real. "But they told me that's what I was supposed to do." And you believed it. That is how illusions become reality.

Women in these fairytales and in our patriarchal society are treated like children and property. They are disinfected of their instinctive natures as if these natures were germs, and they accept this without question. As a result, a woman's ability to express her true self is stifled, leaving her with feelings of powerlessness and continued doubt, which in turn blocks her ability to follow through, take the necessary steps to evolve and build the Self.

Women too often give their creative abilities over to others. This includes essence-draining choices in mates, or work, or friendships. This relinquishment of creativity lends itself to inertia of being, or staleness. Women in this state may feel drained, frightened, or unable to be passionate. They may also be afraid to stand up for themselves or may create overly strong boundaries when warmth is needed. This creates resentments that will either be self-directed, or at times, explode out onto others.

Trivializing feminine curiosity, making it seem like snooping or childishness, as witnessed in the three stories, prevents access to women's insightful nature. This is the function of the fruit of Eden, the desire to know Eros, and the key to Bluebeard's room.

Wise women *should* want to taste new ideas, investigate unknown mysteries, and develop their intuitive wisdom. Proper questioning causes growth and evolution. Without it, our dreams and hopes die, we lose the energy to create, and we become anemic. "What do I know deep within that I don't want to know?" is a great question to start with.

A woman may create for herself an image that looks like it fits the role she wants to play in life, but her actions will be out of sync with who she really is and how she really feels. She stores her true feelings in the

freezer and intends to take them out to defrost when the time is right. This "right time" often never arrives, though, and it seems more and more elusive as the clock ticks on.

A Starving Soul

A woman who has been captured, as in the fairytales, will settle for something—anything—that seems similar to the original treasure she had as her intended goal. A slave takes the scraps of food thrown her as a gesture of kindness and love. The "Stockholm Syndrome" effectively illustrates this concept: a victim (usually of a kidnapping) begins to empathize with her abductor, sometimes to the point of helping him. The most famous case of this was Patty Hearst and her abductors, the S.L.A.

A captured woman may look pretty and put together externally, but her inner world is filled with fear and hunger from a childhood of pleading for sustenance; She will accept *any* sustenance, for she is making up for past losses and unmet needs. Unfortunately, this surrogate sustenance is much like food made of plastic: appetizing to look at, but fake, nonetheless.

She is a captive animal, one that can be easily compared to other captive species. Look at zoos, for instance. Some captives are unable to breed, their appetites for food and rest are twisted to meet zoo hours, and their wild instinctual behaviors dwindle into lethargy, sullenness, or unexpected aggression toward their caretakers. Animal depression is a zoological term for this condition. These caged ones are prevented from being their true selves, and they are expected to act as the zoo, or in the case of the captured woman, as society, dictates.

The instinct-injured, caged, and deprived woman has a difficult time asking for what she needs or even for help. Fight or flight instincts are deadened, sensations are sanitized, and she cannot feel fully. Nor can she love. Her sexuality is also a casualty.

The Fairytale Princess and Other Illusions

The theft perpetrated by the play-acted love robs her blind. Naïveté is the poor insight into another's motives, inexperience in seeing cause and effect, blindness to consequences, and the missing of the clues life presents. People robbed like this are in a kind of psyche sleep—a trance state. What they were not taught was that loving fully does not mean loving blindly. Further, loving must include loving Self. If you neglect Self, you will run out of steam and start play-acting.

Women have, in the patriarchal system, been taught that they are only legitimized as humans through marriage and child bearing. They have been force-fed the notion that they must need a man because women are vulnerable without the masculine protection. But vulnerable to whom or what? Men? Life? Other women? Everything contains an element of fear. Women are taught that fear is the norm.

A man will feel a woman's neediness and be afraid of being overwhelmed by it. So he keeps his distance. This is part of a man's fear of commitment. At the same time, however, he feeds her fear through the macho behaviors he displays as a result of what the patriarchal system has taught him. The gender that is her savior can also be her enemy.

If this sounds like a gloomy picture, remember you have the choice to accept it or to choose another picture based on different perceptions. But first you must handle your own issues within. I am not saying there aren't negative elements in life. I am saying that these elements are only part of life, not the whole. Life presents wondrous beauty and great joy along with elements that may seem unpleasant or even scary. What occurs in many lives is that the scary elements become the whole; the beauty and joy are lost. Most people do not realize they chose to focus on the negative, making it their totality.

Protectionism creates nothing and starves us from what we need. Selfishness, rigidity to our beliefs, screaming, or lashing out all drain us of our essential energies. Partnerships are meant to build-up, reinforce, and transform the individual partners. Often, partnerships are seen only as vehicles through which we have our needs filled; our partners are there

to fit our agendas. In the ideal partnership, the essence of both partners will be encouraged, stimulated, and released: freed to grow and work their magic. Human nature attempts to create ideals, but in an imperfect world, it would be self-torture to expect this.

It is the wisdom of the feminine energy that understands the complicated rhythms of life and how the tides of emotions ebb and flow. The masculine energy within a woman teaches her intentionality, how to focus, plan, hunt, and how to use the loving spark that is not bound by fear. Of course, using this masculine energy requires understanding that it exists, what it is, how it is incorporated positively within the female psyche, and how it can affect her behaviors when ignored or left unguided by her own feminine wisdom.

Misdirected use of a woman's inner masculine energy can have disastrous consequences for a woman. You've no doubt heard the expression, "Boys will be boys." When this becomes the unbridled driving force within a woman, she loses her Self; her feminine essence has been relegated into the background of her psyche.

A woman must rule her inner roost through her feminine wisdom, but in partnership with her inner masculine energy, which must remain in the background. The opposite is true for a man. He, too, must maintain a healthy balance between his inner masculine energy and his inner feminine wisdom, which should also remain in the background of his psyche, but be fully operative.

What we see all too often in a man is his inner feminine wisdom being banned from his psyche altogether, resulting in the loss of the non-linear abilities this wisdom holds. The man becomes stuck in a two-dimensional rut. I've been there personally, too. The other extreme happens when a man's inner feminine takes over, and his masculine energy is pushed into the background. He becomes feminized. Obviously, neither situation is optimal for him.

Nowhere have I seen this balancing of both the feminine and masculine inner energies taught. We are usually directed (by the patriarchal

teachings) to the polar opposites of gender where the battle of the sexes rages on. The purpose of my books is to present an alternative to this destructive insanity. I am looking to bring about the creation of a new perspective that includes mutual respect, partnership, and even adoration between the genders.

Chapter 4

The Barter System

The Art Of The Deal

In the "Fairytales" the princess gives the hero her kingdom. This is symbolically true, but the material reality, the patriarchal reality is that wealth was kept from women. In fact, women were considered property themselves. This has changed in many parts of our world where women are gaining in this arena, but the collective memory of this remains, and women are still taught to look to men for material support.

During her junior year of high school, my oldest daughter went through an exhausting period of schoolwork (she was in the top of her class), busy social life, gymnastics, and student government. She realized that life, especially as a successful engineer (her goal), would be real work, not necessarily fun at all! Her response was, "Maybe I will just get married and raise a family."

First, know that I consider raising children to be God's most important job. However, I didn't hear her say she wanted to take care of kids because she felt it was her calling. What I heard was that she saw it as the easy way out. I just said, "Hmm, boys don't have that option." She replied sympathetically, "I know!"

Women inherently know this option. And they are not being forced into it either. They are being *lured* into it. But is it just society's training that lures them, or is it their own laziness, or lack of self-worth, or the easy convenience that brings them to this option?

Women—The Goddesses Of Wisdom

Recent statistics say "the percentage of women in their twenties who are extremely or highly likely to marrying for money is sixty-one percent." This source went on to further say "the percentage of women in their thirties who are, is seventy-four percent."[2]

"Well, what's wrong with that?" said a physics professor I know named Andy, literally as I am writing this. "Isn't that the way it is? Isn't that wisdom to choose a better provider? Doesn't evolution dictate that a wealthier husband would be a better provider for one's offspring?" In fact, he went on to say that, "if it weren't for these instinctual evolutionary dictates, mankind would not have survived."

I replied, "In other words, you're saying the caveman that brought home the most brontosaurus burgers won the cavewoman? He was the best provider, therefore the best choice for a mate, right?"

Maybe, maybe not, but what seems true is that not much has changed with this underlying belief system that predates the Patriarchy and modern civilization. The question is, "Who are we really?" Are we just cavemen and cavewomen, Neanderthals in modern-day garb, or are we beings with the potential to be more evolved? And either way, does our living based on these old beliefs leave us feeling fulfilled? In the U.S. the divorce rate would indicate it does not.

Okay, there was and still is truth in the need to raise children and have help in doing so. True, a provider can be useful; but at the cost of pretending a feeling relationship exists where it doesn't, bartering one's soul, and losing one's integrity? This is the state of a majority of relationships, and men know it.

Men are deeply damaged by this model of behavior. It is extremely disheartening to think that I, as a man, have no value other than to provide a lifestyle for some pretty little fluttering thing—a bird I must cage—or else I will be left abandoned and alone. Our lifelines to feelings, heart and soul—what men hope women will be for us—will be gone.

2 Harper's Magazine, March 2008, citing: Prince and Associates, Redding, Connecticut.

The Barter System

Most men resent being seen as "Johns" in bartered-for relationships. We know we are not really seen or wanted for who we are, not truly cared about or loved. Of course, there may be the "show"—the illusion of caring put on by the women in these relationships—but it's not real. It's just part of the bartered-for arrangement, and we men don't trust it. We believe we are being used as lifestyle providers. Many see no other option than to just use women back, resigned to this shallow dance we choose; we were not forced into it. To participate in this lie that is a bartered-for relationship, a man must further shutdown emotionally, walling off what little access to his heart he has left after his patriarchal training. (For more on this read *Men—The Gods of Love*.)

I know this place intimately and have struggled to understand and heal my own misguided beliefs. This book is the result of my work: work that was made more difficult as it became clear that many women participate with such aplomb, a self-possessed easy cool. They carry powerful underlying programming that goes like this:

"A woman's got to lookout for herself."

"Diamond's are a girl's best friend."

"It's just as easy to marry a rich man, as it is a poor one."

"Marrying *right* is very important."

How is this predicament, this relationship paradigm that is so clearly evident, even possible? It is like the pink elephant in the living room that no one wants to speak of. And why is it that we have become so mired in the muck, our own muck? Like swine in a sty, we bathe in it; and we have long since resigned ourselves to this condition, giving it but a passing thought.

Why? Because WE HAVE BECOME ADDICTED TO THESE BELIEFS! We love OUR sty. These addictions of ours distract us from living a "real" life that includes being aware and responsible on the deepest levels. We've become unaware of who and what we really are; most are unaware of this condition. This is because we have "spruced up" the sty,

making it pretty and comfortable. And it is very distracting. It certainly captured my attention for a long time.

However, there is hope. In fact, you are reading this book because some part of you knows these beliefs are not working, that there is something more to life. There is an inner questioning occurring. That's what brought you to it. The challenge for us all is that these questions are not comfortable, not pretty, are they? And haven't we been taught to want a comfortable lifestyle? I sure was. But, for your soul, is this a good trade?

For some yes, for others, no; and many others are in the "not sure" situation-dependant category. Okay, so now we see more clearly this dynamic. We've brought into conscious view the pink elephant; but how did it get there, what underlies it, and why does it hold so much sway over us? Oh, and look at the mess it's made.

Addictions

It is important to know that the basis for all addictions, why we've created these addictions in the first place, is our desire to distract ourselves from certain uncomfortable or unpleasant feelings. Our addictions, which are definitely habitual and may later become chemical dependencies, all start out as distractions from something we don't want to feel, don't understand, or can't stomach. Or perhaps we simply were too lazy to deal with the responsibility of maturing, so we chose to find something else to focus on, like work, play, friends, projects, hobbies, sex, drugs, and rock-n-roll. This may have seemed like a great idea for a moment, or maybe even for a season, but surely not for a lifetime.

Relationship dynamics can develop into an addiction called codependency. Ever wonder why the "victim" in an abusive relationship doesn't leave? Because this person has power that they don't wish to let go of.

The Barter System

In *Men—The Gods of Love*, I gave as an example of this the stereotypical situation of an alcoholic, abusive husband and his wife who pretends nothing is amiss, cleans up after him, and "sacrifices" her life for him. Many feel pity for her due to the abuse she takes. Pity them both as they are each trapped in the same energy dynamic, just on different sides of it. His abusiveness is self-evident; but, what about his victimhood and her abusiveness? Where are they?

She cleans up his messes, makes excuses, and keeps the abuse a "secret," at least from the outside world. Pity the children here. The husband is not leaving because the wife makes it all right, and in doing so, she holds a form of control. As long as she can tolerate his excesses, she controls him, while perhaps feeling a bit superior because he is obviously not well.

She knows he will not leave her or will always come back to her if he does. This is how her feelings of separation anxiety play out. She is called an *enabler* because she enables, or facilitates, his inappropriate behaviors instead of rejecting them. They are both infirmed, caught in a sick play, referred to as their relationship.

Now, how is he abused? In the outside world, his behaviors would never be accepted. He would reap consequences that would clearly indicate just how unacceptable his behaviors are. He would have the option to change or to become a hermit. But within the delusion this couple lives, he never gets the feedback he needs: the reprimanding that could jolt or push him in the right direction. So, he just remains sick, while she has control over his leaving. Effectively, she helps him stay sick; otherwise, he might leave. Very sick this dynamic is, indeed, yet not uncommon.

So we now know a little more about addictions, but what does this have to do with bartering? Women have clearly been placed in a dependent position, and at the same time, have used this position to encourage the continuation of this dynamic. It is the dance in which both men and women participate. Most participants are not evil; no bad guys or girls in general; just us ordinary folks dancing away, mostly unaware we are even doing a dance. We may see our partner doing the dance, and

mistakenly deceive ourselves into thinking that "we're not involved or responsible." Whether this is conscious or unconscious is not important. What is important is that neither partner sees a way out of the situation they feel trapped in, and many don't want to attempt change for fear of the unknown. Some may just be unwilling to do the work necessary to grow and change. They have become too good at the dance, and it is too comfortable.

But slowly, as we age, a voice develops way off in the depths of our being, and it grows, gnawing at our contentment. It will not be silenced, try as we may to ignore it. What's a woman or a man to do? Keep up with our distractions? Or face this nagging voice? What are the options? And making our decision harder is the fact that we have all been taught to fear the unknown and change, not welcome them.

That is what this book is about: illuminating options. It's personal for me. I know what those distractions feel like from direct experience. I know the emptiness and fought to find meaning in it. It saddens me to see so many in the very same struggle for meaning that I have known so well. It will take courage. For a woman, this courage is contained within her inner masculine essence. She must access it, allow it, welcome it and create a balance with it to grow.

Feminine Balance

How can women balance all these forces? It takes wisdom to do this. Luckily, this is women's heritage: balancing the need to survive and provide for offspring with the needs of the soul. The soul's needs are not as obvious as material needs, but are equally important. Among these needs are: honor, integrity, connection, relating, and trust—all aspects of love. Love for the in-dwelling infinite, and for all things big and small. Again, not a huge task for a woman; she is inherently all that.

However, she might just have allowed herself to lose sight of her very nature. True, that's very silly, but understandable, as there are so many

bright and shiny distractions for one's attention, and goblins around every corner to fear, or so many have come to believe. This is the oppositional force, the great deceiver, the trickster; illusion by any other name would still be untrue. Yet we believe in these illusions, worship their existence. Here is where the feminine wisdom must come into play. A woman's primary task must be to balance out her material needs, while remaining true to her soul.

What poor bargain a woman does make by surrendering her inner vitality. A bargain made long ago while asleep, in trance, by choosing what caught her eye—like riches, lifestyle, and security—she has given up her creative, passionate soul.

She injures her instinctual nature, harms her womanhood. If her masculine part (animus) is kept in the dark, unaware, and untrained, it will be blind to these self-betrayals. It is the masculine part that rises up to defend her. Things and people are not always what they seem to be, and an instinct-injured woman misses out on the warning signs. The unseen price a woman pays in missing these signs is her own self-worth.

Self-questions like "How does this relationship support the real me?" or, more importantly, "What is the real me?" are not asked. A woman buys into her chosen role and becomes an actress upon a stage. Some relinquish their creative artistic parts, bartering for a grotesque security, or a financial marriage, to become the good wife, daughter, mother; or they surrender their calling to be more acceptable, liked and, of course, to get more positive attention.

The Material Girl

"I am a material girl," crooned Madonna, referring to the material lifestyle. Material girls are bought and paid for by material things. Worse yet, most know they are empty on the inside and emotionally unfulfilled, but continue to believe that "another diamond, another acquisition should do it." This is very unfortunate for the human race, as it directly

feeds the "war of the sexes." *We all* lose in this war. This is part of the original polarity between the sexes, and we must find a new way to relate to our counterparts. The alternative is that we allow our differences to crush our humanness. I believe most reasonable people would agree, looking not only at past history but present day reality, that this is the very predicament the human race is still in.

Chapter 5

Narcissism

Vanity, Thy Name Is Woman

In Chapter One, I mentioned that in the ancient Greek tale of Psyche and Eros, Psyche was given four tasks to accomplish in order to regain her love, her Eros. The story is a metaphor for regaining one's inner love, one's inner masculine, and the pitfalls a woman can succumb to during the course of her journey. Here is part of this myth:

To Hell And Back

The last of Psyche's superhuman tasks is naturally the most interesting. All she must do is go into the depths of Hades (hell) and obtain a jar of beauty ointment from Persephone, the goddess of the underworld. Then she must bring the jar back to the jealous Aphrodite. Simple right? Remember, it was Aphrodite (aka Venus) who attempted to kill Psyche in the first part of the story and was thwarted by her son, Eros. This was all because she was jealous of the attention Psyche was getting—attention Aphrodite coveted. What a way to upset one's jealous mother, by thwarting her plans when she is already upset! Look out Psyche, Eros' mom is enraged, and you will reap the consequences.

Well, Psyche accomplishes this task of obtaining the jar and leaves the underworld with it. She gets past the three-headed guard dog as she enters and leaves; crosses twice the river Styx; then manages to stroll

through hell to get the beauty ointment. She overcomes the machinations of mom's jealousy. But don't cheer yet. She is not done with the task. No, there are no armies, assassins, monsters, or other new hurdles set in her way by Aphrodite. It is clear sailing, except for one thing—she must deliver it.

Now, she has the biggest obstacle to face: herself. She, a mere mortal woman, thinks, "If I use just a small amount of this ointment of the goddesses, I will create a more attractive me to draw-in my love, and he surely will not refuse me." She must believe she is inherently not enough for him to love and therefore seeks a little help, the Madison Avenue illusion. So she opens the jar and falls into a "death-like sleep." In the story she is rescued by her love, her Eros, who again defies Mother.

Now, how does the opening of this jar of beauty ointment of the goddesses and falling into a "death-like sleep" relate to modern day women?

Here I offer an illustrative story. It involves a relationship of deep love between a man and woman. He loved her with the totality of his being and was completely committed to what he saw as a life partnership. He communicated this to her, but it was not enough. She was still healing from a recent divorce, and had just started dealing with unresolved traumatic childhood events. She could not move on, no matter that she professed profound love with her new lover. Her wealthy husband had left her for a younger, "tall, blond big-breasted" woman. She was understandably angry at the situation and blamed him for their divorce. She was very comfortable in her wealthy lifestyle. She was unable to see her part in her divorce, where she had married for lifestyle and withheld herself from participating in what he liked to do.

Her solution to feeling undesirable and rejected was to get a breast augmentation. When she had her new mammaries, she started to act like a different person: aloof, snobbish, and full of herself. Naturally, she showed off her newly acquired attributes. After all, she had spent a lot of money to get them, and they did attract attention when shown off. She became uncharacteristically insensitive to what her love was feeling, feigning being overwhelmed with her busy schedule. Highly irregular

from the person he had known. Her behavior hurt and horrified him. She was a new and different person, a newly created constructed personality living in a constructed reality! The relationship did not survive the changes.

How does this relate to Psyche's story? The symbolic jar of beauty ointment from the goddess of the underworld was her breast augmentation. She had succumbed to the spell cast by her own vanity; her ego's creation superseded her essence. In her mind, she was now equal to her former husband's younger, big-breasted girlfriend. Further, she would now show him! Of course, she would do it by becoming him, taking on his un-evolved masculine behaviors, not by evolving from her own experience. She went after younger men, becoming a "cougar."

This is the "death-like sleep" Psyche fell into when she opened the jar of beauty ointment. First, let's discuss the meaning of the "death-like sleep." It is a metaphor for a deep trance, hypnosis, or dream-like state. Trances and dreams are first cousins; they both bypass the critical factor of the conscious mind. This simply means the conscious mind is out of the picture. It is also similar to the state of daydreaming. She has fallen into a self-induced daydream, an illusion, which she constructed. She disconnected from her true self and became an illusion of beauty, a "babe, hottie, fox, sexy thing, etc." In other words, she has become an expression of Aphrodite in the flesh. Aphrodite had won because she had a powerful ally, Psyche herself. She associated with her unconscious Aphrodite energy, the self-centered goddess-illusion and disassociated from her humanness.

This is the narcissistic illusion that "Madison Avenue" promotes and capitalizes on. Here, superficiality rules supreme, being focused on outer looks, manipulation, power, control, and, of course, the big prize, attention. And men do succumb to this illusion, don't they? But these men don't stay because it is not you they see, only the illusion and how it ties temporarily into their illusion. As "arm candy" matures, a newer model will be desired. Perhaps, this arm candy role is not what women need? Perhaps it needs to be dispensed with, but it has powerfully alluring and addicting aspects, for both men and women.

Remember, when you cast your spell, and he allows himself to fall under it, it is ALWAYS temporary. That's because there is no real relationship created. The "honeymoon" phase is temporary, and it will pass. Unless there is a real foundation underpinning the relationship, so shall it too pass. You cannot create a solid relationship in a smoke-and-mirrors environment. But many women think that if they land the fish, he will come to love them and stay. And, of course, there is always pregnancy to nail him down.

Our augmented character's self-created reality is diametrically opposed to her Psyche, her human soul and relatedness energy. She is not self-involved; she's become self-possessed! This trance-like state of illusion and disconnection has entrapped her in the "death-like sleep." Only her focused intentional inner male, her Eros, can save her. She will need to reconnect with this rejected part, bringing it into balance with her feminine energy. This is how she awakens from her life of sleepwalking, the "death-like sleep."

While an outer male may act as a catalyst, she must awaken the inner. Otherwise, the outer male becomes her rescuer, and she does not grow or evolve, becoming dependent on him. Dependence almost always creates resentment—not a good element to add to the mixture of relationship—and it is also often abused by males. Why? He will know she is dependent, clingy or needy; and inside will doubt why she is really with him. If he doesn't want to be abandoned, he will attempt to control her by keeping her needy, so she won't go. Not a good plan.

The woman in the example has taken a giant step backwards, which she has mistakenly perceived as a leap forward toward independence. Can you hear her crying out, "I am woman, hear me roar," as she conspicuous flaunts her enlarged chest? So it goes with self-deception, trance, and illusion (the "death-like sleep"). We deceive ourselves thinking we are moving forward, when in reality we are moving backward. Incredible, the power self-deception has.

Trance Exposed

How can you know if you are living in a state of self-deception? Listen to the gentle messages of your inner Self. They will be different from what your emotions tell you, which usually scream loudly. Notice the areas of tension you feel in your body. Tension is the physical signal of repressed energy (emotions). Do not resist your emotions; just allow your awareness to focus on them without judgment. They will begin to dissipate. The saying, "What you resist persists," expresses the dynamic that by resisting a thought or belief, we actually strengthen it. That doesn't necessarily mean you need to act it out; just allow the energy, and it will dissipate.

Listen with an open heart to what is being said outside by others too. Ask, question, inquire into what others are seeing. There is an old saying that goes: "If one person calls you a jackass, shame on them; if ten people do, buy a saddle." True, this is not necessarily what you *want* to hear, but maybe it is what you need to hear. This is not to make you wrong, only to show you what isn't working that you are unaware of. This is a critical understanding. Only then can you take the necessary action and change what doesn't support the essential you.

However, listening to the opinions of your peer group must be reviewed carefully. Understand that they too might be possessed by the same group energy dynamic as you are, and therefore subscribe to similar self-deceptions. So their agreement may not be what you need to hear. A true friend will tell you the truth, even if this person thinks you will not like hearing it, because they love you. Often we pick people to be with who support our own perceptions, desires, and ego's ways of thinking, which are self-deceiving.

The expression "partners in crime" is sometimes euphemistically applied to a group of friends. Perhaps, this may be more accurate than it seems on the surface. These are your partners, but they may not be true friends. You and your cohorts may be codependently enmeshed

in a collective or group thinking. This means that all have agreed on a way of being that may not support your individual essential selves. Your interests in each other extend only as far as the group perceives, and these perceptions can be based in similar negative decisions or faulty beliefs. I suggest you seek your confirmations outside your group energy, whether it be from others you know and in whom you trust and have respect for their opinions, or from a professional. It is always best if this advisor does not participate in the same group energy you do. You want objectivity.

Venus And Hercules

Now, let's delve into this important issue of vanity further. We will do this by looking at another short myth. In ancient Rome, Venus was given six tasks to complete, in order that she might be allowed to marry Hercules, who had just become a god. She completed five of these arduous tasks. She was exhausted by her efforts. She came upon a beautiful garden, which had a pomegranate tree with only one beautiful fruit on it. She desperately needed the nourishment of this fruit to provide her with the energy to continue her last task. Then she would have her man. But then she thought, "I am so tired, I must look terrible. Hercules will never want me in this state of being so worn out."

Yes, this was the goddess Venus saying this! So she took the pomegranate, crushed it in her hands, and rubbed the life-giving juices over her face to restore the beauty she decided she had lost. She needed this sustenance to revive her strength, so she would be able to finish the last task. But she succumbed to her illusion of vanity and the need to feed it. In truth, it was her inner strength that needed feeding. Inner beauty is eternal; unfortunately, she wasted this energy on her outer looks, and she vanished from the land of blessings. She dies beautifully in this tale, but her soul withered for lack of nourishment.

Yeshua (Jesus) once said, "What if one obtains the whole universe, but loses one's Soul?" One does not live on pomegranate juice (vanity) alone.

Narcissism

A considerable number of women do not understand that most men, though not all, want a woman to be their soul's partner. Men may not be able to voice this because this desire is contained in that part denied them (their feminine side), but they want it nonetheless. Yes, they want sex, and it can appear to be all they want at times, but it's not. They may not be able to express these concepts for fear you will reject them as not being manly enough. But they do want to find their soul's partner.

Men will also tell you that they are not interested in all the expenditure of energy on make-up, hair, nails, clothes, etc. "If you like it honey, if it makes you happy, then it is okay with me," is what you will get. Men just don't understand all the time and energy expended on vanity. Go into any major department store. Do you not find a small men's department and an overwhelmingly huge women's department? Men do respond to physical attraction of course, but this will never last for more than a short interlude, and any but the most immature man or woman knows this. Speaking as a man, we just want to share love and partnership. We want a friend. We want connection. Yes, we want passionate sex, too. And we don't want to be made wrong for this, or manipulated by it. We may not know how to create a partnership between souls well either, but it is our deepest desire.

Most men think women know how to create partnership and will help awaken this part within them. This is not a woman's responsibility, but it's important to understand. When women do not succeed in creating partnership, often because they don't know how to either, then men wrongly assume that the women are intentionally withholding it from them or that there is something wrong with them, as men. Both possibilities may elicit anger, withdrawal, or looking elsewhere for fulfillment.

Women must stand in the truth of their being, not come from the illusions of their vanity, to create this connection. Women are, by nature and training, more capable than men of creating connection, but it is the feminine in *all* our natures that creates connection. Help the men out ladies, stop blaming and using men, and create partnership. You are

not responsible, but you are more capable. Clear your resentments and misunderstandings, and do your best to help men. However, if you lead them to water, you can only encourage them to drink. Women must learn to stand in the truth of their inner strengths in order to succeed in creating connection. You will be rewarded handsomely. Men have the same responsibility, but don't use their cluelessness to blame them, while withholding your wisdom and love.

The Six Sticks

There is another related ancient story of the Six Sticks that will shed further light on what happens when women succumb to the "beauty ointment."

A woman comes before a Greek judge in ancient times to testify on a friend's behalf. Women's testimony was not readily taken in those days. The judge asks her why she wants to testify. She says to support her friend by telling the truth. The judge asks her what the truth is. She did not expect this question. She replies after thinking for a moment, "The truth is what I see."

"Ah," says the judge, "how can I trust you to tell the truth?"

The woman asks a little defensively, "What do you mean? I tell the truth!"

"Well," continues the judge, "I look at you and see that you are wearing high heels to make yourself taller. You are not the height you present yourself as. This is a deception. I see that you have colored your hair in a lovely shade of red and have applied make-up to your face so that your skin will match this color. This is also a deception. You are wearing a corset to make your waist look smaller and to push up and out your breasts so they may appear larger and fuller. Further deceptions are these. Naturally, you want us all to see you as this illusion you are presenting. This is a misrepresentation. It is fraudulent. How could I believe in what you say

when I cannot even believe in what you are physically presenting?"

Now, the judge was not without mercy, so he gave her a task to perform. He took six similar looking sticks and threw them on the floor. He told her that one of the sticks was a rare type of incense brought in from India. He asked her to pick up the one that was this rare incense. She looked for a moment, and then bent down to pick one up. He asked her why she had chosen that one. She said, "Because you told me to pick up one."

He asked if she was sure this one was the correct stick. She thought for a second and then put down her first pick, selecting another. He asked why she had chosen another. She replied, "Because you asked me if I was sure about the first one, so I thought you were telling me that it was not correct, so I tried again."

"Are you sure of this one?" he replied. She put down the second one and picked up a third.

She asked, "Is this the one?"

"No, actually, it was the first one. You do not trust your own Self; you have lost sight of your truth and replaced it with illusion. You see no truth, even when true, because you are so invested in these dreams. That is why you cannot make this simple choice. Since you cannot trust yourself, how can I trust you?"

Exposing some of the underlying elements in the illusion of beauty is not very attractive, is it? JUST BE YOU! Forget what others tell you to be. Find *your* truth.

Caricature Of Self

Harsh judgments about body acceptability have created a nation of hunched-over tall girls, short women on stilts, large women dressed in mourning, thin women adding padding, and various others that walk

around feeling invisible. Is she worthy or not based solely on looks? It's unthinkable, in a world of whole beings with instincts intact, for women to be so preoccupied with looks. Yet, it is definitely a reality of our world.

It becomes all the more evident in older women trying to appear younger by dressing and acting like twenty-year-olds. These women are great examples of a caricature of Self. They don't look real and are certainly not comfortable in their own skin. Happiness is a commodity to be purchased in the cosmetics department, along with spa treatments and new costumes. The majority of women succumb to this thinking to one degree or another. They don't know who they are, don't like what they think they are, but believe that by creating an image all will be well.

I am not saying spas or clothing are wrong, I like them too. But I don't associate who I am with these things. I can live without them. Can you live without your fix? That is the question.

Chapter 6

Being Female

First, Let's Look At Both Sexes' Attributes

Basic masculine attributes include the aspects of goal-directed focusing, mental awareness, organizing of life into divisions or pigeonholes, and creating doctrine-based structures.

Basic feminine attributes are the aspects of connectedness, relatedness, and defuse, multidirectional, feeling-based awareness. The feminine awareness is inherently unlimited. It can touch the face of God. The masculine has no idea what this means.

A striking example of how women lose their natural perception of womanhood is seen in our generations of women unschooled, unprepared, and unwelcomed into the ebb and flow of womanhood: menstruation. Blood has become a symbol of a bothersome and painful humiliation, rather than being part of the wonder of the "miracle of life." It is something to be handled, pigeonholed, so as not to interfere with a productive life. Think about this last sentence; does it sound feminine or masculine?

It is the latter. The aggressive patriarchal thinking in the form of the pressures caused by social, economic, religious, and cultural demands distort women's access to their wellspring. A woman's time in the *Red Tent*[3] has been relegated to mental procedures, tampons and minimalizing

3 *The Red Tent:* In ancient biblical time a tent where women went during menstruation. It is also a fabulous book of the same name written by Anita Diamant.

distractions. Sacredness is the price demanded and exacted for this trivialization. The trickster energy corrupts a woman's intuitive nature by offering easily deceptive baubles as a substitute to the sacredness offered up.

We must balance all of our natural elements: physical, mental, emotional, and spiritual. These efforts, of and by themselves, become our most important teachers. These are the tools of experience that come not from books or lecture, but from being there. Be conscious of what forces are at play; these are the fires that bake the pottery, making them strong, solid, and mature. We could all mature earlier, except that we are taught methods that insulate us from these fires in the name of propriety, conformity, and acceptability. This blockheadedness is the limiting, destructive nature inherent within the Patriarchy. It attacks our intuitive faith, our will to breakout of convention and question life, or worse, it trivializes our dreams and subsequently our finding of purpose.

Put on your Sherlock Holmes hat and investigate, intuit, and weigh the results. Look for what damage has occurred and change it, using gobs of forgiveness, and become more aware of incoming bombshells of self-doubt. Just as important, be aware of what wonderful things you have experienced and accomplished.

No, Maybe, Try Harder

I was at a talk at a local coffee shop given by the author of a book she billed as the "bible on relationships." She discussed a list of items that she said demonstrated abusive traits in men. The first example given was of men who don't stop when women say "no." I am going to stop and cover item one, but, suffice it to say, the remainder of her list seemed mostly like male bashing by a woman who chose to make men wrong, make men responsible for her choices that she regretted.

As a very young man, I thought that when a woman said "no," she meant no, and that I should respect her wishes. Men should definitely

respect women's true wishes. Herein lies the problem: which wishes? The ones driven by guilt and shame (those socially dictated) or the inner urges? How's a man to know what a woman wants in her "ocean of emotions?" Women are influenced by so many dictates that are definitive in nature of immature femininity. Rigid dictates are not an indication of maturity either, only a replacement for it.

As I grew, I found out that "no" might mean *no*, or it might mean maybe, or it might even mean *try harder*. It could also mean "yes, but I don't want you to think I am easy, so I'll say no." No can mean a variety of things when said by a woman. The last one is the most misunderstood and creates the greatest harm. But before I get to this, if men can't believe a simple "no," how can they believe anything else? Food for thought, aye?

Now, as to the last iteration of no, women simply make men responsible for and blame men for sex. There are three reasons that stand out as to why a woman cannot say yes. First, she may feel that a man will think of her as "easy," or a slut. The male reasoning as to why one doesn't have a relationship with a slut is because you cannot trust that she will remain faithful if she says yes too easily. Yet, to make matters worse, at present, the role models presented by the media and being imitated by women exalt this slut image. I have coined the phrase "slut-ebrities" to characterize Hollywood celebrities' behaviors. "I am a hottie, but I am to be taken seriously!" Yeah, right! And they are moneymaking machines. So women will try to appear like sluts and at the same time deny that they are. Confused? So are they, not to mention the men who are now being told to treat women as slutty sex objects and as ladies to be honored at the same time.

The second reason why a woman won't say yes directly is because she may be ashamed, judging her own sexuality as shameful. Women may say something akin to the following: "You got me pregnant," or "You ignored my no." Of course, there are cases of rape where a man did just that. This should not be tolerated, nor confused with the behaviors I am discussing. However, in my more promiscuous days, I'd occasionally meet a woman,

not feel any connection to her, see that she was wanting and willing, and think to myself, "What the hell, why not?" I played out the male sexual role that I had been taught.

Afterwards, I would hear, "I didn't know we were going to do that." At the time, I would listen in disbelief and judge this woman as a "nut." "You not only agreed, but it seemed like you were the initiator," I'd say. Either I received a blank stare, or she'd act surprised and deny this. I didn't understand her words or her actions. I am not sure she did either. Was it all show? If she didn't realize she was the initiator, as may have been the case, then she was certainly unaware of herself.

So let's look at this dynamic more closely. Why would a woman not consciously recognize her own desires that men can nevertheless feel and respond too?

Years of making women's sexuality wrong by the Patriarchy and its religious proponents is a root cause. So men become the projected recipients of women's sexual desires. This causes women to disconnect from their sexuality. This teaches them not to enjoy their own normal needs. This is useful in manipulating men, but not in creating fulfilling relationships, nor in being sexually fulfilled. This is not a problem for women who are trained not to think about their own sexual fulfillment.

A third reason for saying "no" is that women have eons of the collective experience of becoming pregnant, which may not necessarily have been what was wanted. The long-term consequence of pregnancy has always fallen on women's shoulders. They may have felt trapped. A consequence that encompasses huge volumes of collective fear is that many women have suffered and died during childbirth. This is ingrained in women, not incorrectly, and carries weight in their decisions and attitudes toward allowing sex. This understanding should not be minimized.

Granted, women have for eternity dealt with the profound biological consequences of being female, from which modern birth control has attempted to free them. In our modern world, a woman can give herself to the sex act, free from the fear of life-changing pregnancy, mostly. Yet,

this fear in women still rises up from the depths, sometimes at the most inopportune of times. Even when reason and science assures them of this choice, the collective fear is still there.

Of course, after menopause, women are freed from this particular worry, which can create a desire for sex at the age when men's desire starts waning. Women are often caught unawares of this and may think it is they that have become undesirable. It certainly is not in the "women's handbook" that tells women "all men want is sex," is it? This creates a different type of strain on a relationship than has been previously encountered; and if one is not attentive, it may be damaging.

So, how does a woman face these challenges when the collective fear surfaces? The first step in being free of any fear is to stare it in the face, to know it. Go inside with the fear and ask to see the origins of it. Understand, heal, and release it with the light of your love. Communicate this fear with your partner and peers. When you find out you are not alone, this awareness is healing in and of itself. Your instinctual Self will develop when bathed in the light of consciousness.

It takes a high degree of focused consciousness in a woman for her to be able to observe the basis of her instinctual actions. But observe she must. Finding out what is correct for her, which beliefs actually serve her, and which are incorrect and archaic, is critical. The personal disguise, the persona we enact based in either the anima (feminine within a male) or the animus (masculine within a female), is a shadowy costume. It contains society's collective beliefs, which animate our day-to-day created expressions of Self, our personas. These are not often true to our individual natures, but are learned as socially acceptable.

Truth

To thine own self be true,

And it must follow, as the night follows the day,

Thou canst not then be false to any man.[4]

Utter sincerity is the key to this truth. This is not inherent in the feminine chaos of unfocused emotions, which dictates the truth moment-to-moment based on the ever-changing feelings of the moment. Women must incorporate this all-important inner masculine principle in order to relate to their own inner masculine, no less the outer ones. No half measure, white lies, prettied-up stories; only the truth—the whole truth, so help you God.

The difficult part would seem the easiest, *to thine own self be true.* Why? It presupposes that you actually know what is going on within your own heart and mind. This is required in order to be able to see clearly, to define life without rigidity. But most women are operating using set-in-stone doctrine they have learned from our patriarchal societal system.

It is the power to focus that makes men able to create. It is the ability to take inspired ideas and bring them into matter. This is the masculine energy, without which these are just powerful emotional feelings that ebb and flow. When they go unused, they vanish into nothingness, forgotten for lack of action. This is the energy a God of Wisdom harnesses. To focus, see, hold and take action as the idea emerges is what separates creation from dreams.

Directing The Masculine

The task for a woman is holding onto her feminine essence, which the conditioning of our present patriarchal society denigrates, while creating a synthesis with her masculine. That is wholeness for a woman.

4 William Shakespeare, *Hamlet,* act I, scene iii, lines 78-80.

Being Female

A highly critical and oft missed understanding for a woman attempting to incorporate her masculine essence is that "he" needs directing. Without this direction, he will focus his attention on anything that seems interesting, like a child focusing on bright and shiny baubles. But if a woman consciously recognizes and asks for the use of his attributes, he will readily agree and take to heart the task her wisdom has defined. He will then create awesome projects that she will have inspired and directed. Many professional women have discovered this, but have forgotten to take back the reins. He then takes over, and she is relegated to the backseat.

June Wolfe, the President of the South Florida Manufacturers Association, told me her story of feeling the need to act masculine in an industry dominated by men. (Used with her permission.) Wanting to fit in, thinking she needed to be "one of the guys" to be successful in her new job as a staff member, she left her feminine clothes and her emotions at home. She viewed her femininity as a weakness, something to be hidden, suppressed.

At a leadership workshop, she learned that energy expended to act differently from who you really are (in her case, acting masculine not feminine) limits the amount of energy available to lead and that one can never reach the top of her field if she is "acting." Perhaps her femininity was her greatest strength.

It was an "ah ha" moment for her—a moment when she began to feel her power. She changed her dress, her hair, her style at work to be in line with her natural being. She was still working in a man's world but in a feminine way. The results were very dramatic. Before a year had passed, she was viewed as a peer by the Association's Board of Directors rather than just staff.

Being true to her essence, she was much more effective as a businessperson. She is now at the top of her field. This is what I refer to as being a Goddess of Wisdom.

If a woman does not use her inner male creatively, she will find herself at his mercy, for his light is continuous; one must either direct it or be overpowered by it. He is her greatest friend, or foe when he lapses into disconnected action for action's sake.

Without question, a woman's hallmark is relatedness. Yet, when she allows herself to be enslaved by the masculine (inner or outer), she disconnects and loses her Self and her hallmark. Sexual intercourse without connection may feel good momentarily, but it will fester in the belly of her soul; just as it does in men. None are aware of the price they are paying. The same is true of mental or physical achievements; they suck the life force out of you when you lose your relatedness.

The inner war that rages in unaware women who have allowed their feminine energy to be overrun by their masculine is intensified because they don't know who they are, nor what is the correct stand to take for the feminine. A woman needs her masculine's inner light to illuminate what is innate, so she can consciously know them both (feminine and masculine). But she must be the captain of her ship. Abrogating her duty only leads to her ship floundering upon the rocks because there is no destination set for the ship; it just sails till it runs out of water.

Women often seek to recreate their own identity from that of their loved one. It is an attempt to relate, but nullifying one's Self actually prevents true relating. Some immature men desire this. A mature man, however, wants wisdom as a partner, not as an appendage.

Also understand that men are conditioned to create islands from which to relate, sparingly. He sees this as self-preservation, a protection of his perception of the conscious world. Men fear losing hold of the solid ground they have conquered and made their own by being swamped by the ocean of emotions. This is what women represent to men.

A show of emotions from a woman does not devastate her, as it would a man. Women are like ducks in water paddling through a sea of unconscious emotions. A river of tears releases the stress within the pressure cooker, calming her, much like sex does for him. He, however,

fears this river, and believes this ocean will leave him ravaged, blubbering out of control, unable to function. He's been taught that the showing of emotions (other than anger) lessens his manhood. And remember, women complain about strong men, but at the same time seek them out. So, as a woman, your first order of business is to sort out your own wants, needs and desires, before you project them in such a confusing manner onto men. Men are confused enough with trying to figure out who they are supposed to be.

Men may try to "educate" their women on how to be more rational and unemotional, like them, only to later reject these neutered women. These men are not mature enough yet to handle their own inner feelings, so they reject these feelings in their partners. What these men are blind to is that a woman who is no longer in touch with her feminine non-rational Self ceases to be the woman they fell in love with. The vitality in their relationship will be drained, replaced by something controllable, boring, and ordinary.

The male will probably blame her for what is missing, but won't see that he asked her for this. She of course is responsible for consenting. Instead of learning to focus her non-rational, she has allowed herself to be masculinized, neutered of her fertile inspirational abilities. A woman must protect these fertile feminine grounds, yet must also learn to use her masculine to plow nice neat rows in part of her fertile field, while leaving enough of it wild and vital.

Many people fall into the trap of substituting shared interests for the relatedness and emotional bonds that we lack. These relationships subsist upon this agreed substitute, not knowing there are other possibilities, or at least not knowing how to enact them. This is the domestication of the natural instinctual women. He has left nothing of the wild, and she is no longer a wild buffalo, but a penned up bovine.

A woman possessed by her masculine will be much more entrenched in her ideals and goals; she will be unwilling to make exceptions. She will not understand the wisdom of the reed that bends with the wind, but will

Women—The Goddesses Of Wisdom

attempt to be the rod of steel. This is because her masculine is impersonal and disregards human needs. She, of course, will be blind to this. The same is true of men whose inner feminine is wholly impersonal. The forces of the unconscious must be used, incorporated, and understood. The latter is so very important because these forces are dynamic, but are not necessarily insightful of the type of humanness we would desire. Therefore, we must understand their nature and direct them.

When the masculine, discriminating side is consciously and fully engaged in a woman, she is creative and efficient. But giant pitfall appears, when purpose is lost. This is what her masculine savors most, it is what will inspire him, giving him purpose and direction doing what he does best: focusing, ordering, and structuring. This will happen when she goes inward, is distracted, and becomes or remains unconscious. He then focuses his attention outwardly, without really being in the here and now. This is incongruence of being. Nothing is in alignment; the tires are tracking in different directions. They will wear out sooner and use more energy to sustain. But if she chooses to remain conscious and feel the inner feelings she doesn't quite want to admit to, he can express what she really means. This is her masculine in harmony with her. This is wisdom.

Wisdom 101: Communication

A man who attempts to communicate without using his feminine feeling side to create a connecting bridge will be seen as speaking from his head, lecturing. Will his partner feel his truth, feel his sincerity even if it is deeply felt? Not likely. Empathy, compassion, and just plain humanness will be missing. The vital nature of communication will become data transfer. Only in the movies do machines fall in love with each other.

Similarly ineffective is a woman who attempts to communicate with a man without her inner man. She will be upset that he doesn't get it and blame him for being clueless. But to him she has not made clear sense; she has only spouted out chaos in the form of feelings and emotions. He needs her inner masculine rational side to clearly translate, so he can

understand her.

Both are handicapped in either situation. Women can communicate with disconnected men and men with disconnected women if they know themselves, that is, their inner opposites. If not, then "who can ever understand them" will be all they can utter.

Women are usually more tolerant of a man's emotional outburst probably because they understand non-rational moods and impulses. She is accustomed to their vacillating, changeable nature, and with a shrug of her shoulders, awaits their passing. He, on the other hand, thinks these states are real reflections of her totality and takes them to heart. They affect him deeply, and she may misinterpret his reactions.

He may think he is crazy during his outbursts because the emotions seem to take over. These explosions are intensified when he taps into his repressed emotions, which may panic him.

Women understand their emotions and know men are often clueless. Many have used this to their advantage. The man is affected by her emotional decrees that sound true because they destabilize his mental clarity. There seems to be truth in what she has uttered, but he is at a loss to figure it out. These utterances are close enough to the truth to be confusing. This may be a great debate strategy, but not a good one for communication, connection, and relating—the strong points of the feminine.

Of course, he may have been off target too, but neither will know because they are too busy trying to *win*. But, there is nothing to win, only connection and relatedness to *share*. It goes without saying that if one party wins, then automatically there is a losing party. The loser will have resentments about losing, and neither party will be able to relate. All that is left is a cold war, until the next skirmish. Instead of the connection of the sexes, we create the battle of the sexes.

In our present transitional world, no one quite knows his or her role. A man doesn't know what a man is. He is conflicted with his inner

feminine, her wants and desires some real, some illusion and what society offers as a proper role model. Women have been given back their inherent right to purpose and self-knowing in most of the world, yet old habits die hard. She is as conflicted as he is and just as clueless. The results of the present predicament are painful. This is actually a good sign. It means we are witnessing evolution, but those damn trees are in the way again, so we can't see the forest. Or is it the other way around?

Dr. Irene Claremont de Castillejo said in her book, *Knowing Woman*, "In casting her net in wider waters modern woman has caught not only the fish she sought but a devouring monster as well which is busy destroying the more feminine among her number."

Women can't physically knock their husbands down, so they try and find ways around them. It is easier than standing your ground, and perhaps less dangerous, but it leaves relationships in a state of cold war. And it supports a sneakier you. Men see women sneaking around and, rightly, don't trust this behavior. True, men do not see their part in creating the situation. However, the effects of not being courageous and truthful create nothing of value. Someone has to apply the brakes to our out-of-control relationship dynamics. I see no wisdom in letting this continue, and there will be no chance in creating fulfilling relationships without truth. I do recognize the investment needed to be courageous and truthful. But the price for its lack is devastating unhappiness.

Women are taught from childhood that men are dangerous animals, not to be trusted, which creates a physical fear of them. These beliefs nurture "monsters from the *id*," Sigmund Freud's term for the unconscious non-rational emotional state. Because a man has no idea to what depth this has been instilled in a woman, her defensive actions seem irrational and incomprehensible to him. He trusts her even less then. The truth shall set you free! Can you see the wisdom in this?

Sex

Intimacy is a sacred wonderful union of whole beings. It doesn't have any requirement to be sexual. Sexual intimacy, a component of whole-being intimacy, doesn't necessarily require the sex organs either. Cuddling, hugging, walking hand-in-hand, or just looking at your partner can be sexual. Full sexual union includes the sex organs and should also include other aspects of Self. Yet humans, men especially, are taught that sex is the great reliever, the emotional surrogate, in and of itself. There is no bridging of souls, no real connection in shallow experimental or distracting sex. This shares nothing and turns into a session of (hopefully) mutual masturbation using another body. Not necessarily wrong if it is mutual, but this kind of sex is empty, hollow, and unfulfilling.

Women learn early on the assertion that "all men want is sex," and they resent not being wanted for who they are. This is instilled within them from countless sources. A woman hears this message coming from her inner voice, and this can happen at the most inopportune times. She can then turn into an icicle, when her loving warmth is needed.

Our Patriarchy teaches women that their bodies are only of value to attract mates and produce offspring. Women's bodies are not as big or as strong as men's and are shown to have little other value. Menstruation is called "the curse," and most women are programmed to believe that "it's all about looks." Their bodies are not honored as sacred temples nor as the homes of great wise souls. Of course, their bodies do get them the attention they crave, so they buy into these beliefs by the boatload.

A woman's true soul dwells inseparably within her body. If she is conscious of all of her parts, then any man that enters her in sexual union will find this difficult to miss. She will see that her fears of being unlovable, or of men's love, are unfounded. This is not to say that a man cannot be completely obtuse and miss the point of union. But, that is a factor in discrimination of partners. A woman must also realize that a man is taught to be this way. With this knowledge, she can guide him

with love into allowing this connection, which will seem frightening to his machismo.

From personal experience, I've learned something that may surprise women; it surprised me. The emotional ones, women, are just as scared of a soul connection as are men. They may know how to handle men who are focused on sex; but, a soul connection for a woman is a state of vulnerability that only the courageous can handle, no less invite. Women are no more comfortable with this than are men, I found to my surprise. Yes, more women want to play house, get married and live out their fairytale replete with living dolls to care for. But to share one's deepest essence, secrets held under lock and key, or to surrender one's heart—well that is just asking too much for many.

Neither gender is comfortable here; whether by training, learning, or sheer protectionism, the very essence of relating is toned-down to "safe levels." What does wisdom say about the level of fulfillment attainable when you play it safe? "What? Now you are trying to trick me into love!"

The Invisible Woman

Invisibility for anyone is demoralizing. It is: *not* being seen; being taken for granted continuously; not receiving the needed amount of attention. This includes the man who is seen as the money provider, who takes out the trash, but is invisible otherwise; or the woman who cooks, cleans, and is used as a sexual tranquilizer for his stress and other "male needs." This will strangle the life out of any relationship, turning it into a prison, each being locked in solitary confinement, occasionally with conjugal visits.

Women, imprisoned in fairytale castles of their own making, find themselves stuck in roles dictated by both the fairytales and our commercialized society that preys on women's vain emotions. They may be overwhelmed by the domesticated housewife role that is never as simple as it seems and often precludes outlets for their other abilities.

Talking baby talk with the children all day may leave one starving for adult conversation.

A woman can participate in the breaking-up of another's marriage, while closing her eyes to the collateral damage she's caused. But inside, she will never feel quite fulfilled and later in life will rightly fear that the same may happen to her. Someone more cunning or beautiful or sexual may entice him away. This is not to say he will be innocent, only that she definitely will not be. And choosing to be this blind to her own life choices prevents wisdom, without which a woman will never feel quite right, never be "safe" inside, no matter how smart, cunning, or successful she seems. Her karma is emptiness.

Some women make their man their sole focus, living through him. She places all her energy, needs and wants into a fragile, delicate, and sacred relationship, forcing it to hold far more than it is capable of holding. It is like trying to put the ocean in a cargo ship. The relation-ship is to be buoyed by the ocean of love, not flooded and sunk by it. We ask too much of our relationships, giving these sacred unions the liability for the personal growth, the establishing of Self, that we need to do ourselves.

Chapter 7

Grief, Anger and Rage

Grief, Anger And Rage

Men, as discussed in my first book, use anger to cover their grief. This is because "big boys don't cry," and they certainly don't grieve. They may go off into a corner, sullen, and drink themselves into oblivion, or find a myriad of distractions refocusing their attention, but they are taught that grieving shows weakness and is feminine.

The opposite is true for women, for whom grieving is permitted. Not too much of course, otherwise the medical profession (witch doctors) will too readily prescribe a tranquilizer, mood elevator, etc. So even full grieving is not allowed for anyone. We will cover this later; for now let's look at what women use grief to cover.

Anger is the emotion women are not allowed to express. "Nice girls don't get angry," is the verbal or non-verbal directive taught to most women by the patriarchal social structure. Often, both in life and in my practice, I would come across depression in women, which on the surface looks a lot like unexpressed grief. Looking deeper I found their grief usually was being used to cover repressed anger. Anger stewed in our place of repressed energies, the shadow transforms into rage. When a female client would come across a scene in her life that was painful or traumatic, she would easily start crying and grieving. Yet, she found it nearly impossible to be angry with the person who had wronged her. These clients may have been beaten, raped, or otherwise abused; yet there

was no anger. The opposite I found true for male clients, who immediately get angry, but find in nearly impossible to cry and grieve.

Men are only allowed to express anger, which is necessary for the warrior. No other emotions are permitted. Women are allowed all emotions, except anger. Now, recently, women are making headway in expressing anger. I have spoken to a number who proclaim they express their anger freely. But when we dig deeper, usually we find that the most important aspects, their deepest darkest feelings, especially from childhood, they remain mute about.

Men are taught to base themselves in their minds; women are to be based in their emotions. Therefore, women are also denied in varying degrees their abilities to be logical and to develop reason. Naturally, this would prevent women from living their heritage to be Goddesses of Wisdom. It deprives the world of this wisdom, and we deeply need it.

Boundaries

Anger is not wrong; it is an important emotion for both genders. It declares something to be unacceptable in a strong way, and it creates or reinforces one's boundaries. Boundaries are important, and women often don't have well-set boundaries, especially where needed. Or they may go to the opposite extreme and use rigid dictates they follow to replace their appropriate individual boundaries. Like the so-called "book of rules." Book of guidelines would be a far better concept. Boundaries represent your clear expression of your true Self to others. Lack of boundaries, or too rigid or too harsh boundaries, is a reflection of an inner emotional makeup that includes confusion about Self and poor self-esteem.

Positive boundaries do not harm or degrade others; they clearly state limits, without attacking or degrading those who approach our limits. They are important defining characteristics of desire in a healthy relationship.

Grief, Anger and Rage

Integrity, keeping our word, is a key factor in creating positive boundaries and is the critical factor of self-esteem. We know when we have been dishonest; yet, we suffer from self-imposed blindness to our lack of integrity, as we have repressed into our shadows our disingenuous actions. This does its self-destructive work in the shadows, damaging our self-esteem. Then, we wonder why we may never feel quite good enough. Always hold to your word—or lose your self-esteem!

Shadow's Bliss
Ah, the ecstasy of the unnoticed.
Slipped unseen down the rabbit hole,
momentarily forgotten.
I didn't do that, did I? No!
Do what?
I'm sure I don't remember to what you refer.
That past is not my past,
and I am too busy to worry about it.

Not sure why I feel uneasy.
Better get busy.
Maybe you will tell me I'm all right,
Or give me a good spanking,
a bedroom confessional.
Ah, that will make it all better; it hurts so good.
Till tomorrow.

Women don't like anger because what they have seen and experienced from men is rage, repressed anger. When stewed, anger explodes out, releasing pent-up emotional tension and pressure without regard for others like a pressure-cooker valve. Repress for too long and the vessel itself explodes, like in murderous rampages. It is a part of the shadow or

"dark side." Yes ladies, you have a shadow too; men just express theirs more directly and violently while women hide theirs under layers of lipstick and make-up.

The shadow, when polluted with repressed anger, is not a fountain of inspiration or of the free flowing "Kundalini" energy. It is contaminated waters. The pollution must be cleansed from our wellspring, released, and transformed by the light of consciousness and forgiveness. Repression limits and blocks access to this light and healing. It affects any expression of our essence, twisting it by its nature.

Anger and rage are sometimes used to create dominance, to frighten, and gain power. It demeans the receiver, causing resentment, while it lowers both parties' self-esteem. That's because the receiver knows inside that they are being forced, coerced, or controlled. Therefore, rage feeds one's negative self-image, fuels self-hate, and intensifies one's darkness.

Control is an illusion that can explode in our face, as it doesn't really exist. When it does, we feel helpless, which is the root cause of the need to control. So we try to control better instead of stopping to find other options.

Seething anger (rage) becomes a tool of revenge, and it never settles any scores. As Mahatma Gandhi said, "An eye for an eye leaves the whole world blind." Only forgiveness can settle anything and bring peace. Forgiving never means the offender's action was, or will ever be, okay. You are simply giving up holding onto the resentment, freeing yourself from the imprisonment created by the offender.

Grief, Anger and Rage

Rage

Notice that I have given rage its own subchapter, separate from anger. That is because it is so important for women to recognize their rage. Most do not. Men's rage is evident everywhere; women's rage is everywhere disguised. We all know men need to work on their rage. How can women work on theirs when they hide it even from themselves? "Hell hath no fury like a woman scorned." I guess I am not the only one to have noticed it. Rage is always destructive. But anger can be used as a force to affect positive change. It is not necessarily destructive. Let's use a story that may point the way for women.

The Crescent Moon Bear[5]

There once lived a young woman who was living alone, while her husband was off to war. One day she received a message and was ecstatic to learn he was coming home to her unscathed. She immediately went shopping and purchased the ingredients needed to create his favorite dishes. She cooked them with love, cleaned and organized their house perfectly, and after studious attention to her own appearance, waited joyfully. Her lonely days were coming to an end; he would be home soon.

He returned but was very different—hardened, reserved, and mean. This was not the man that had left her. She could not understand what had happened to her wonderful man. Physically he looked fine, but he obviously was not. He would not be with her in any way, refused her bed, her company, and barely spoke to her. She offered up the meal she had prepared with so much love. He pushed it away, knocking it onto the floor. Oh, how could he! She was horrified and enraged at his insensitivity. Could he not see how much care and love went into preparing his food? Could he not see the efforts to make their home perfect and welcoming?

[5] Ancient story adapted from a version contained in *Women Who Run With the Wolves* by Clarissa Pinkola Estes, Ph.D.

Could he not see how lonely she had been and how she missed him? MEN!!!!

No, he couldn't, and he would not live in their home, instead choosing to live outside in the woods! This was what he was used to. He would have preferred a trench or concrete bunker, but slept on a bed of leaves.

It angered her to think, "He prefers a bed of leaves to being with me!" He had become impenetrable. War does unimaginable things to a man that women do not understand. It is a man's job to see that she doesn't; he protects her from the unimaginable experience of these horrors. The cost is high.

The woman was naturally beside herself, disappointed, hurt, enraged, and confused. She had longed for this moment, but who was this that had returned in his body, and what should she do to get back the one she remembered? She loved him totally and wanted him by her side. She went to an old healer woman, wise beyond years, and poured out her predicament. The healer nodded her head, listening intently while looking into her eyes and through them into her aching heart. The woman almost vomited up her emotions, but the healer silently listened. The healer remained silent when the woman was done.

After a time she spoke, "I feel your love for this man, and offer you a way out of your dilemma. I can make a potion that will cure the poison that has stolen his heart. However, I need one ingredient more. I need a hair from the white crescent under the chin of the great black bear that lives upon the great mountain.

The woman, shocked, acknowledged the instructions. First, she remained still, absorbing the enormity of the task. She knew it was superhuman. Luckily, to a woman on a mission of love, nothing is impossible. Her love did not waver, and she was willing to place her life on the scales of love. She left for the mountain immediately, stopping only for some things she knew she would need.

The slope was steep, and there were huge boulders to climb around and thickets of thorn bushes to push through. Never once did she

Grief, Anger and Rage

complain as the thorns tore at her clothes and skin. Her love for her man drove her. Broken nails did not deter her. In fact, she was grateful for every opportunity to prove her love. Somehow, it strengthened her. She climbed and climbed, and it got colder and colder the higher she climbed. She took shelter when she found it and finally made it to the domain of the Bear. She had the food she brought, which she ate sparingly.

The next morning, after sleeping in a small cave, she went in search of bear signs. She found them in the piles left by the bear and followed the tracks until late that evening when she saw the bear making its way back to its den.

She reached into her bundle and placed food in a bowl she had brought. She set it outside the den and then ran to hide back in the cave she had found as shelter. The bear smelled the food offering, came out of the den, looked around, roared loudly, and after circling the food, partook of it. Then the bear lumbered back into its den for the night.

The next evening she did the same thing, leaving the offering in the bowl, but instead of returning to her cave, she retreated only halfway. Then, on the next evening, again the offering, and again the retreat, but only one quarter of the way back to her cave.

Finally, on the fourth night, she laid out the offering, but did not retreat. She stood by the bowl at the cave's entrance and waited, not without fear, but she waited anyway. The bear smelled the food and came out of its den, only this time it saw both the food in the bowl and a small human. The bear roared at the sight of the woman, and she trembled, but did not move. The bear stood up on its rear paws and roared again. She still did not move. Then it approached her. The woman shook, but did not move.

"Oh please, dear bear," she pleaded, "sweet bear please; I've come all this way up the mountain because I need a cure for my husband."

The bear returned to all fours. It peered into her eyes. "This human could be a tasty meal," it thought.

"Please, dear bear, I've been feeding you for these past few nights. Could I please have just one hair from the crescent moon on your throat?"

The bear stared in silence as powerful moments passed. The bear's mighty heart sensed the woman's heart. It was true and sincere. "Yes, you have fed me these past few nights, you were good to me. You may have one hair, but take it and leave quickly." With that he rose up and exposed his throat. She took one white hair from the bear's neck. The bear flinched, but took no action.

"Thank you, dear bear." She backed away and, after a safe distance, turned and hurried down the mountain. She almost flew down, moving quickly through the thorn bushes and over the boulders. Finally, she arrived at the abode of the old healer.

"LOOK, LOOK!" she exclaimed as she burst in, "I've got the hair from the crescent moon bear's throat."

The healer took the hair and studied it for a long moment and then said, "Your courage is a measure of your love, and you have risked all for it. This is the hair from the crescent moon bear!" The old woman stood in silence, the young one bursting with anticipation. The healer walked over to the fire pit and threw the hair in. The hair crackled as it was consumed.

"NOOOO!" cried out the woman, "What have you done?"

"Be calm brave one, all is well," the healer said. She then continued slowly and deliberately, "Do you remember each step you took as you climbed up the mountain? Do you remember what it took from you to acquire the hair? Do you remember who you were on your quest? Especially important, do you remember what you were offering and willing to sacrifice?"

"Of course I do!" replied the young woman nearly screaming.

"Ah, how wonderful," replied the healer slowly, deliberately, and with absolute sincerity. "Now my dear, go home with everything you have offered and become, and offer that to your husband. Love him the way

he needs to be loved, not the way you expected him to want to be loved. Discard what you wanted him to be. Discover who he is and what he needs. Call forth your wisdom and you will know what to do."

Rage is anger, first repressed either by prohibition, "Nice girls don't get angry," or by a feeling of impotence, or helplessness to affect change. This is the masculine energy in a woman, unable to "fix it" or affect a change. Your inner masculine doesn't like this and can sulk, becoming moody. Ever seen that in a man? Then, the moodiness boils over, and if one is not careful, one can burn the very essence of our love—your own and your outer love's. I don't think this is of value, do you? Yet, it is all too common, isn't it?

What normally happens is that the woman feels rejected, does not understand his actions, feels hurt, rejects him back, withdraws, or goes for the jugular. This doesn't mean that underlying anger should be repressed, only that the situation must be consciously understood. Then, with directed attention, it can be handled, neutralized, and healed. Would this not provide a better outcome for all? Is this not wisdom in action?

In our story, the woman does get angry at her husband's ungrateful and heartless actions, but does not withdraw into herself, into a state of inaction, or more damaging, move to take revenge. She knows something is amiss in him, something has occurred, which she doesn't understand. Part of her knows not to take it personally. She initiates *intentional* (masculine) action to make it right. She doesn't give up or write him off as just another unfeeling jerk. She goes to see the healer and embarks on a quest to find the cure. It's not a pretty quest, and is one in which she must summon up all of her courage and strength.

She is consciously directing her masculine task-oriented energy. A word of caution here: the heart must direct the masculine within a woman; otherwise, it will run amok. Just like men, disconnected from their heart connections by societal conditioning, a woman's inner masculine will run amok in the world and cause unimaginable collateral damage.

Women—The Goddesses Of Wisdom

The loving husband returned home unloving. Maybe in real life she just woke up from her illusion to his unloving, shutdown emotional state, or maybe it was the war, or both. No matter why, she takes it upon herself to effect change and becomes change itself.

I remember a client, a daughter of another client, who came to me and said her relationship was in shambles, her boyfriend had all these issues, her career was at a dead end, and she was looking to fix it all. "Life is so screwed up!"

I asked her what the common denominator was in all these situations. "Grrrr, all right, it's me," she replied. We climbed the mountain and saw the bear; that is, did regression work. She said this had a profound impact on her. *She* changed and like magic, so did her life. She is now happily married to her formerly "screwed-up" boyfriend, has a great career and a baby. Somehow the boyfriend became fixed too. Magic happens.

"It takes two to tango," but it only takes one to change the "dance" both are in. Here is where the majority of issues arise. The course of action chosen, the affect created, is from a defensiveness based in blame, not love. This IS the way it is in the world, unfortunately. When you blame others, you project your feelings and the responsibility for changing your life onto others. This has a major side effect; it places you in the role of *victim* and allows you to think you are powerless to affect your own life. It also allows you to deny responsibility for your actions. "It's not me, it's them, and they're at fault!" This type of thinking guarantees status quo, nothing will change. In fact, it will get worse, like a dirty infected boil.

Today is a good day to change this dynamic, don't you think? The world depends upon it. You are the difference. There are no easy ways or magic potions. Take the long road, up the mountain; don't tame the bear, making him less viral and impotent. Love him and stand firm in your love. He will roar, but you are bigger than that. He will pound his chest... so? He will test your truth in his masculine way. Do not falter, for you are stronger.

Grief, Anger and Rage

Why is it necessary to say this? What illusion have you bought into? You can rule the heavens and earth with your wisdom and heart, but you will have to get your hands dirty and muster up that courage I previously mentioned. We men need you to be this, so we can be your Gods of Love. This allows you to be our Goddesses of Wisdom, and so on. Love begets wisdom, wisdom begets love. This is the cycle of creation. Nothing less will do.

The directive to turn the other cheek is not applicable in all situations and must be clarified. Not because it is untrue, but because it is not understood. You choose when to take things personally and when not. This is turning your cheek. This misunderstanding can be dangerous for Goddesses of Wisdom. Women can misunderstand this, as it feeds their prohibition against anger. Women have been required to be silent in order to survive. And in many parts of the world, this remains true. They must address issues, but understand not to take them personally.

Often, women express the bits they do take personally by shooting off their rage like scattered buckshot: pick, pick, pick, nag, nag, nag, with a coldness that burns; or with sweet but poisonous words. They attempt to force their will on those who are dependent, or they withhold love, or threaten the loss of relationship (abandonment). If a woman does this to her mate, she is internally doing the same to herself. This is a form of projection onto another what she does internally to herself: she injures the depths of her instinctive nature. Do onto another what you would do onto yourself.

Right actions, based in integrity, allow the right expression of anger. Without wholeness and integrity of self, destructive rage results. And this rage is *always* self-destructive.

People whose instinctual nature has been injured have difficulty recognizing when they have been violated or intruded upon and cannot see their own anger until it explodes in rage. These injuries to one's nature occur when young girls are told to ignore any feelings of dissension they may have and to be peacemakers. They are not to engage in the fight;

they must withstand their pain in silence. With the progression of time, these girls second-guess themselves compulsively, stifling their real instinctive responses.

Women's collective anger has for eons been stifled, repressed, and minimalized. All this can be directed as anger, not rage, to birth a dialogue, initiate corrective action, and even require accountability, progress, or improvements. At the same time, women must be aware of their own lack of responsibility as well as their culpability in the selling-out of women to the Patriarchy. Yes, these behaviors may have been based in survival, forced, but they are still actions accepted.

Patriarchal Control

I have pondered the three thousand plus years of the patriarchal belief system, how it formed and what created this belief system that replaced the previous Matriarchy. Women ruled the roost in the old days and often still do. The difference is the "roost" was originally the tribe's cave, nothing more. The men were off hunting for food and clothing. The older, more experienced and, therefore, wiser women ran life in the caves, especially when the men were gone. These older women where in their late twenties or early thirties! Things have changed; life expectancy has nearly tripled. Survival for many, especially in the U.S., is no longer in question. Roles are expanding and changing. This is easily seen.

Many women resist and resent the limiting roles they have been taught. But *whom* or *what* do they blame for their predicament? Men, mostly. But men are trained and limited by these same teachings. As a woman, can you imagine going through life without feelings, not being allowed to even admit you have feelings, with crying being considered shameful? No woman would put up with this! Yet, this is the predicament men are in, like the soldier in the Bear story. So blaming men is counterproductive.

The patriarchal teachings that define our male and female societal roles are the underlying basis at fault. We must focus on changing that, not

on blaming others who are themselves trapped by these same teachings. Women need to understand this and encourage men to feel and change; making men wrong will only guarantee they continue as they are. This is the path to finding the "pot of gold at the end of the rainbow."

How did this system develop? I have seen the chaotic emotionality plainly evident in teens and young women. This would give one concern in trusting their judgment. Self-centered emotionality is their battle cry. They have simply not matured enough to gain their wisdom, balance, and grace. Back in ancient times with an average life span of no more than thirty years, there was no need to worry about trusting "anyone over thirty." People did not have a lot of time to mature. Women were married at thirteen and raising a family, doing chores and speaking baby talk with their offspring.

Now, as men became more involved in daily life, probably during the agrarian (farming) age, they saw this state of emotional chaos as being inherently the nature of women. Could this have possibly led to an attitude of distrust of women among men? Don't these (immature) women need to be directed and focused, as their flip-flopping emotions seem only to lead to chaos? Also, the women in charge might have liked things their way. The returning men may not have agreed, or may have felt left out. I think the Patriarchy was formed partially in response to the Matriarchy.

Unfortunately, the Patriarchy, in taking a leadership role, chose to make femininity wrong, to judge it as less than, instead of just undeveloped. Partnership was lost. It also took no responsibility for women's lack of development either. This caused men to view feelings as chaotic and wrong. Out of this they lost their own connection with their feminine feeling side; therefore, fulfillment became nearly impossible.

This is the damage done by the Patriarchy and those institutions that support and promote it. It lessens womanhood. So what can a woman do with this understanding to effect change?

1. Understand one's whole Self, including the masculine mental element as a necessary element to be trained and directed to assist the whole.
2. Understand one's opposites with new eyes that no longer have the same "make them wrong" filters.
3. Work to promote this new understanding, or paradigm, in all aspects of life, like: relationships; work; government; society; religion; and community.
4. Create and continue a dialog that invites participation and does not make others wrong. Allow men to move at their pace into this, as they have limited experience and will have difficulty giving themselves permission to feel. Women have an advantage here. Men know women have used this against them to make them wrong. Do it gently. Acknowledge how you have transgressed and commit not to repeat this.
5. Live in the truth; the illusions and lies we have been taught and continue to tell ourselves must be revealed and allowed to dissipate in the light of our consciousness.

Chapter 8

"It's All About ME!"

Maturity

The Puer Aeternus, which is the "Eternal Teenager," is a psychological behavior model that refers to people stuck in immaturity. They never grow up and continue to live in a fantasyland. As anyone who has had teenagers knows, they are all about themselves. This is part of their developing a sense of Self, but left unguided can become imprinted as normative. Look at the Hollywood celebrities who are encouraged to exhibit "unique" behaviors that would ostracize the normal person.

But what is growing up? It is ripeness, full development of character in a balanced manner, along with responsibility. How one reacts to stressful or difficult situations is also a reflection of maturity. Taking on fake "airs," play-acting, is often misjudged as maturity. Using outward appearances to mask inner weaknesses is immaturity.

Some of the telltale behavioral signs of the eternal teenager are: the "princess act," narcissism, body image fixations, and emotionalism. The princess act is a reflection of the eternal teenager. One must mature into the wise queen. But a queen has many responsibilities, and her life is viewed as less fun. In the world of the princess, it is all about her. Responsibility—who would want that?

Narcissism And Body Image

"It's all about looks," as proclaimed by my older daughter to me at age fourteen. This is the battle cry young women are taught and carry with them into adulthood. It is the song sung on the beauty chain gang, encouraged and fed by the guards hired by Madison Avenue. Narcissism is an egocentric view of Self and one's image. There are two forms of it.

The first, the classical understanding, is of being fully engrossed in your own beauty, as was Narcissus, the self-admirer. He of course died of his self-involvement, alone.

The second form, Negative Narcissism, is the self-hater. This is the total absorption in one's appearance, calamity the outcome of a hair out of place. Gluttony is another expression of it. The gluttonous self-hater doesn't believe there is ever enough, which really translates into "I am not enough." Therefore, a constant effort is made to attain more in hopes of being and having "enough." The negative is actually the most common form of narcissism. But don't ask a narcissist; they won't have a clue. Shadow awareness would be seen as intensifying self-hate.

The fixation many women have on their body images, including constant dieting, is a form of this negative narcissism. And society, their peers, and the cosmetics industry teach women this negative self-imaging. These beliefs destroy self-worth. Plastic surgery, augmentation, Botox®, all suggest *you are not enough*, continually. Actors and models are super thin reminders of what women "should" be. Women are taught this narcissism, but the image reflected in the pond isn't even theirs. Be your fabulous Self, not someone else's image.

Emotionalism

Women are emotional; no one will deny that. That is not inherently wrong, bad, or negative. So why is this not honored or celebrated? Emotionalism is defined as the tendency to be easily swayed by emotions,

or an exaggerated or undue display of strong feelings. These all indicate a lack of balance.

What grounds emotions in reality? The answer is reason: a being's mental or thinking abilities. Making good sense in one's decisions is a sign of wisdom. The key is sense, all the senses, which include thinking and feeling. This is the basis for the disharmony between men and women. Each has been taught their own gender-related imbalance. We are taught to be crazy. Just look at the world, is it not crazy?

Emotionalism indicates imbalance of the senses, incongruency in action. "I feel, therefore I am," is women's modus operandi, or M.O. For men it is: "I think, therefore I am." This indicates the exact same thing, only the imbalance is the opposite. Neither pole allows for expansion into one's higher possibilities, nor do they allow for one to just be whole.

For men, this imbalanced thinking position creates a form of gluttony, an insatiable accumulation of outer possessions, which can include women. For women, it is the same, only their gluttony becomes more about inner gluttony, such as the need for attention and anything that creates more attention or shows that one has the center stage in life.

'It's all about me!" is the battle cry of the feminine version. For men, it is "Look what I have!" which actually indicates a fundamental lack of worth internally for men. Nobody sees this dynamic. Men accumulate what they have been conditioned to want, so the conventional wisdom would say all is good. The Rolling Stones lyrics say, "You can't always get what you want, but if you try sometimes, you just may find, you get what you need." Unfortunately, both genders have been taught to want what the Patriarchy says is correct, not what we really need. Why do we not question further? Because, despite having that feeling in the pit of our stomachs or on the backs of our necks that all is not right, we have been shamed into believing that we are wrong, we are not doing it quite right. Otherwise, we would be feeling fulfilled.

The Patriarchy has force-fed us these lies since childhood. We *must*

question who we are and under what premise we are unconsciously basing our lives. That is the question: "to be or not to be" unconscious, lacking in self-knowledge, robotic, or whole-conscious beings. Consciousness takes work and includes responsibility for what we have created in our lives. Most people find responsibility uncomfortable. It's just easier to remain in a world of illusion, based in blame and victimhood. This allows us to place responsibility outside of us. Convenient, but in the long run, it will not be what you need.

Estrogen: The Loaded Gun[6]

(In a later section I will discuss the blaming of the world's problems on testosterone by some.)

If testosterone is considered a causal factor in men's conscienceless behaviors, perhaps we can also consider estrogen to be a casual factor in women's less than perfect behaviors. If women blame everything on men, then they don't have to look at themselves or their part in life's dance, and they don't have to accept responsibility for what they create.

Elements of women's part in the dance of life and relationships include:

1. The plans they are conditioned to construct (the fairytales) about how life is supposed to look and what they choose to overlook.

2. The expectation for men to follow along with their plan about how life should look, which includes an assumption that men know what their plans are and agree.

3. The consequences their actions have on themselves, their mates, offspring, friends, and the world.

4. "To be or not to be" responsible, that is.

Women are taught by the patriarchal group role model to think that

[6] Previously published article by the author.

"It's All About ME!"

their ability to reason is not equal to that of a ma's. Further, more direct "in your face" expression (like this section) is considered allowable only for men. Of course, this is nonsense, but not untrue. However, women develop brilliant ways of manipulating to get what they want, which shows their innate intelligence. Unfortunately, what women have developed, and are blind to, are their own belief systems, concurrent actions, and consequences. They don't see themselves in the mirror, only the illusion of self they have created: "Mirror, mirror on the wall" and "don't tell me anything I don't want to know."

One of these behaviors is learning to avoid responsibility like a stealthy ninja. In Billy Joel's song, he says, "She cannot be convicted; she's earned her degree; and the most she will do is throw shadows at you, but she's always a woman to me." This refers to the ability to dodge or shift responsibility, refocusing the negative on others.

I have never heard a man say that he doesn't trust men. What I have heard from many women is that they don't trust other women. I asked a number of women to describe their experiences with other women. Here is what *women* have told me about *women:*

1. They're smile-faced backstabbers.

2. They will say anything to get what they want, no matter who they hurt.

3. They're home wreckers. It's interesting to note then when a man is unfaithful, with who is not really important; it's the man's fault. Women will go after another woman's man without blinking an eye, and get away without facing loss of prestige, job, or even sustaining much ridicule. Somehow that is acceptable, as little consequences befall these women.

4. They're Drama Queens who play the lead, director, and producer in the dramatic productions of their lives.

5. They're competitive, in a destructive fashion. Winning not by

excelling, but by destroying the competition, who could even be a friend.

6. They're hypocritical, having differing standards for others they don't need to follow.

7. They can be intentionally mean, belittling, and petty.

8. They can be fake; pretending to be something they're not, or feeling something they don't, like friendship.

These women also gave me the following reasons they believe to be the causes of why women behave in the above manners:

1. Insecurity

2. Jealousy

3. Fear of the unknown

4. Fear of being different

5. Fear of being ordinary (invisible)

6. Neediness

Why do they behave in these ways? Because their conditioning teaches beliefs that lead to these behaviors. Directness, a male characteristic, is called unfeminine. "A woman must be sweet and pretty to be liked" and "sugar and spice and everything nice" are some of the dictates given to women. This is like the conditioning men receive with "big boys don't cry." All of these dictates separate parts of our true Selves from our whole being. We are the walking wounded because parts of the whole are considered only acceptable to the other gender. Men are disallowed emotions, becoming unfeeling beings. Women are disallowed reason, becoming chaotic emotional beings.

While the men of Wall Street, the bankers, and others are doing their gluttonous grabbing of the loot without conscience, where are their women? Pretending to be unaware while living the good life and amassing fortunes? Pretending to be unaware, remaining in the dark, by

"It's All About ME!"

choice provides a convenient alibi.

Women, it is time to stand up, look in the mirror, take off the make-up, and see what is really inside. Then, you can make the decision whether who you are is who you want to be. If so, continue; if not, change, recreate, and educate yourselves. Now, get with your men and ask them to awaken to their full power, their love, and feelings. You know how to motivate them use this to help them evolve. Recognize that the same dance men are doing, you are doing too. You have an important say in this, more than you may want to admit, and your men need you and your undeveloped wisdom. Develop it, please, for the sake of the world.

CHAPTER 9

Secrets and Lies

As discussed in the first chapter, the unknowable world (to men) of feminine emotions can be a closely guarded secret. Women are good at speaking the language of emotions with each other, but do a poor job of communicating and explaining it to men.

Of course, men's disconnection from emotions makes it a far more difficult job, and for some men it is nearly impossible for them to understand. The degree of disconnection a man has from his emotions directly correlates with his ability to hear a women's language. *Men—The Gods of Love* covers how men can change themselves. And it does take "two to tango." But let's be honest, men are not as ready to open themselves to emotions as women would like. In fact, men are conditioned to be this way because they are taught that women want the tough protector who "fears no evil." There is truth in this, isn't there? So how can a wise woman communicate with a mental-based man?

Emotional Strength

No question about it, women's strength lies in the area of emotions. This is the area that can touch infinity, the face of God, and is not stuck in the masculine linear thinking mode. This is a mighty and awesome power—and responsibility. A working relationship must be created and nurtured. Men at present are not going to be the most well-equipped of the two genders in this arena. So therefore a woman must be the guiding

influence. This requires care, consideration, selflessness, and selfishness. These last two are where many get into trouble.

Selflessness is simply giving of Self, without thought of Self, altruism. There are no hidden agendas, underlying motivations, etc. The definition[7] is:

1. The quality of unselfish concern for the welfare of others;
2. Acting with less concern for yourself than for the success of the joint activity. The unbalanced or negative aspect of these qualities is the forgetting of one's Self.

Selfishness is simply solely caring for Self, making sure you're getting what you need, ego-centrism. Defined[8] it is:

1. Concerned chiefly or *only* with yourself and your advantage to t*he exclusion of others;*
2. Concerned primarily with one's own interests, benefits, welfare, etc., *regardless of others*. Notice the parts of the definitions in italics. These are the parts of natural selfishness that are learned, allowed, or encouraged by how you are raised. They are harmful to others and allow all sorts of hurtful behaviors; and they damage us. How?

When you exclude the world that you are a part of from your consideration, you are building a wall around you that isolates you. You think the walls are part of your fortress that will protect you. In reality they are part of your prison that isolates you and keeps you unfulfilled.

So how does one balance selflessness and selfishness? No, you don't need a magic wand or new outfit including shoes. You need to understand paradox, the state of being of two seemingly opposite qualities that are both true at the same time. When the two conjoin to become one, they become greater than the sum of their parts.

Paradoxically, selfishness, and selflessness become self, as in the answer Moses got at the burning bush, "I am,"—the world. The world is me. All

7 Random House Dictionary, ©Random House, Inc. 2009.
8 Random House Dictionary, ©Random House, Inc. 2009.

that I do affects the world, as I am an integral part of it. The world must be considered as the greater "me." So selfishness includes care of the greater "me," which is selflessness at the same time. It's a paradox in action.

Okay, let's get back to what to do about men and relationships. So if men are a part of the greater you, a part that has been damaged by their training to be the "man" for you, how should you handle this? I suggest with a wise heart, guiding, loving, and creating opening after opening for them to rise up to. You may face disappointments. You can handle it, especially if you know they are not doing their "man act" to spite you, but because they think they are supposed to. And you may recognize that, in some ways, you have encouraged this. Own both sides, love both sides, and use your expansiveness to encompass all, and nurture it. This does not mean you should allow disrespectful behaviors; just don't seek revenge, and only use correction through mutual understanding. Let go of being right, winning the argument; be right about what you are creating, the relationship.

Unfortunately, the feminine is not without weapons of its own that it uses when scorned.

Emotional Weaponology

Emotions can be used as a form of subterfuge covering underlying agendas, thereby confusing the issue with emotional smoke and mirrors. This creates a distraction or an excuse for our actions. We prevent others from identifying our motivations, and we can actually blind ourselves from seeing who we are really being in the process. We "buy into" our own illusions. This enables us to disguise lies as truths, or at least pardonable silliness. These disguises we affect prevent the truth, which is actually our heartless or cruel actions, or our selfish inconsiderate actions, from being revealed consciously.

Sex can also be used as a weapon, metered out to the beast that has so much invested in the only satisfaction it is allowed. Sometimes it seems

that he cares for nothing else. What a predicament, by withholding and judging, you deny yourself and your loved one connection; but then again for him, it may be nothing more than stress relief. It is your job to keep it sacred. He has been taught differently, and until he learns the error of his training, you must be the flag bearer.

Some of a woman's "secrets" are of a different vein, like family secrets. Abuse, alcoholism, and neglect are examples of this type. The blame and torment a woman is threatened with, which prevents her from speaking her truth about these shameful secrets, withers her essence. Her expressor, the fifth chakra in the throat, is stifled. You can hear it in some people who speak in shrill tones, as though there were invisible hands around their throats, choking them.

It is important to understand something important about women's heritage: *wisdom without honor and integrity is impossible.* Honor and integrity are masculine traits; they are mental ideas, not emotions. These are required for one to be wise. So are the traits of compassion and empathy, which are feminine emotional traits. As we have seen earlier, men are taught to work almost exclusively from the masculine mental list of traits and women from the feminine emotional ones. The goal is to balance both aspects. Women are not taught honor and integrity the same way men are.

An example of why this may be is the lack of team sports for women. Team sports teach working as a team, supporting each other, connecting with one another, and being honorable to your team. Types of teams can include sports teams, gangs, businesses, or the military. Men can get all worked-up over their teams. Women don't understand this because they have little team experience. The Marine slogan, Semper Fi (Fidelus) means *always faithful.* This is how men are taught about honor and integrity. They can do anything, good or bad, seemingly without conscience, as long as it honors the team goals. Unfortunately, what is left out of their training is the feminine traits of compassion and empathy. This would preclude heartless inconsiderate acts.

For women it is the reverse. The emotions are dramatized, without the masculine traits. This allows women to steal each other's men, backstab each other, use others, be irresponsible, but with deep feelings. How women can be so heartless, while being so emotional is answered with this understanding. They are single-minded, egocentric, and taught to take care of themselves and their family based on their emotional components. Their emotions are justification enough, and they are not required to explain them.

Unfortunately, for other women and men, this can lead to emotionally painful wounds that make an emotional person untrustworthy. You never know what her actions will be because she may not know either. The emotion that will dictate her actions has not yet surfaced or formed.

For men, actions without emotions are heartless. For women, emotions without reason are mindless. This is the challenge both genders face. To mature out of these limited existences, one must balance his or her inner repressed nature with the outer. To do this there must be a partnership between these aspects.

Partnership requires knowing each other's strengths and weaknesses, and balancing both to the point where the whole is greater than the sum of the parts. That partnership is wisdom in action.

Withholding

Women have all heard or been taught by other women the following statement: "All men want is sex." Certainly, men have worked diligently to provide ample evidence of the truth of this statement. Does this mean women don't like or want sex themselves? No, that's not true, so why is this statement such an important part of women's belief systems? Further, what is unspoken in this statement, what is contained within it?

The answer to the first question, what makes it so important, is the word all. "*All* men want is sex" inherently means that men do not want,

care about, desire, think about, or even love their women, only the sex they provide them. Further, if men don't receive sex, there is the belief that they will abandon their women. And this does occur.

What underlies this belief system? Here are some points that may help explain it and what it creates:

1. First, the above may be true for some men, but are definitely not true for them ALL.
2. These beliefs imply a lack of self-worth, as in "I am a pleasure unit, who cooks and cleans."
3. This belief creates resentment because it is misunderstood.
4. Resentment creates withholding.
5. Withholding is experienced as a way to manipulate, to gain the advantage, power.
6. This creates resentment in men who see it as proof that women cannot be trusted.

The answer to the second question, what is unspoken, is: they are heartless animals, monsters, users, and must be manipulated for survival. "I, as a woman, have limited value, which is to work, provide comfort (sex) and bear their children." On the surface there is enough evidence to support this conclusion.

Women naturally take issue with this view of their worth and with sex. Add to it the physical reality of pregnancy and its historical components still in the collective consciousness, and we have a problem, a big one! Here are some of the significant points contained within this situation:

1. Sex = Pregnancy = A lifelong, life-changing commitment (prison sentence to some) and another mouth to feed.
2. Sex is a powerful tool to be used and doled out, not enjoyed. This follows many religious dictates.
3. Sex can be seen as something about women that is desired by

men which is: a) bad, or wrong, or dirty; or b) can mean they are not seen or wanted, just their bodies are desired as masturbatory devices for men. There is some truth in this.

4. Sex without intimacy becomes work, drudgery for some women, instead of a sacred joy.

5. "Men are pigs," has been said by many a woman. This thinking makes sex piggish, and some women feel it makes them dirty.

6. Women can resent all this and withhold not only from their partner, but also from themselves. But what are they really withholding? Themselves from life.

What are you holding on to by not surrendering all of you? What do you think you are protecting? Surely not your heart, because a caged heart never gets what it needs. Oh, you think you will know when the right time has come to let it out. This is a common illusion that most fail at. The lock becomes rusty, the key is lost, or worse yet, the existence and location of the cell and its contents have long since faded from memory. Know anyone like that? What is left after that but to barter for lifestyle and survival? That is the illusion of life, played out by many, meaningless and empty.

The Bad Boy And Desire

Women want to be taken by men, so they can surrender and be loved. However, they distrust and resist this concept. It is the "bad boys" who push past this resistance and "force" them to surrender. At least that is the script that seems to be in favor at present. Of course, these "bad boys" are self-absorbed, so consideration is usually not a possibility. Oops, now what? Let's blame men in general.

Why, that is exactly what is done. So how does a woman surrender to a man that loves, honors, and cherishes her, while he leads the partnership in his masculine way, and she does the same in her feminine way? Sounds

like a fairytale doesn't it? There is one difference you may have missed. Both are leading, but in gender-specific ways. I will write more on this in my third book on relationship. For now, let this percolate within. But remember, leadership, whether or not from a feminine or masculine point of view, requires responsibility for the partnership's creation and maintenance. A mature man and woman are needed for this, or at least ones in the process of maturing consciously.

If you want a bad boy to take you, then you are making him the responsible party. This is different from conscious surrendering, where you do not give up you, only give your all.

Chapter 10

Men

These stupid men and their stupid wars,

How could they do such monstrous things?

They struggle constantly for position and power, without consideration of whom they use, or hurt.

They complain of not getting enough,

yet can't even feel what they have.

But if you give them just a little ego boost,

you have them.

And they're so easily manipulated,

especially with sex,

which is all they want anyway!

What insensitive heartless bastards.

And they all think they're Gods of Love.

Ah, such loving words. Ever heard them or thought them? There's no doubt, men can earn these words, at times. They can be heartless predators pursuing the light of women in hopes of gathering enough light for themselves to release them from their own dark, dank emptiness. Yet, they haven't a clue what they are pursuing. This means that even

when they are able to obtain this light, they ignore or discard it as useless or unimportant. Or worse, they use it to get another woman. "Every morning there's a halo hanging from the corner of my girlfriend's four-post bed. I know it's not mine, but I'll see if I can use it for the weekend, or a one-night stand"—from *Every Morning* performed by Sugar Ray. Even if women understand how men's thinking is conditioned thusly, why don't they correct what obviously (to women) doesn't work?

What are their options? Perhaps it is not so obvious for men as to how to take on this light without becoming feminized. They are correct in this. Men need to incorporate their feelings, learn how to be gods of love as men, not as women. Their quest is to find their own light within. There is precious little to guide men on this quest. This guidance is the intention of my first book *Men—The Gods of Love*.

For a woman to know the predator requires her maturity—not naïveté, inexperience, blame, or foolishness. The emotionally ruled woman, beautifully chaotic, but not balanced with her masculine side, will find knowing the predator nearly impossible. The predator is the warrior energy within a man. It is not wrong. However, without connection to the whole being, it becomes heartless, compassionless.

This is the patriarchal model taught to men. It stresses a mental code of honor, which includes loyalty, fidelity, and obeying orders no matter how horrendous. Checking in with one's heart and soul is not considered pertinent. It's not in the conditioning. As an example: The Nazi SS and Gestapo underlings were "only following orders," as they butchered their way across Europe. This is the heartless monster men can be molded into in the name of egocentric honor and duty. It must be understood that it is not their inherent state. They must be guided into wholeness. This isn't occurring at present, but I am committed to this outcome.

A spiritually connected warrior would be the more balanced version. This balance needs to be encouraged in men. Making them wrong will have the opposite effect. Standing firm, while holding men to their potential greatness, promised by their heritage, is very effective.

Men

A failure of communication and understanding is behind all this disconnection. Women can and do provoke or undermine without a care for the groundwork upon which men have built their realities based on their teachings; both men and women are blind to this. This leaves men floundering. Am I the protector, provider, warrior, or the feeling, gentle man? Today more than ever, he is unclear as to who he should be for his woman, and she is just as unclear, though probably doesn't think so.

She can clear her "air," out of frustration or the desire to control, without understanding why and how men act the way they do. Her blind actions cause untold damage in him, which inevitably she will pay for. Yes, he can be a predator. That is not wrong. A predator with heart though, if you please. Women should be seen as partners, not as prey for the male.

How does a predator attract his prey? What brings her into the castle walls and its high towers and low dungeons? The naïve or instinct-injured woman finds herself attracted to promises of a life of ease, contentment, and attention. What's love got to do with it anyway? Besides, "it's just as easy to fall in love with a rich man as a poor one," and "diamonds are a girl's best friend" aren't they? I am talking about falling in love with a lifestyle, not a man. She sells out her inner warrior in the process. This inner warrior would be the one that protects her, helps her to see clearly and rationally. Instead, she trades him off for a life that promises ease and contentment. This is a promise that won't be kept in the way you would want; only you will be kept, that is.

Women can move gracefully from a state of living freely into a state of living in illusions, freely. She can become the queen of a realm of consumptive meaninglessness. With a slight adjustment in her perception, she will see it as success. "She who dies with the most accumulated things, wins." This is her masculine energy talking. She sacrifices her soul for accumulation, murdering it. Ever see men do this? She can then become the queen of mean. The queen of mean is a predator. This is her masculine nature overriding her feminine, not guiding it in mature partnership. Her instinctual psychic nature is what she has killed off; it dies slowly behind

a facade of safety and security, perhaps a wealthy one if she has "married well." This is part of the training women receive. I know all have heard this expression. She has bartered her soul. To whom, according to myth, do you think she traded it to? The trickster.

The good news never mentioned in myth is that a woman can get it back! By making new conscious choices based in the congruency of being, a woman can retrieve her soul with intention. Then a woman can effectively see and understand her inner and outer male.

Men can't see the forest for the trees. This is true, as it takes one's feelings to hold a sense of totality. As men are taught goal-oriented actions, this will be difficult. However, women can't see the trees for the forest. She can't focus on a tree because of her diffuse connection to the totality. Both think the lesser of their opposites because of their lacks, while not seeing their own lacks.

Being cut off from his emotions has created blinders that a man now wears. When he is allowed his feelings, a man will then be able to see himself, to see and feel the self-destruction and collateral damage he has wrought by giving-up his feeling nature. Then he will be able to morn his loss of connectedness, realize his loneliness, his longing for inner love and acceptance. Here is the critical point for a man when a woman is most needed. A man experiences this upwelling of grief, loneliness, and emptiness as overwhelming. It will take all his courage to face it and stand strong, being all too easily drawn back into old habits of distractions.

Up to this point he's replaced his needs with outer material accumulations and other distractions like indiscriminant sex. They become surrogates, blow-up dolls to replace soul connection with his female partner. It's safe, but full of his hot air, nothingness.

He thinks he lives in the present moment, but he doesn't. His created illusions, the movies in his mind, are used to replace the present. These are based on past experiences and hopes of future victories. He has unwittingly placed himself in a trance.

Men

Being in the present moment, a man will no longer need the anesthesia of a woman's sex, or other distractions for that matter. He will desire real connection, not momentary distractions. Those women who are mature enough, and hence aware, want nothing more from a man than for him to face his inner wounds and heal them. Then he can love them with his mighty heart, which is kept under lock and key.

Hero

Why is being a "hero" so important to a man? What is this model's (archetypal) significance? To be a hero is nothing short of his evolving emergence from Neanderthal prehistory, the ongoing evolution of his consciousness. He is commanded by instinct to understand, and he does so by ordering and structuring. This enables him to conquer nature, or at least to tame her to his will. He adds to his knowledge base in so doing, and then puts to use this knowledge he has learned of the mysteries of Mother Nature. Occasionally, she corrects his thinking with a show of her awesome power, but she is, after all, in his service, even though she birthed him. Mother Nature understands the give and take cycles.

Whatever new learning, or discoveries, or penetration into unknown territories he masters, whether in outer or inner space, his heroic nature is manifesting. His impulse to protect and overcome danger arises from his essence, though it's not always appreciated. The struggle for consciousness is the perennial struggle of the son to break free from the Great Mother (Collective Unconsciousness).

The day-to-day consciousness included in a man's ego, which he diligently worked to develop, has its foundation in far less solid ground than you may have thought. Just look at how easy it is for a woman to shake a man's tree to its roots without any awareness of its damage to him. His grip on terra firma is not as strong as he may think. This is not to say that just like Mother Nature, a woman may do so properly when reminding him of his arrogance. But be careful when playing Mother Nature, or you may destroy his delicate essence that he is holding onto

for dear life, while thinking you are teaching his macho persona a lesson. And remember, he *is* you, your inner masculine; when you "get" him, understand him, you will "get" you.

The story of David and Goliath personifies the heroic masculine spirit. This is the very same spirit that women so often mistakenly think they need to tame, or domesticate. Doing so emasculates a man. A woman loses the very thing that attracted her to him in the first place, the very thing she needs most. The title of the book by Joe DiPietro comes to mind, *I Love You, You're Perfect, Now Change*. "It is unquestionably the male of the human race who is the active partner and has explored the greatness of the heavens." "It is also he who became conscious first and has, as a result, been the architect of modern culture."[9]

This does not mean that women cannot do the same, only that they, due to many factors including their limiting conditioning, did not. In fact Carl Jung said, "Man can go no further in the pursuit of consciousness until woman catches up to him."[10]

A woman must develop her own masculine aspect in order to cast its light on her own 'mysterious' unconscious emotional nature. Women are already in the process of awakening. But by taking on men's values and belief systems, they run the risk of becoming masculinized. To mature, a woman must heroically hold onto her true feminine self, so her values can blend with her masculine qualities. Then she can create what Huxley called "a brave new world." A world not based in heartless accumulation, mindless consumption, and overpopulation.

This is women's purpose, but few are awakened to it, preferring the cowardice of lifestyle to integrity based in courage. We've all heard that "hell hath no fury like a women scorned," showing the destructive power of the feminine, but what we don't see or hear, or even recognize, is that heaven hath no power like a woman standing strong.

9 *Knowing Woman* by Dr. Irene Claremont de Castillejo.
10 In an essay on "Modern Women in Europe."

It takes heroic deeds to stand strong, to deny the pleasantries of our created lives and the carefully groomed masks we wear, to shed light into our dark places. Places where our own cruelty, hate, and complete lack of caring lie. Women fear what they will find in their dark depths. Perhaps a monster of biblical proportions lies in wait? Or perhaps women fear they will find, under the most beautiful and well-meaning facade, a heartless tyrant who will do anything to get what she wants—anything.

Deep inside we store every act of hate and unkindness we have ever perpetrated, no matter how we covered them with justifications. And we know that our conscious light will find them if we look. Now, the choice is to be courageous, or not to be. Do we choose to look at the ugly parts of ourselves or not? For a sex that has been conditioned to believe "it's all about looks," you can see the conflict that arises. So, what do you choose? Are you a rat in the "rat race?" Or perhaps in training to be something else, like a Goddess of Wisdom?

Our inner visionary is that part of us that has the wisdom to find a balance between the needs of a material world and that of love and spirit. This is the wisdom inherent within women; it is their part that will create the bringing of spirit into matter. This is the place where our spiritual aspects can make proper business decisions, like being environmentally friendly or taking care of the business' family (its employees) as well as its bottom line. Few are able to accomplish the colossal task of holding together all their elements, without breaking into pieces. Retaining our inner visionary, while holding onto our own in this material world, is truly an exhausting task.

Understanding Wounded Men

Men who have been wounded may wander for years; the walking wounded, from place-to-place these walking dead move, sucking the life force out of all they touch.

There is an ancient Greek story of a great archer and warrior named Philoctetes who was in possession of the bow of Heracles that had special

powers. He received a wound to his foot, which most versions say was from a snakebite that festered and would not heal. And it smelled awful. Because of this he was exiled to the island of Lemnos and was left alone for ten years. He was understandably angry at the treatment he received from Odysseus, King of Ithaca, and his fellow Greeks who had ordered him stranded. His loneliness drove him to the brink.

Then it was revealed that one of the things needed by the Greeks to win the Trojan War was the bow and arrows of Heracles. When the King learned of this, he and Diomedes rushed back to Lemnos to recover Heracles' bow and arrows. Surprised, they found the stranded archer still alive. Odysseus tricked Philoctetes into giving him the weapons, but Diomedes refused to take the weapons and leave him in lonely isolation. He was moved out of compassion, and his refusal to leave him alone swayed the King. Once back in civilization, his wound was healed, basically by his rejoining civilization.

Do you know any men stranded, alone, in impenetrable "caves?" How did they get there, and what forces pushed them into this isolation? These men are like the soldier in the story of the Bear.

Shame is an isolating, life-stifling force that creates an inner separation from parts of ourselves we judge as wrong or defective. These wounded men believe that since parts of them are wrong, they must inherently be wrong, so there is no way out. They isolate in their shame, unable to heal their wounds, like Philoctetes.

Why do men carry such wounds without healing them? One reason is that they simply don't know how to do this or if it's even possible. Deep inside, men don't think there is any hope of healing, since they are defective. Such is the power of shame. The island of isolation a shamed person withdraws to may be work, or sex, or a myriad of other distractions or addictions. But their separation from humanity, and therefore God, is a *fait accompli*, something already done and beyond alteration.

Only when a man walks through the fire of his own grief and tears can he come to understand that the healer he seeks, often seen as the

outer women, is within. But outer women can help by assisting men in accessing their inner healer. With this understanding he can take on the task of healing the desperate exile, the disassociated part within himself. No woman can do this for him, not even Athena, Sofia, or Aphrodite. Only his inner Goddess of Wisdom can lead him to the most powerful force in the universe, the one that lies within, carried in secret but never acknowledged. Incorporating this initiates all creation: his sun, the light that emanates from his magnificent heart, his radiant soul.

Any woman who tries to be his savior is only fooling herself. He must undertake the journey of his own free will. Interestingly, women have the power to lovingly encourage this, or sabotage it through their own unmet needs and rage. Some women will do one or the other; many do both, but only acknowledge their encouraging acts. I need not delve into the damage and distrust the latter creates.

No amount of attention, love, sex, or encouraging actions can heal him, but they may help. Resentments will hinder his healing. Healing can only occur with his self-compassion and attending to his personal wounds, by choice, of his own free will. Here lies men's challenge: they have been taught that emotions are wrong and shameful. What is compassion, if not emotion? So you are getting clearer about the state the Patriarchy puts men in, called "between a rock and a hard place."

The very thing he needs to access—his inner healer, as well as his inner wounded child—is inaccessible. He has been told, starting with "big boys don't cry," to distrust and deny it. You can ask for it, encourage it, but you cannot will it, or force it, or manipulate it. And withholding from it will only sabotage his progress toward it and create resentment.

As an example of how men's training shows up in men, the father who is collapsed in on himself, a hollow shadow of a man, has locked away his essence and doesn't remember where his true essence is. This is because his feeling essence has been labeled as shameful.

Now ladies, if you are thinking there is nothing that can be done, you are not being who you are, which is the Goddesses of Wisdom. You can't

do much, or maybe even anything, but you can BE the wise loving being you are and stand your ground; be the welcoming example. He must wipe his feet before entering the home, he must wash-up, and pitch in, but his endeavors are honored, and he is lovingly welcomed, not just tolerated as a necessary evil.

Now, if you find yourself, as a woman, enmeshed in a relationship with a wounded man who fits the previous description, you are dancing with him, and you are also wounded, just as wounded. You may be looking to him to heal your emptiness; or by saving him, you think you will be saved. Or perhaps you think your loneliness will come to an end, and your purpose for living will be accomplished through this partnering and its progeny. This is codependency.

Testosterone[11]

It was pointed out to me in the spring of 2009 that all of the Wall Street traders and the bankers that made huge profits writing and selling loans along with other unscrupulous acts, which have crushed the world's economy, were men. This was further applied in general to men in government that thought that business would behave as good citizens and balance out business and social needs for the good of all. Starting with the Reagan administration, capitalism was repackaged as a good citizen, not a gluttonous devouring beast. That some of the whistle blowers were reportedly women was also mentioned. The speaker's conclusion was that it was testosterone that was behind it all.

As reported in the *Seattle Times*, two Cambridge University researchers, John Coates and Jim Herbert, have written about irrational market trading with too much testosterone. They "have found that market fluctuations affect—and may be affected by—hormones associated with stress, sexual development and aggression. High levels of testosterone in the morning predicted higher profits that day. If people want to get practical, it would be good for both banks and the financial system as a

11 Previously published on the author's blog www.davideigen.com.

whole if we had more women and older men in the markets. The findings could dramatically rewrite the way economists model human behavior when it comes to financial decisions. If there's a biological element to financial life, we have to start building different kinds of models and thinking about policy in a different way. It's proof to me we're dealing with a biological organism rather than a computer."

Continuing, I once worked with a transgendered person, male to female, who said he/she had figured out the problems of the world, and that they were all a result of testosterone. His/her way of dealing with it was to excise the demon by having "it cut off."

Okay, so following all the above "logic," the solution to the world's problems might be the castration of all males. Ah-hmmm! Clearing my throat, I have a different idea to offer, one based on my understanding of how men are conditioned toward undesirable actions, an idea I clearly outlined in my previous book, *Men—The Gods of Love*. All women should read this.

First, allow me to make an analogy, albeit a poor one. Guns are inanimate objects, and they don't do anything, including kill people in and of themselves. It takes a person to kill another person using a gun. This is indisputable. The same is true of knives, bows and arrows, spears, sticks and stones, and bare hands. Used to hunt, defend and protect, they all have positive uses. Used by people, who are admittedly mostly men, they can also be used for less than desirable purposes.

Now, let's look at testosterone. It wasn't forged by man, like the gun, it isn't a tool, it is a hormone created in perfection by God, the universal intelligence, or whatever you prefer to call the force behind the creation of all things. That makes it natural and sacred. All right then, you may think, if testosterone is so perfect and sacred, what the hell are all these men doing and why? Excellent questions!

It all starts for men with the prohibiting directive "big boys don't cry," and continues throughout life as men are taught the patriarchal dictates

that prohibit feelings (except for anger). Don't cry or show that you are scared, or feeling alone, hurt, or powerless; suck it up, be a man (of the unfeeling macho type). This is men's training worldwide. This disconnects men from their feelings, creating a dissociative state in them. Men are told it is wrong, weak, and shameful to have human feelings. It messes men up severely, handicapping them. They are trying to be "men" for their women, and this training teaches them to repress the very feelings that are the underpinning of love and relationship. These denied feelings are also what create vitality in men along with their inspirational creative abilities.

Feelings are also a part of conscience. Repressed, men's feelings explode out as rage, and the repression limits their ability to empathize, be compassionate or considerate. So, it is the testosterone-driven force in men, or a gun for that matter, when used without feelings and conscience, that is the cause of such unwanted behaviors. And it clearly leads to disastrous consequences. The above researchers drew the conclusion that we are working with a "biological organism, not a computer." No, we are dealing with human souls twisted by mental dictates.

Feelings have been excised in men, and this is what fails to direct and guide the driving force in men. It is not the inherent nature of the men in the previously mentioned examples, but how they have been brought up, what their training dictates, that is at cause. It is time to allow men to express feeling in masculine ways. This is not as easy as you might think. Men have for eons been taught that feelings are shameful; they basically have no models on how to express emotions other than in the same way women do. Men need to learn how to do this in a masculine way, which does not feminize them. Communications, admitting these feeling to themselves, peers, and women, are crucial elements.

Step-by-step, men can be guided, or ridiculed as wrong, bad beasts. Blaming it on testosterone is male-bashing and castrating. If you don't understand men, then look within them and read my previous book before you do anything else.

Women are not innocent, but they like to think they are. Importantly, any judgment a woman makes about men, she makes about her inner own masculine as well. She is shooting herself in the foot. Passive acceptance of inappropriate behaviors, while receiving their benefits, makes women just as culpable. Here is where change must start. All must recognize their participation in this dynamic and communicate it, create a dialog, and put a stop to wrong behavior, even if it means fewer baubles. Then we must allow change to happen, not by passively wishing it so, but by being an active participant in it.

Emotions are a crucial part of humanness; the gluttonous behaviors mentioned at the beginning of this section are clearly linked to a lack of conscience, empathy, and compassion. It is a completely mental and egocentric strategy at work. It is easy to blame specific things like hormones or guns. But it is men's training that is the root cause, just as it is women's training that prevents them from being their true heritage: the Goddesses of Wisdom.

Our present economic meltdown will be a creative restructuring force, and from its ashes the Phoenix will rise. What do you choose that Phoenix to look like? What are you willing to change within yourself to create this? Men must rise up out of their mental stupors, their constructed realities, that say "he who dies with the most toys wins," or "it's all about the bottom line." They must not accept the belief that consequential damages are just a consequence of life and therefore okay. They must become the dynamic and feeling beings they are. Women must rise up out of their stupors, their fairytale of emotions and other illusions, their constructs, and become the embodiment of wisdom needed to guide this world. Teach us all how to bring the wisdom of spirit into matter. Stand up and be counted. The stakes are nothing less than the world.

The Savior Codependent

Life in its fullest form is a series of births, deaths, and rebirths. We must let go of one phase, aspect, cycle, season, reason and move to the next. This

is all part of Universal Love. Women may be better at understanding this as their own bodies' cycles teach them about life's cyclic nature. Love is embracing, letting go, while withstanding these endings and beginnings. These changes may occur in the same relationship, or be a part of shifting ones. Civilization seems to teach the myth that says change is wrong; it will often stop at nothing to prevent change. This makes our feeling at ease with change more difficult. Change is the death of one thing and the beginning of another. It is a needed, necessary part of life.

Men not only run from their own feelings, but will run if they feel a woman's neediness. He is afraid he will be overwhelmed, sucked dry by it. He may feel he doesn't have enough of his own energy, the essence to keep going on; how can he give her what he doesn't have? He is right; she must handle her issues from within just like he must. However, instead of pulling energy from each other, they might share their feelings. The sharing in and of itself is healing and bond-building.

This is similar to a lonely man's attempt to grab at another soul's light, not seeing the other's soul. What he is trying to grab is a physical reflection of light. This is the same as the above example of a needy woman. We can't take it from another, only from within. Neither gender, by training, understands. Light, fulfillment, and security cannot be had, boxed, held, or grabbed. But our limited awareness does not allow for an alternative. We love the light sensed within another, but cannot quite put our fingers on what it is. How do you touch light? Surely not with your finger.

The answer more women usually know than men is: with your own light, your soul's essence extends outward. Since women do this inherently, all the while not understanding that men have been cut-off from this, they assume men are doing it intentionally.

Another voice, the "angry feminist," says it's because men are inferior: buffoons, children, or just plain animals. Either way these women become resentful and enraged, and wreak havoc on their men and their relationships. Shooting themselves in the foot, so to speak.

Also remember that male initiations are based in shame and humiliation that supposedly "strengthens one's character." The crucial needs of the soul are ignored, trivialized, or made wrong. Lack of competent initiators is also part of it dynamic. Our teachers are uninitiated.

How does this apply to women, besides as the recipients of male rage? It applies directly to the masculine energy within women. This is the energy that wants to do, direct, order and structure, explore and adventure. It is a women's inner warrior. How she treats outer men directly impacts her inner masculine.

It is imperative for a woman to know her inner man. If she doesn't, he will not be there to support her if he feels judged, powerless, or emasculated. And the outer ones will reap that rage just by the mere fact of being male. Or if a woman's inner man is angry, he will make himself known within her through bouts of rage, which can be self-directed, full of destructive behavior patterns, the likes of which she would rather not know, but probably already does.

The most important thing a woman must do is to not overlook this masculine part of herself. What you don't know will come back to bite you. Your animus must be directed through conscious intention, evolved into a perfect partner, or it becomes an undisciplined gangster, or petulant child. He won't be silent; better that you have a handle on him and are not taken by surprise.

Chapter 11

The Man in the Womb

Biologically, it is clearly demonstrated that we are all females for approximately the first six weeks of gestation. Yes, this is fact. All new fetuses have rudimentary ovaries, vaginas, and clitorises. Not until six weeks of growth does the fetus that contains the Y genes start to differentiate. The ovaries drop into a sac formed by the vaginal lips and become testes. The vagina closes, but its remnant is a seam that remains on the testes, continuing part way to the anus, like a vagina would. This is visible on men. Naturally, the clitoris enlarges into a penis, and presto, we have a man.

Other not-so-noticeable changes occur too, but are unnecessary to discuss, such as changes to the endocrinal system. These changes do not occur overnight, but with time. From a developmental viewpoint, the male starts out as a female and at six weeks is given the biological instructions, "Stop and recreate what you are." This sets men developmentally behind women many weeks.

Now at birth, a child may have male gonads (sex organs), but it almost always relates to the one that carried it for nine months, birthed it and nurtures it: its mother. Through a process called mirroring, the child identifies with the mother, believing it is one and the same. The child was in fact at one point the same in her body, a female! The child does not yet know there is a difference called male or female; it assumes we are all alike.

This process of mirroring is how we learn during our first years, and this continues throughout our lifetime supplemented by reasoning. Yes, that means that there are times we are mirroring who we are not, as modeled by those around us. For example, a little boy thinks he is like his mom, then finds out he is not.

If the child is female, this mirroring of the mother should not be an issue. If, however, the child is a male, he will soon enough discover his own male organs. This is where all the "fun" begins, as the child learns about this "thing" between his legs, how he changes, and how he is to relate to the world. This is the same scenario played out for him as in the womb. "Stop. Undo what you have developed and recreate yourself." This will further delay his development as a male versus female.

A boy often finds out about being a male when he receives the first castration wound. He will be exploring his sexual organs innocently, and his mother in seeing this says, "Don't play with that honey." He will realize at some point the he is different from her. He may even think that since he shouldn't play with it, it is wrong or bad. I did a study on this dynamic, asking mothers of young children of both sexes if they had said this to their children. In over eighty-five percent of the mother of boys the answer was yes. Interestingly, it was one percent of mothers of girls that said yes.

Clearly, women are comfortable with, or at least not threatened by, self-exploration in girls. After all, they did it themselves. But it is a completely different story with boys, isn't it? This bias should not be overlooked.

"... a man, mommy?" "What does it mean to be a man? God only knows Dear." Can you not see a boy asking this question and being redirected by Mother from such silly thoughts? She can't figure men out herself, or may harbor negative opinions about men. Besides, she is a woman, and he needs a man to guide him in the answering of that question. Of course, this is an issue too because most men probably do not know either, being trapped in the masculinity they've been taught,

not self-developed. The young boy's questioning will bring him into contact with all that is male. Mother may not be comfortable with this either, just like a dad talking with a daughter about menstruation.

Further, in this day and age of absentee fathers, emotionally unavailable ones, or simply no fathers at all, his initiation into manhood is that much more difficult. He will struggle between being like mom, feminized, and the machismo presented as masculinity by our media, music, and peers.

Now you have a little bit more information on what is the basic undertaking of a man: to discover what precisely it is to be masculine. He will try mirroring his chosen role models and eventually may break out of the outward, into the inner search to know himself.

Karen Horney was a brilliant German-trained psychoanalyst who came to the United States in the 1930's. She courageously challenged Freud's view on female penis envy, which she felt was the result of cultural subordination, the subjugation of women, not an inherent desire to be a man. She felt women wanted the power men had, not their penises. She had a revolutionarily different idea.

To illustrate this, I had a client once that was born a female and, through the intervention of the "medical arts," became a male. He/she felt that women were inherently weak and decided to become a male, so she could feel powerful and safe, as a "he." Of course, the work that we did was to resolve this belief about the feminine and allow it to feel safe.

This naturally created another issue to be resolved, now that she had physically changed herself into a male. He had to come to terms with the female that he was now accepting, but had physically severed.

Continuing on with Karen Horney's ideas, it is axiomatic, that is, self-evident that: "What one fears the most, one tries to control using the greatest of one's energy, and this is somehow desired by an unconscious part of them." That said, Karen Horney's statement that flew in the face of Freud was that "castration anxiety is actually man's ego response to an unconscious wish to be like mother, to be a woman." Therefore, men

place the greatest amount of energy in resisting anything that remotely resembles accepting feelings, or the inner feminine. That there is truth here is unquestionable.

Men are afraid that if they let the feminine in, they will become overwhelmed by it and become, or go back to, being female. This was their original state. The resistance to the latter part is subconscious, and according to Dr. Horney, would indicate an underlying secret desire to be feminine. However, I believe that this is a distorted truism. By this I mean that there is truth in it, but it is a poorly understood truth and thereby logically distorted.

It is really a man's inner feminine that he wants to connect with, not become. However, as permission for this is denied them, men would naturally feel fearful to say the least about connecting with this inner feminine aspect that they are taught is wrong. So this turns into the inner "battle of the sexes" for a male, and for a male to be a male, the masculine must lead, superseding the feminine; but he need not, in fact should not, subrogate, judge, or destroy it.

If one is aware of this feminine aspect from childhood, does not have it hindered or diminished, all the while having the masculine fully honored and encouraged (which is not the case in our present society), would this not preclude or mitigate this inner battle?

The truth for men is that the feminine is already inside you, and accepting her does NOT equal becoming her! This is exactly the opposite dynamic for women: they must incorporate their inner masculine, but the feminine must lead. The masculine should not be judged, subjugated, or made wrong and denied.

In fact, a woman's masculine allows her to use all that energy currently being channeled into denying the masculine in partnership with it to create wisdom and balance within. This will give her the fulfillment she desires. Then she can use it as a Goddess of Wisdom to create an external partnership that equally creates love.

The Man in the Womb

Now, all teachings in ancient history were traditionally oral teachings, passed on by word-of-mouth. When one has an inspiration, that is the *breathing in of Spirit*, it passes from Spirit to our Soul or unconscious level and then on to our conscious rational mind. In doing so, it passes through all our layers that act as filters we have created based on our perceptions about life. These filters where created to help order and structure our thoughts and perceptions, categorizing them so we can make them congruent, in line with the world, as we know it. This, for a woman, equates to being safe and secure, which feels loving.

As we were and are in a patriarchal society, these inspirations would be adjusted to fit into our current male dominating views. So we have the virginal or pure Word of the Divine being adjusted.

Then, as in the case of the Old Testament, there are translation adjustments from Aramaic[12] to Hebrew. Remember that this process is occurring orally; it had not been set down to paper at that time. That's because paper didn't exist then and wouldn't for a few thousand years! These adjustments or changes are on top of the adjustments made by the filters or viewpoints of each and every person in the chain of oral transmission. Then as time passed and after being written down, it is translated from Hebrew to Latin, Greek, and other languages, till it finally reaches the commonly known work of this day. This process occurred over a period of 5,600 years!

The point of all this is to illustrate the opportunities the patriarchal beliefs would have had to change what many take as coming directly from divine source—unchanged.

Okay, now here is what all this has been leading up to. It is clear biologically that we all start out as female and that part of the masculine journey of discovery is about learning what this difference is. We live clearly in a patriarchal world, influenced strongly by it. Given the clear embryonic developmental process based in the feminine, is it not possible

12 Aramaic: ancient language not spoken for 1500 years. The common or street language of the Middle East, spoken by Yeshua (Jesus).

or even probable that it was Eve's rib that was used by God to create Adam, not the other way around?

Consider the patriarchal system. Would it welcome and accept such an idea as this. I strongly doubt it. So a "small" adjustment may have been made to be more acceptable to the beliefs of the recipients of the knowledge. Hence, we may have a reversed creation story.

This makes perfect sense considering whom God entrusted the task of the continuation of the species to: women. This does not mean God did not trust men. Men where entrusted to be the partners of women and support them, as they support the whole human race. A man's job is a huge and important job.

It is the masculine energy that is the creative spark. This spark starts or energizes creation, and the feminine's blessed task is to carry it through to fruition. We all have a place, a job description; we all have divine purpose.

Now, looking at this from a spiritual perspective, if the masculine energy is the creative spark, then perhaps this spark was referred to metaphorically as the rib of Adam?

Quite a dilemma this creates. The importance of looking at both possibilities is to realize the importance of both genders, not just one.

We are in the period of the Patriarchy. As mentioned earlier, before the Patriarchy took over, it was the Matriarchy that directed society. Think of the hunter-gatherer period. If there was no food, the hunter hunted till he found something to bring home. This may have meant days or weeks. Who then was in charge of the community? The women. They made the decisions; they had to. There were no men around, as they were busy bringing in food. The elder women would have probably ruled.

Now, I have thought in the past that the Patriarchy was a reaction to an abusive Matriarchy. While still possible, there is another possibility. What happened when the men no longer needed to go off on long hunting trips? I am speaking of the times of civilization building, agrarian (farming) societies. The hunters were becoming part of this society. Fred

Flintstone™ was staying at home more with Wilma and his family and interacting in the community.

How did he as hunter fit into the running of the community that was part of a woman's job? Should he be a woman? No! What then was a man to do with himself? This is still the question. So perhaps the Patriarchy was an attempt for males to create a boundary and define maleness within a society defined by women. Perhaps the Matriarchy was not all that abusive, just not masculine, and the men needed some way to express that male part in a female society. Perhaps the Patriarchy developed as the masculine attempt to masculinize the feminine society.

This would be an outer mirror of the fetal male conceived and initially socialized as female, trying to find his masculine identity. This is still the masculine journey to love, as a man.

We still have not yet achieved a workable understanding of this, have we?

Chapter 12

Initiations

Initiations are the introduction to something new and perhaps secret and must be accomplished by one that has completed the process. They act as a guide in the development of one's life.

One must be careful in the selection of a guide and understand that we are responsible for our learnings. This means that we must question what we are being taught. Many teachers' egos have difficulty with this. They have experienced the journey and its pain, and may have been wounded. In their attempts to understand and heal, they may repeat the same wounding over and over—with you, their student. Or they have set in stone their beliefs about how life is, leaving no room for evolution.

However these teachers have handled their own experiences, often they have not healed their own underlying rage, and so they inflict in on others. This is what projection is, and it comes out of their shadow where it was buried. That is what they project.

When a woman's inner nature is polluted, one way this can be seen is in her inability to accept sincere compliments. She must practice accepting them, while questioning the underlying belief that prevents it. Take command of the self-talk that may say, "You don't know how bad I am, how many mistakes I've made, or how phony I am." Say no to it, summon up the courage to look it squarely in the face, and face these aspects with full nonjudgmental attention. Keep up the focus, and you will find that this self-talk will lose its charge and power over you.

Hypnotherapy would be useful in accessing the source of the negative self-talk, so it can be healed and released.

Creativity is the ability to respond to life and make clear choices based on intuition and reason. This is wisdom. Take clear action, value your time, stay the course, and nurture yourself consciously. What stops this in a person? Their psychological blocks which prevent them from getting to their truth. These blocks will include the fear of rejection and fear of abandonment. All too often, when one is afraid to speak the truth, she feels inadequate and will settle for the mediocre. Anything being better than nothing!

When you find yourself trolling for meaninglessness, you need to stop. The results are an almost magical change, like the magic that changes lead into gold, or alchemy. But every alchemist knows that this change is not without cost. One must be willing to give up many cherished things like whininess, victimhood, and the role of doormat. Letting others be responsible is another huge ingredient that must be thrown into the fires of change. This enables deep insight, intuition, and alters perspectives.

You will yearn to free your own true nature, to teach it to fly on its own. Like a mother bird coaxing, pushing its young to take to wing on its first flight. This mother encourages its charges to expand and use innate talents. We can encourage ourselves, self-mother ourselves, to expand the talents that we intuitively know we possess. The initiator is a catalyst that assists you to create these results. He/she explains life in such a way that makes you look forward to the experience of soaring.

An initiator can see your uniqueness as assets to be nurtured and added to your personality. Sometimes a person sees these differences within themselves and others as indicating that they are misfits. Conformity does not support wholeness, but is promoted commonly. All parts have a role to play and must be understood. Then the positive aspects of these differences can be incorporated healthily.

Critically, any parts of Self we are blind to, we are blind to in others as well. The limitations or motives of others cannot be properly weighed because we are blind to them. Like the three monkeys, hear no, see no, and speak no evil. The blind one cannot see what another does in their blindness, the deaf one cannot hear what others say in their deafness, and the one that can't speak their own truth cannot relate to another who is mute. This is because when we limit ourselves, we are limited to anything similar in others.

The Red Tent[13]

Without question, for women, menstruation is an initiation. A woman becomes aware of vital forces within that ebb and flow, not always comfortably. This is a concept that men only learn when they look deeply at life. Women get it naturally—ready or not, here I come. It is a time of deep intimate connection to the miracle of life not only within, but to all of life. Again, men don't get it without a lot of help.

Our patriarchal society, therefore, doesn't "get it," doesn't understand the sacredness of menstruation and relegates it to something that must be hidden, medicated against, and viewed as unpleasant and unclean. This disfigures a woman's self-image. The goddess is unclean, unwanted. Only a disassociated male view could be behind this. This lessens women and leaves a lot less for them to give men. Men are shooting themselves in the foot by demeaning the feminine's sacredness. But they can't see this anymore than women can when they demean the masculine.

The importance of understanding nature cannot be stressed enough. It is the breath of God inhaling and exhaling. Women know this when they are allowed to be women; men often are clueless. The Red Tent consciousness of the ebb and flow of humanness is what a woman is made aware of, and when allowed, creates as a fantastic base for life—a foundation from which to build.

13 *The Red Tent* is the title of a fantastic book by Anita Diamant that I highly recommend all to read; men too.

Women—The Goddesses Of Wisdom

Without this understanding, men build a "house of cards," as do women who are not anchored in the understanding of nature and their part in establishing and supporting it. That is why women are more at home on this planet, and men are wanderers. Women are physically reminded that they are a part of the earth and its ebb and flow; men walk it, use it, but cannot relate to it. This is not inherent in men's nature, but part of their dissociative patriarchal training. As women move into the world and mistakenly think they should act like men, they move away from their relatedness also. They leave the red tent, and it becomes myth for them.

Initiations are accomplished when you complete certain tasks that are in many ways akin to rights-of-passage. These can be biologically required, like birth, puberty, giving birth, menopause, and *"Death, The Final Stage of Growth."*[14] These are quite evident to all, though not necessarily understood. But there are many other initiations that involve certain tasks that are important to one's growth and evolution. Often, these are not well known and can be overlooked easily, or though of as unimportant, old fashioned, or unfashionable.

Tasks that are part of the structures of learning may be as mundane as cleaning, sorting things, and the nourishing of everything from the house to the soul. These are all parts of the rhythms of life and death. Strategizing, building up one's personal energy, and creating new possibilities are all part of these training vehicles.

Part of the initiation process is the letting go of old beliefs: ones that don't serve or sustain you, that hold you back. Maybe they are too comfortable, or make you scurry meekly, instead of walking upright with a strong gait.

Another behavior that is self-destructive is pretending you are taking risks, lying to Self, all the while staying embedded in the comfortable concrete of status quo. Risk is necessary in taking on tasks; it requires courage, one of your masculine traits easily accessed with consciousness,

14 *Death, The Final Stage of Growth*, the groundbreaking book by Dr. Elizabeth Kubler-Ross.

knowing it is present within. Can you use these male traits and remain feminine? Absolutely, but you need to be conscious of them, allow them, and train them.

Tasks have a wonderful benefit of revamping the shadow, or housecleaning your inner dwelling, where your inner flow or wellspring of inspiration, creativity, and passion resides.

Chapter 13

Basic Training

The masculine aspect within a woman, named the animus by Dr. Carl Gustav Jung, is the part that protects and stewards the anima (feminine), which is the outer, expressed physical part of women. The reverse is true in men, where the anima is within and the animus expressed. The animus's job in a woman is to augment her in partnership. When misunderstood, this male part can hinder creativity by over-structuring and limiting expression. Ask a woman who is dried up and has lost her vitality what makes her happy inside, and she won't know. She may say a clean organized house or happy successful children, and these things are okay, but she will have no clue what she needs to jump-start her joy within.

The male figures in women's dreams become the missing link to understanding the workings of the animus. He is the part that illuminates how to handle life in a way that supports your entire being, not just your emotional desires. He watches and guides you in maintaining the reliability of your exchanges and encourages you to follow through with the commitments you've made. Without him, life is lived as a fairytale illusion that remains in your dreams unrealized. Your book has not been written; forget being printed.

Tasks: Developmental

Also, understand that within women's culture there is a suspicion of the masculine, for some a fear of needing it, or an ongoing healing from a painful wounding by it. In the collective consciousness of women, there is a clear memory of being viewed as property, children, not valuable partners. Women who had great ideas had them expressed as originating from and through a man. "Behind every great man is a great woman," can refer to this. It also can refer to her animating affect upon him, which does not necessarily mean she has relinquished anything to him. This is the important part that is a crucial part of all relationships: the animating effect of support. The critical differentiation is not giving up a part of Self, while still knowing that supporting another into action adds to your life.

The masculine aspect that includes clear inner thoughts and principles such as integrity and honor must be developed consciously in men and within women. It is part of a women's inner masculine that must be given regular workouts and training. This includes self-examination, asking what motivates those actions and appetites—okay now, what's really under that? This is a process, not a one-shot action, and it must be repeated in order to understand core motivations and drives. It will not be pretty and only worsens when resisted. What you resist persists!

Without this form of self-examination, the animus within carries out senseless egocentric desires, including blind unconscious desires, the consequences of which are usually not seen. For example, look at the word slut. Envision the word as if it is in front of you. Then using your senses, see how it feels. Is it feminine? Or does it feel masculine? *Slut* is the masculine energy in a woman run amok. Her river of emotions was untrained and unimpeded, and, worse, directed by an untrained (immature) inner masculine energy. He allows for behaviors that are, well, masculine. The price you will pay to cleanup your unseen mess is always way more expensive than the cost to choose another course.

Self-esteem and reputations are easier to maintain than to be resurrected, not to mention how the transfer of blame for your choices

Basic Training

to men affects your future view of them. This is the grand purpose tasks serve: to access and train your inner masculine. Then he can be called upon more easily.

Imagine your bedroom with piles of dirty clothes and other things not put away, making a walk through it difficult. Maybe you won't have much to imagine? Either way, the effort to tackle the problem seems huge, like climbing Mount Everest. If the first article had been put in its proper place originally—a small effort—then each subsequent one also put away would have resulted in no Everest to tackle.

Unquestionably, getting a teenager to organize their room can be challenging. "(I have two.), But what they will learn by this training is invaluable for their future." This is part of training the inner masculine. Further, the piles that build up also prevent the builder from receiving the benefits of the things on the pile's bottom. It's as though the things on the bottom don't exist, are lost for all time, but they are only missing in action. What was missing was the requiring of the tasks to be accomplished; the disciplining of Self, or of our progeny, was left to chance, or their whims, and usually not accomplished.

This is anarchy, the chaos of emotions, the unlimitedness of the feminine, devoid of masculine intentionality. Creation then either does not occur, or what occurs is not what is needed or planned for.

Here is a graphic representation of the feminine:

Multi Directional

Unlimited — Female — Chaotic

The feminine energy without the masculine is unlimited (it can touch the face of God—metaphorically), it's multi-directional, and without question chaotic.

The masculine is unidirectional, limited and intentional as illustrated:

Unidirectional ▶ Limited ▶ Intentional ▶

Imagine a long ditch, the masculine is in it. He can't see outside of it, can't change direction, but he will get to the end, with great intention. If you need a job done pronto and have a very feminine woman or very masculine male to choose from to do it, choose the man. Not because she is incompetent, but because she will stop to chat, ponder, or be side tracked with a pretty flower, bright object, or an emotion. Such is the effects of unbridled emotions of the one-sided feminine. A man on the other hand, sees nothing but the goal and, like a juggernaut, without conscience, will get it done.

Now, what if both sexes balanced their inner opposites? The woman will still be unlimited and multi-directional, but will now be focused by the intentionality of her inner masculine. This is what wisdom is. For a man, he takes on from his inner feminine being unlimited and multi-directional and retains his masculine intentionality. He becomes love expressed. The intentional aspect is the mental part. The unlimited, multi-directional aspects are the emotional parts.

A Goddess of Wisdom graphically looks like this:

Multidirectional - A FEMININE Characteristic

Unlimited - A FEMININE Characteristic

Intentional - A MASCULINE Characteristic

This does in no way infer that we will all be the same. We will all be able to use our God-given essence as whole beings. But we will do so from our respective feminine or masculine perspectives. Learn to understand, accept, and use all parts of your being, separating the differing aspects and needs from one another and use as needed. Then you will be accessing your wisdom.

Chapter 14

Midlife

Midlife is usually a period somewhere in one's forties where we get the "itch" for something undefined; we may be feeling unfulfilled and question our lives. At this point in our lives, our focus has started to shift from outer attainments to inner ones. This is the reawakening of our soulfulness. This state is usually more pronounced in men, than women. This is because men are more disconnected from their souls, which requires access to feelings denied in men. Women will usually not have as pronounced a midlife experience, or crises, but they may have one nonetheless.

During a properly handled midlife experience, the ego does not vanish, only becomes recognized as the first officer of the ship; the soul moves into its rightful captaincy. This is an absolutely crucial refocusing, necessary for a complete life.

The Self is the paradoxical union of the opposites within, the centerpoint of the Tension of the Opposites.

The ego is the created outer person, the persona, and it demands that life fulfill its wants. It attempts to direct life's events, so it can feel good. It reduces the mystical to insignificance, or to chance. It is afraid of letting go of its created "realities" and rightfully so.

The spiritual aspect of being, the true essence of humanness, does not lend itself to emotional whims. The ego cannot participate in the processes of soul. The ego is lonely and cannot experience love or a soul connection to another. For the ego, sex is a form of mutual masturbation. A

soul-based loving connection must be non-linear, natural, and instinctive in nature.

Lonely women have souls that have been disallowed, put in the brig by the mutinous ego, in league with the animus. The ego is self-absorbed by nature, surrounded by forces that it cannot understand, clueless about what's real. It thinks the answer is to control (limit, manipulate, pigeonhole, lie, barter, demand) those forces in its sphere. In doing so it seals its own fate of separateness. The controlling ego is empty and isolated, like a princess in a large castle with many rooms. Servants abound, material abundance is distractingly evident, but the soul is not consoled. Midlife brings questioning. Ignored, these questions doom you to poverty of the soul.

To be bitter or not to be, that is the question, but what is it about? Bitter about broken hearts, broken marriages, and broken promises. All of us have received and given these "gifts." Some have learned and evolved from them. Others devolved into beasts defending territory, eked out of the scraps of one's life and beliefs, clung to with ferocity, a mother defending her cubs. By returning to the instinctual nature of the soul, a woman can breathe new life into her stale little world that threatens to entomb her, and be reborn with renewed spirit and restored to health. This is the phoenix of legend that rises from the ashes of her former life. But she must be willing to sacrifice this old, maybe comfortable, known place for a new unknown one. This is the disagreeable part.

"The task of midlife is not to look into the light, but to bring light into the darkness. The latter procedure, however, is *disagreeable* and therefore not popular."—Dr. Carl G. Jung.

"Rise above it," the modern "new age" slogan is counterproductive. Looking into the light while ignoring the dark is a spiritual bypass. We bypass the enlightening of the "disagreeable" darkness and only focus on the pleasing light.

Ignored, our inner darkness never goes away no matter how deep we cover it, or blind ourselves with light. An issue that some "spiritually

aware" people have is they have not yet dealt with their darkness, their shadows. They've attempted to "rise above it." What they have "risen above" spills out in their actions, creating havoc, yet they believe it's everyone else's fault and project blame onto these others. They after all have "transcended" these issues. Our illusions are a powerful force, especially when we have invested heavily in propping them up.

Now the "disagreeable" part is looking at and being responsible for our darkness, and then taking the necessary inner actions to create a new framework for living. Number one is survival, and the next thing is getting what one wants, which is seen as outer world attainments.

The next step, then, is to ask oneself, "What in me stops me from seeing me and thereby prevents my growth?" The answer would include, "My own inner turmoil and self-limiting beliefs." All humans must take inner action to accomplish their own personal evaluation and evolution. So how does one commence inner actions needed to bring light into one's own darkness?

The Critical Component

The critical piece necessary for our healing is forgiveness. All of those broken promises and divorces hurt. They make us gun shy, distrusting of others and ultimately of love itself. If we don't trust love, life will remain empty, without hope of fulfillment. We will become addicted to distraction after distraction, but fulfillment remains unattainable.

Now, there is a critical component of the critical component. It lies within a woman's masculine part. It is the courage to address the issues, ask questions, and then forgive. Why does it take courage to rid yourself of the inner poisons that are retained resentments? Because we have become comfortable with our "woundology." *Woundology* is a term coined by Carolyn Myss, which refers to people's investment in victimhood that our "self-help" society has nurtured.

People are addicted to their wounds and the process of healing. They're unwilling to forgive and thereby release their life's traumas, preferring instead to cling to them as a definition of Self. "I am an abuse survivor, alcoholic, etc." No, you have experienced abuse, alcoholism, or used other self-subterfuge in the unsuccessful attempt to deal with what you couldn't at that time. You are a soul having a human experience. You are not your experiences, but something much greater. Why limit yourself, define yourself as your traumas, or symptoms? Perhaps, because it is just easier?

Chapter 15

The Dark Queen

The Masculine Energy In Women

The Wicked Witch of the West in the Wizard of Oz, the Black Queen in Snow White—the list is long and all are examples of the masculine energy in women run amok. Though they are usually well groomed, none of them are thought of as examples of a loving female, are they? They are the embodiment of the dark side of the masculine: the driven, feelingless, compassionless, goal-oriented abuser of power. That the masculine can be viewed this way will not come as a surprise to most people.

What may surprise you is the appearance of the dark queen's younger sister, the new version of this masculine energy in women that has become the role model for younger women today: the Aphrodite energy run rampant, the Slut Queen.

Resplendent with tattoos and body piercings, displaying every body part no longer suggestively, but grossly, she uses her sexuality for power, control and, all importantly, attention. One can easily see her in music videos acting like a stripper, the stars displaying their breasts at Super Bowl Halftime shows. She makes herself known in the everyday dress of our young women, where it is clear they are, for example, wearing a thong. Their labias are clearly outlined, as are their nipples and breasts along with everything else. It is slut-chic, a clear sexual display; but does it feel soft and receptive, that is feminine, or is it hard, coarse and direct like the masculine? It is the repressed masculine energy forcing its way to

the surface in women, overpowering and unbalanced with the feminine energy. And then these women complain, "All men want is sex." How should men respond when this is what they are being presented with? There is of course another side of this which I discuss in *Men—The Gods of Love*.

The Queen is evident in Hollywood celebrities who started out as lovely young teen women. They were then sexually repackaged, their breasts augmented. They act out for the tabloids, becoming slut-ebrities. They followed Alice down the wormhole and got lost, that is, fell into a trance that numbed them to the price to the soul. The Gods of Attention, Fame and Fortune have their souls. Surely they've been paid handsomely. From the state of their tabloid lives with one-day marriages, drugs, sex, and rock-n-roll, they've created a new role model—the Slut Queen—for young women to emulate.

Women, especially younger ones who have not had the time to develop wisdom, are very susceptible to the allure of attention. Attention is the sought-after commodity; being honored as wise human beings unimportant. Ladies, no matter what you are being told, sex symbols are only toys, temporary playthings. And it keeps men trapped, thinking of you as sex objects. Wake up please; you are hurting yourselves and your inner and outer men.

When my oldest daughter told me during a conversation when she was fourteen, "Dad, it is all about looks," I responded, "How sad I am to hear you say this. The truth is that it is all about who you are as a human being." This is a lot bigger viewpoint of life and Self. I continue to encourage her not to sell out her essence. I have faith in her and am ever ready to guide, that is, to be a parent, not giving into her whims, and she knows this too.

A woman can and should draw upon her masculine energy to direct, be intentional and focused, but she must never lose sight of her feminine energy. Nor should she allow it to be overrun by the masculine, her inner masculine or her outer man for that matter. This is the same idea, but in

reverse for a man; he must bring in and incorporate his feminine, but remain masculine.

A woman needs her masculine strength and reasoning abilities. She needs to be able to order and structure things, focus her emotions. But many women, either because they see the feminine as weak or are seduced by the drug of attention, allow their unguided masculine to take over, which reduces the feminine.

The feminine appears weak and chaotic when it is out of balance with the masculine, just as the masculine appears unfeeling when it is out of balance with the feminine.

A huge mistake many women make is to become men, especially in business. These women are seen as hard, driven bitches. They are trying to appear as strong men, not as powerful women. In fact the model of powerful, wise, feminine woman is only now taking form.

My experience with my own and other men's reactions to both types of women are that we will do most anything for a powerful feminine woman, and will resist tooth and nail a masculine woman. If you are being resisted, then who are you being?

It is interesting to note that women, who have historically been subjugated by the Patriarchy, have tried to do masculine things to symbolize their retaking of their power. I remember an older cigarette commercial aimed at the female market saying of a woman now being "permitted" to smoke, "You've come a long way baby." Yes, you have baby, and you can now take on all the disgusting and unhealthy habits of men, but why would you want to? This has continued to devolve into tattooing and piercing, which this author finds repulsive. I personally don't like it on men either, but to scar up the Goddess, the beautiful feminine, is horrifying. Yet, many think "tramp stamps" are sexy. And they do get attention.

Men know women with tattoos are sexually active. It's an "in your face" message of gross sexuality. Yes, this is the Slut Queen: she smokes,

is tattooed, pierced and will f--k your brains out. Unfortunately, men will probably not be able to create a true partnership with her because she has lost this ability, just like men have. However, she thinks she is choosing it as a declaration of independence, or a right of passage.

I miss femininity. I love it and cherish it. I respect it. However, I too am guilty of supporting the Slut Queen, of helping damage the feminine, simply by responding to her overt acts. Why would a woman take this path? Simply because it is easier. But it lacks courage.

What Are We Made Of?

The role models we all find ourselves following, how we see ourselves as women and men—the paradigm—is based upon our personal experiences. This includes what we've been "told" we should be. Combined, our experiences and dictates form our "inner programming," the constructed reality, or constructs, by which we operate. Society reinforces the way we are supposed to behave, think, and view ourselves. But these "ways" fall far short of the truth of who we really are, to a point where it degrades us. Our views of femininity and masculinity are contaminated.

Our programming creates a dissociative state, which severs our connection and creates distrust and animosity. Women are dissociated from their reasoning mental abilities, men from their feelings. Dissociative disorders are clinical conclusions. So this means that we are all being taught role models that make us crazy. Ever thought the world was crazy? It is, and it's taught to be that way.

We can change our perceptions by making clear choices about what we really are, by updating our programming. Our "programs" are so ingrained in society and our lives that they *appear* normal and correct. But if they represented the truth, then why do we experience such turmoil? Why do we have so many questions about our opposites and ourselves? Why must men learn to hide their feelings and emotions, while women are taught they are not men's mental equals? The only logical answer is

that we are actually something very different than what we're taught.

So what are we really? How should we behave, treat others, or react? To better answer these and other crucial questions, we first need to find out what the stuff we're really made of is; what really comprises the human species? First, let's look at why things are the way they are.

The Patriarchy

In essence, our society is patriarchal. Patriarchal societies are male-dominated groups that place women into dependent positions. Males are usually in charge and are assigned as the providers and guardians of women and children, who are viewed as weaker, less capable, and dependent. This model forces certain behaviors patterns upon us, while stifling others.

Women are fully capable of being intelligent reasoning beings, but this is not presented as the appropriate model for women in our patriarchal world.

No human is fearless, yet this is what men are told they should aspire to. As a result, they disconnect, or disassociate from their true feelings, and this is disastrous for humanity.

The Driving Force

Now, what is the driving force, or whip, that controls women and creates this dissociative pattern? It is fear and an inherent lack of self-worth. How can women be Goddesses of Wisdom, when they are taught that they are mentally inferior to men?

Some of the key messages destructive to femininity that are given to women, messages that create fear and unworthiness, are:

1) "Don't trouble your pretty little head about it," because you're not smart enough.

2) "Big girls don't show their anger, it's unfeminine;" they must look pretty and sweet.

3) It's all about looks.

4) All men want is sex; therefore, women's minds and souls have no inherent value.

5) Women are smaller and weaker than men; therefore, they are not as capable.

6) Women and their offspring are dependent upon men to aid and protect them; therefore, they are not as capable and must be submissive in order to survive.

7) Pretty, barefoot, uneducated, and pregnant is the role of a "good" woman. Her sexuality is the measure of her worth. Her mind is not so important.

These patriarchal dictates have taken on a life of their own and yet go completely unnoticed in our world. And there are many more than mentioned above, aren't there?

Men are taught that all men should be strong and should not show emotions like fear or sadness, and that crying is out of the question. "Only women are supposed to do that!" Because of these teachings, men conclude that feeling weak equates to being feminine. Therefore, feminine is wrong, and unworthy.

They are told to take care of women because women are weak, fragile, and basically incompetent. Men are taught that these weak ones can't be trusted and will manipulate with their "feminine wiles," which is another way of saying they are all "lying whores." All men have heard this phrase. The barter system women are taught actually steers women into these types of behaviors.

Women are stuck trying to be women and trying to do "right" by this paradigm erroneously called womanhood. And they face turmoil in

being powerful, respected, intentional beings. This denies the world of the greatness of the feminine.

The Patriarchy also implies that a woman must experience life vicariously through her man. This perspective is not an uncommon one even in these modern times, though it is changing.

The Patriarchy has warped the experience of femininity, entrapped it in its web of self-delusions of emotionality, dependence, and inequity, using fear and shame as a prod. Lost in confusion and misinformation, femininity is unclear and chaotic, thereby denying women wholeness.

Men do not help the situation either by judging women for being what they have been trained to be. In fact women have been taught to be this way for men; at least this is what they believe. Men can help support women into becoming whole, or they can twist them with their own anger, egocentric blindness and demands such as, "Be our submissive whores," "Be pretty and sexual," or "Be the nurturer, mother and loyal housekeeper." "Oh, and while you are doing this be completely wise, our trusted friend and advisor." This will not happen without men allowing women to evolve into their heritage—wisdom embodied.

Women are taught not to think independently, yet are berated for doing just that. Women don't usually make the big decisions. Their opinions are overridden as emotionally-based; yet their wisdom is undeniable. One could spend an entire day depicting these kinds of impossible scenarios that put women in no-win predicaments. And, yes, there are many men who want or at least expect a submissive woman. These expectations encourage and continue the patriarchal system that must come to an end. Men must find their own feelings, so they can release women from the burden of being men's surrogate for feelings.

The patriarchal demands on women are archaic, and the so-called desirable submissive female state has been, and always will be, an impossible request for women to accomplish due to what the individual itself really is made up of.

Shadow: Bringing Light Into Darkness

What is it that drives us to do things we don't understand? What is the source of these actions that seem to come out of nowhere: "It couldn't be me, could it?" Our shadow is our elusive part, the part we can't clearly see. Yet, it has far more power over our lives than we would like or wish to admit. It contains all of our buried emotions—those we could not deal with.

We all know every belief and feeling buried in our shadows, though we tend not to identify them as our own when they show up in our lives disguised as the actions of others. We choose consciously to hide our dark, shadowy sides even though the price for our attempts is far more costly than we've ever imagined. We have not been taught how to handle the dark feelings within us or are ashamed of them, so we hide them. Yet, it is impossible to hide this shadow for any sustained period, and it saps our energy 24/7 in our attempts to do so.

People handle their shadow and pain like a child trying to remove an adhesive bandage. They slowly, bit by painful bit, peel it off. "Ouch! Ouch! Ouch! That hurts!" Believing that facing their issues head-on, quickly removing their bandage, will be excruciating. The truth is, it is much less painful. It is the holding onto of every millimeter of the experience that creates and lengthens the painful experience.

As an example, we can grieve deeply now or slowly and painfully over the years. The first option is a process that, when completed, is over. We then can move on with our lives. The second option is giving up our lives, entrapping ourselves in grief that festers into a boil—one that never quite goes away and flares up at the most inconvenient times. What do we give up our lives to? The answer is our shadows.

Let's discuss what the "shadow" is in greater detail. The shadow is a term coined by the noted psychiatrist, Dr. Carl Gustav Jung. It refers to the aspect of our being that is not seen with the light of conscious thought. Therefore, it is considered the hidden, dark, or shadowy side. It is an unconscious aspect of our being.

Dr. Jung described the shadow as having "an emotional nature, a kind of autonomy, and accordingly, an obsessive or, better, possessive quality." This can be thought of as self-possession.

How will this autonomous darkness manifest in us? Not well. Let me illustrate: women who have had negative experiences with one or two men, or with their fathers, often develop resentments and distorted views of *all* men. Then these women project their shadowy beliefs onto other men; it matters not if these other men are innocent or guilty. These women see all men as being the same, which is being dictated by their past negative experiences. If one man has betrayed a woman, she will always be wary of this from all other men. And because she has this belief and is familiar with this energy, she will actually attract this type of man into her life. This is how a construct, which is an illusion of reality, is formed or reinforced. And she will prove herself right about her beliefs. Many people would rather be dead than wrong.

Further, when one gender projects its shadowy beliefs onto the other, the recipient's beliefs often become twisted. These beliefs are then returned also by projection onto the former gender, which then develops more twisted beliefs, and on it goes, throughout the generations. They call this the "battle of the sexes." Have you seen this in your own life?

Primordial Wellspring

One important point about the shadow is that it is not inherently negative. It is the primal, gut-feeling energy of our being that creates wonderful works in our lives. I liken it to the Eastern concept of *Kundalini* energy. This Indian concept comes from yogic philosophy where an awakening occurs, and one's spiritual energy is then freed-up. This book has been written with that energy rising up from my shadow, my primal wellspring of unconscious energy, in conjunction with my conscious awareness. It is my shadow that drives me to put all this to computerized pen and ink. I am accessing my primordial Self and directing it to the

task of creation instead of destruction. I have admittedly accomplished the latter more often than I would have liked.

George Bernard Shaw said that the only alternative to torture is art. Allow me to rephrase his statement: the alternative to a tortured, twisted expression of life force is a creative one.

How did we get a polluted shadow? First we buried (repressed) our feelings because we couldn't handle them. Then, we created an illusion where we pretended they do not exist. However, they are always there. The keys to releasing and healing these thoughts are to: acknowledge, understand, be responsible for, and forgive.

We must be willing to look into our wells and cleanse out the pollutants. We must be willing to acknowledge that we are not just playing the role of innocent victims; we are also playing the part of perpetrators. Those who identify themselves as victims cannot heal because they take no responsibility for their feelings or reactions. Everything is always "done to them." Nevertheless, it is the person's choice to keep the well polluted through a belief in their victimhood. *"We"* are the ones that need to start the recovery of our toxic waste sites by releasing and healing our toxic thoughts, feelings, and beliefs through appropriate ownership.

The Nature Of Repression

Throughout history, the earth has been called Mother Earth. The Earth Mother is the source of all sustenance for all living things. If she is polluted, she spews back foulness from her depths. And if we continue to poison her enough, she will mask the sun with toxic clouds, ceasing all further growth on the planet. If our inner soul that mothers us, our unconscious, is polluted, then clearly we will receive contaminated nourishment that will stifle our personal growth.

Why do we bury our feelings into our shadowy places and contaminate our wellspring? We simply don't know what to do with these feelings, so we do the best we can to manage them. When that is not enough, like the

ostrich, we put these feelings into the sand and cover them up because they hurt so much, and we don't know what else to do. "Forgive them, for they know not what they do," refers to this all-too-human reaction. What we bury makes its way into our wellspring and contaminates our unconscious mind, just as toxic waste pollutes our drinking water.

Our goal must be the integration of our total being, our parts, which we perceive as inferior and have rejected in life. This requires looking into our dark side with the light of our conscious, awakened Self, and deciding to be responsible for what we see.

This is no simple task in a society that has been taught "victim consciousness." Victims never take responsibility for what is "happening to them." The nature of victimhood is to perceive our experiences as being done to us. There is no understanding or responsibility for how we are creating, allowing, or attracting the offending situation. Blame is the foremost tool the victim uses in creating continued victimhood. Blame is simply the taking of inner feelings and projecting them onto others, which makes these "others" responsible for our feelings. A victim says, "You made me feel sad, hurt, lonely, abandoned, unworthy, frightened, or angry."

As an indicator of your own or another's victim consciousness, consider the phrase, "You make me feel happy." Seemingly an innocent phrase, yet it indicates a position of victimhood. Why? Because YOU are the only one that can make yourself feel anything!

No one can make you feel any emotion—positive or negative—unless you choose it. You may not like what you're experiencing, but you can decide not to take it personally, or to continue experiencing it! These are your reactive emotions that you are experiencing and projecting or blaming on others. Underlying all reactive emotions are negative beliefs. If one believes "The world is not a safe place," then in reaction to this belief, one will feel fear and may cover that up with sadness and/or controlling anger.

You could also choose to experience the offending situation with a positive emotion such as compassion and forgiveness; to turn the other cheek to *not take it personally*. This is proactive as these emotions are based on conscious choice. But know beyond a *shadow* of a doubt (pun intended) that it is your choice.

You are wholly responsible for your own feelings. Great news! It means you are not a victim, not trapped in the feelings that are not to your liking. And it means you can do something about them. You have options. "I feel happy with you," is different from "You make me feel happy." The language that we choose to use is far more than just semantics, or word play. Our language choices are clear indicators of our beliefs, if we will only learn to look for and recognize these cues. Then, new positive beliefs can be instilled, replacing the false negative ones. We must learn this so we can stop hurting one another, as we are all brothers and sisters of the same ultimate progenitor (originator)—God.

For those who need more concrete concepts, quantum physics says that ALL matter is made up of the very same ultimate essence. The rate of vibration of these base particles is what differentiates all matter.

The law of the shadow is simply the opposite of the law of gravity. The law of the shadow is: "What goes down must come up." What we bury, repress deep inside, will always come up. This is undeniable and logical, as the shadow is the mirror image of our conscious state, and gravity is reversed in this realm. When we resist looking at our shadows, this resistance twists and energizes what is released.

However, we usually can't see our resistance any more than we can see our shadow. That is why it is called the "shadow"—because it is hard to see. Unfortunately, we can see the damage it leaves in its wake: collateral damage.[15]

It is critical that we all look into our shadows and release what we find there. "The tree that would grow to heaven must send its roots to hell."

15 Collateral damage: injury inflicted on something other than an intended target.

The Dark Queen

So said Nietzsche, and this directly relates to the importance of working with our shadow.

Dr. Carl G. Jung said, "If a person wants to be healed, it is necessary to find a way his conscious personality and his shadow can live together." If one part is resisting or suppressing the other, then this can't happen. A word of caution: do it at your pace and gently, always remembering the critical factor of forgiveness—of Self and others.

Our blindness, or inability to see ourselves, is self-imposed. It is like we are asleep at the wheel of the vehicle of life we are driving. What's worse, we are actually lulled into this sleep and taught to be blind when we are taught to conform. Conformity merely protects us from our own ignorance and blindness. This sleepy blindness is actually a trance state, similar to hypnosis. This is the real power of trance. Trance numbs us to the consequence of our actions. When we are caught unaware in its midst, we truly cannot see and, therefore, "know not what we do." Yet, we are the ones who act as our own hypnotists! We must awaken ourselves by desiring to be awake and not safely tucked away in our bed of dreams!

Ever gone to your refrigerator and forgotten what you went for? Ever missed your exit on the highway because you were off somewhere in thought? Do you even remember most of the drive? Most would reply no, including me; the autopilot was on. So who was driving? Above, I mentioned being "asleep at the wheel of the vehicle of life." Who is driving this "vehicle" for you?

Now, imagine running out of fuel in your vehicle (vehicle of life), walking to the nearest fueling station, and coming back with a bucket of soapy water and a sponge. You then proceed to wash and shine your vehicle. Upon completion of this cosmetic clean up, you attempt to start the vehicle, and damn it, it still won't start. The outside looks good. "What is the matter with this piece of junk?" You did not attend to the inside, the fuel. Some people just remain by the side of the road, empty, and blame the vehicle, or life. Others accept responsibility for running the damn thing out of fuel, get fuel for their empty tanks, and drive on.

Please know that I have had my challenges with a polluted wellspring and have been intimate with victim energy. Further, I sadly acknowledge my trail of collateral damage I have left in the wake of my initiation process. I can promise you that you can move out of these "thought traps" by being willing to look within, take responsibility, and initiate action to make changes.

Chapter 16

What Is She Made Up Of?

Sugar And Spice And Everything Nice—And A Lot More.

Currently, women find themselves in uncertain circumstances. But by exposing our falsehoods and replacing them with more accurate information, we grow. Becoming aware of what we really are can be the springboard we need to affect this. The topic of what women are has been one of unending discussion and debate. We have been told many differing things, most with good intentions. But not knowing exactly what we are is a strong factor in what we become. Knowing what we really are made of will help us regain our original whole. This chapter unravels the composition of the female.

Body And Soul

We are more than an organic machine being controlled by a biological "computer" called the mind that thinks and emotes. I am sure you've had the experience of watching yourself thinking or experiencing some emotional situation. During those times, what part of you was witnessing you? No, it was not another part of your mind, it was your soul. We have been taught that the soul doesn't exist, other than in theory. One of the great proponents of this misinformation was Dr. Sigmund Freud, who said the soul was a creation of the mind. In fact the opposite is true: our souls create our minds, emotions, and bodies. We are an expression of our souls, the essence of which is divine.

In order to uncover who and what we really are as human beings, we must look at what we were prior to coming into the physical form: our souls.

As souls—the purest sense of what we are—we are perfectly balanced. Imagine us, our souls, as the Yin-Yang symbol. This symbol is an excellent visual representation of our soul's essence. Our divine essence is neither male nor female, but rather paradoxically intertwined and combined as one.

The soul incorporates all aspects of being. It is the *awareness of Self* that goes beyond this physical realm. It is the generative force that creates and continues our *minds*, our *emotions*, and our *physical bodies.*

Now, imagine your soul projecting part of its essence as a physical body. The half, or *gender,* your soul expressed into physical matter—your body—was determined by you and is the sex you chose in this physical lifetime. What happened to the other aspect that was not expressed?

What Is She Made Up Of?

Nothing happened to it. It is still there in a nonphysical realm as part of you. This is important to understand because it becomes the part that we yearn for when we don't realize that it is still there, as part of our totality. We yearn for it deeply and many search for it in outer opposites, or look to reconnect by becoming our opposite gender.

Unknowingly, it is this part of our own self we feel disconnected from, which creates an uneasy feeling of emptiness or longing, a void within. The reality is that we have become blind to what is already there. This is the part most of us try to appease when seeking fulfillment outside of ourselves instead of from within.

Imagine your being as an automobile, your *vehicle of life*. Sliced lengthwise down the middle, it has a two-wheeled left side and two-wheeled right side.

You could compare the driver's side with the part of our soul we have expressed into matter, in my case the masculine. So visualize me going down the road on what you know are my two right-sided wheels, but which I perceive as my *only* wheels. I could not be parallel to the ground, as I could not balance evenly on two wheels. So I operate in a skewed position, at a forty-five degree angle!

What a stunt, and it creates some interesting situations maneuvering on the roads with other traffic and around the potholes of life. I, of course, think this is absolutely normal, as all the other males are doing the same

thing. So are the women, but in an opposite fashion. This separateness is challenging and hell on the tires, too!

I evolve (yes it's possible) and find a way to be a man, but one who is now balanced with my feminine soul counterpart. I've created a "whole" new paradigm, or way of perceiving, on four wheels parallel to the ground! I am still a male and driving from my male side, yet I am much more. My potential has increased exponentially. How much more am I now capable of based in my new balanced center of gravity?

Dr. Carl G. Jung has said that the "process of life is one of relocating the center of gravity [focus] of the personality, the center of consciousness from the ego [unbalanced outer persona] to the Self." He saw this as the life's work of all humans. Upon completion of the refocusing of our awareness from outer fulfillment to inner, we will come to know our soul, which is essentially divine.

Why is this so important? Because the balance between your inner male and female is a direct reflection of your ability to love and be loved!

Every one of us yearns to be whole, balanced on four wheels. It may be an unconscious yearning, but it is there. Sometimes we disown that part of ourselves unconsciously and sometimes consciously. We do this because we were taught to be ashamed, in fear of, or even hate this other part of us!

What Is She Made Up Of?

Whatever we believe, we will perceive and create, no matter what reality is. We will undermine reality and create it in our own image—the image of our inner reality projected outwardly. This is projection. So the hated part continually shows up in full regalia in our lives. We call them in, but forget why: to remind us what needs to be healed and balanced within.

What we really feel inside is illuminated by what we've created or allowed to be created on the outside. If our inner world is based on negative beliefs, then we will create our outer reality to match it.

The same is true of group consciousness. Take a look at the world as it is today. Is it an expression of love, or is it an expression of fear, pain, grief, disconnection, arrogance, and hate? Hatred exists within our group energy because of imbalance. Since the world has been mostly male-dominated for a few thousand years, it is the feminine energy that has been directly undermined. This imbalance must be addressed; its roots stem from our disconnection from our souls. But also remember, the feminine shadow has indirectly undermined the male for an equal period of time. We shoot each other in the feet and wonder why the world is handicapped. "Hmmm, I don't know, but it must be *their* fault."

Westerners have been strongly indoctrinated by the patriarchal programming, which gives little thought to any connection with the soul, or to its very existence. The soul is something we typically consider only in relation to death. If we don't recognize our soul's existence, how can we recognize our divine inner gifts? Furthermore, do we understand the occurrence of souls being attracted to other souls, which we call soul mates? If we do not believe that the soul exists, how can we begin to understand this most crucial part of ourselves, no less connect with it? The truth is we can't. But recognizing the spiritually disconnected nature of western culture, we can realize the source of our own doubts of our spirituality—if we happen to have any doubts.

The evolution of our spiritual aspect, commonly called the soul, is the purpose of the symphony we call life, and the focus of this book. Since we ARE our souls—spiritual beings—we must understand and

be able to connect with our spiritual nature. Otherwise we are like an automobile traveling down the highway of life—skewed—on two wheels. Unfortunately, this is not uncommon.

The Mind

Mental thinking is the masculine aspect of humanness. It is rational and linear in nature. But it has another critically important aspect: intentionality. This latter attribute is not highly regarded as necessary by most women. It is, however, absolutely necessary for the maturation of the feminine. It is the ability to focus your entirety with intent that is necessary for women to reach wisdom. Otherwise we have multidirectional, unlimited chaos, which looks to men like unstable emotionality. Ever see that in another woman, or yourself?

With intention, a woman can direct her fabulous, multidirectional boundlessness, and from this she becomes the embodiment of wisdom.

Paradox

Thoughts are finite; they have a beginning and an end. True feelings are infinite; they just exist with no beginning or end. So the paradox of life shows up in the combination of the infinite with the finite.

Take the feeling of love, for example. You may feel love at any moment, or not, for any reason. The feeling itself is eternal; how you apply it is what creates and changes. Love, which is synonymous with God, is the all-encompassing infinite.

The mind cannot understand God. That is why the human race has, for thousands of years, mentally struggled with, created our own versions of, or simply rejected the concept of God. Therefore, the mind has minimal or distorted connection to not only its own soul, but to love and God.

What Is She Made Up Of?

Taking the previous paradox to another dimension, with the infiniteness of God and the finiteness of our material world allowed to both coexist as true at the same time, we have the resultant bringing of spirit into matter. This I consider the purpose of life. Life is a paradox; it is not linear like the mind wants, or circular like the emotion want, but both, at the same time. Welcome to Paradoxville.

NOTE FROM THE AUTHOR: While I use the word, "God," I wish to stay clear of any religious concepts used to depict God, especially as being separate from us. God is often depicted as an old bearded man on a throne, who from his heavenly abode watches and judges each and every one of us. This is the patriarchal view of the infinite intelligence that is and flows through everything.

It was written that: "In the beginning there was nothing, but God… and God created the universe…" From what? No, God did not conjure up the universe like a magician. Since the only thing that existed was God, then it follows that God created everything from God's own Self, God's own essence. God is neither a male nor a female, but contains both, and much more—infinitely more. In fact, there is nothing that is not God.

How do we answer questions like "What is our soul?" and "What is the nature of God?" These are certainly outside the limits of linear mental understanding. And emotional faith does not fully clarify the question either. Only using our totality, not our limitedness or our unlimitedness, but both, to ponder the infinite will bring fulfillment of this longing. Only that part which we have lost sight of can do it: our souls.

Continuing, our soul's "thoughts" are not of the common mental variety, nor are they ordinary feelings. These "soul thoughts" are of the nature of a spiritual knowingness that includes, yet transcends, thoughts and feelings. Presently, it is "I feel, therefore I am" versus "I think, therefore I am." Paradoxically, this becomes "I AM THAT I AM," or simply, "I AM."

Soul-centered knowledge forms the basis of wisdom and leads you along your path. What is your path? The human race is on a path to evolve our loving souls, with God's blessings and support. And we are

Women—The Goddesses Of Wisdom

a part of God, literally. This is bringing spirit into matter. It's a process that seeks equilibrium, a natural balance. Everything seeks equilibrium, yet we are taught to resist this possibility. This prevents finding balance. It simply creates a crazy unbalanced world.

Male Attributes: Mental	Female Attributes: Emotional
Giver	Receiver
Doing	Being
Control Situations	Capacity to Relate
Presenting Component	Receiving Vessel
Initiator of Life	Producer of Life
Rigidity	Flexibility
Directive	Guiding
Strength	Sensitivity
Focus	Inspiration
Structure	Vision
Intellect	Faith
Logic	Intuition
Guardian	Nurturer
Provider	Sustainer
Order	Fluid
Linear	Circular
Rational	Symbolic
Warrior	Defender

What Is She Made Up Of?

Male And Female Attributes

Above are some of the traditional beliefs held about the genders. Men and women both possess masculine and feminine attributes, but their outward display is normally one-sided. This is as it should be unless their other side is seen as alien, wrong, or even dangerous, and is rejected. It may be somewhat shocking to realize that internally women have masculine, and men have feminine attributes. Why is it shocking? Because of the misinformation that we have been force-fed. How else could we possibly be startled over what we naturally are?

As the sexes are both indoctrinated, this realization can be difficult to conceptualize, no less accept. But stop and think for a moment how our universe is set up. Aren't all things in balance? Of course, that is the natural way. It is our training that causes the confusion, not reality. Plus or minus, black and white, hot or cold, light or dark, male or female are all examples of nature's balance; the laws of physics say, "to every action there is an equal and opposite reaction." Why? To provide balance. We see nature as opposites because we don't see all aspects as part of a continual balancing mechanism. We can continually seek balance, or be balanced.

You can find balance just about anywhere you look. Things are only extreme when they are stuck on one side. When things are balanced, they are perfect: warm, moderate, mean, comfortable, working in a balanced harmony. Things need their counterparts in order to create balance, and they cannot be balanced and whole without both aspects. Hence, God expressed God's Self as men and women, the masculine and feminine to balance each other. And just as you can't have black without white, hot without cold, light without darkness, you can't have masculinity without femininity. It's physics, it's biology, and it is spirituality all in balance. So it is only logical that men and women possess both male and female attributes, as God created this within us.

What do you get when you combine all the shades between the extremes of black and white thinking? Something much greater than shades of grey; you get the rainbow. The whole IS greater than the sum of its parts.

CHAPTER 17

Feminine Courage

Feminine Courage

Don't rock the boat. Don't create waves. Nice girls don't get angry. Or at least direct displays of anger are not permissible. The conventional wisdom is to go along with things, seek the easy way, the path of least resistance. There is some truth and wisdom in this, but not in all situations.

Women have been portrayed—no, make that conditioned—to believe they are weak, and they have also agreed to accept this view of themselves. The fact that women are smaller in size and physically less strong than men is used by men to repress women. This is undeniable. But that doesn't make them less powerful as human beings. And physical power does not create leaders, nor does it mean one is weaker than larger people. Look at our leaders, both governmental and corporate. They are not the strongest physically, yet they wield enormous power. It is simply a patriarchal lie that says women are less than men, but a powerful one that has been shoved down women's and men's throats.

There are so many restrictions placed on how a woman should look and act that what she often displays is not herself, but an act. It's her illusion of how she believes she should look. Her expressions of anger (the only emotion she is not fully allowed) usually come out as twisted and underhanded. The Goddesses of Wisdom have lost themselves, just as The Gods of Love have, by their conditioning. Men lose the ability

to accept and appreciate women's wisdom because they don't see it; they only see chaotic expressions of emotions and other illusions women present. They see only what is expressed, not what's underneath.

This is identical to women not see the loving nature of men; it's hidden behind years of macho conditioning and prohibitions against feeling. Men have their macho illusions too. Neither allows for the full expression of being and this leaves all hungry, unfulfilled, confused, and frustrated.

These conditioned illusions prevent both sexes from trusting, connecting, and feeling safe with each other. These roles do not bode well for relationships, life, or the all-important "bringing of spirit into matter," do they?

For women this leads to a life of busy work, pretending, dress-up with no place to go. She is lost, but doesn't even recognize the forest she's lost in. There are no trails of breadcrumbs to follow. What is she to do?

When a woman has strayed too far from her inner essence, her heart-centered core, she slowly loses the ability to move forward into the unknown of life. Her vitality is sapped. Her feminine limitlessness becomes limited, stale, tired, repetitive, and she finds herself starving. None other than herself denies her sustenance. Her vital nature becomes concretized in routine, and she acts contemptuous, and uncompromising on the one hand, or dried-up, victimized, used, and abused on the other. She often will shift between the two at the snap of a finger.

There is only one way, one solution, one healing possible for the predicament women are trapped in. "Healer, heal thyself." And stop blaming everyone else, especially men. We must realize that the world is trapped in the same place, the same governing illusions that teach insanity.

The only possibility to fix the world is to fix us first. To do this we must first take the journey to find all the parts of Self that we have disconnected from. This is doing the necessary inner work, the balancing, combining, and evolving of our belief systems. It requires eyes wide open not only to the outer illusions, but also most importantly, the inner ones.

This includes forgiving Self and others along the way. During the process it will be necessary to incorporate our parts and then recreate ourselves. Some call this being reborn. And all along the way there will be fabulous opportunities to forgive.

Forgiveness

Holding in anger is like swallowing a poison pill and expecting your enemy to die. Instead you die, slowly, bit by bit. There comes a time to free the spirit from all the poison pills we've swallowed in order to restore tranquility and our footing in reality. One may resist establishing peace because often the rage is used as a tool to empower, to keep one "safe," or as a tool of revenge. This may have seemed like wisdom at the time; however, it actually sucks out your life force, and creates collateral damage. You've shot yourself in the foot, but think you are fighting the good fight.

"Neither is the fieriness of rage to be mistaken as a substitute for a passionate life. It is not life at best: it is defense that, once the time of needing it for protection is past, costs plenty to keep. After a time it burns interminably hot, pollutes our ideas with its black smoke, and occludes other ways of seeing and apprehending." [16]

Just imagine you are wearing a backpack filled with rock-like weights equal to your body weight. The stones are all your stored rage. Carrying these stones means you are tired all the time. These weights are densified elements of your shadow. They generate tremendous heat and pressure and are like inner pressure-cookers consuming all love, life force, and hope. These rocks are all elements of spontaneous combustion that have been created by swallowing the poison pill.

No crop can grow in the soil of revenge, save poisonous things. Inside you know you can't win before you even speak. We all become sizzling meat in the fires of the flamethrower that is revenge. At other times,

16 *Women Who Run With the Wolves* by C. P. Estes, 368.

revenge may act like a silent killer, sucking all of the air out of the room; you cannot breathe, no less speak. Ah, revenge is sweet! Or is it?

Forgiveness is like an onion that must be peeled layer by layer, for long periods. It is a practice that never ends, but it is worth every pound of flesh, every inch of gut invested. Forgiveness is wound care; wounds are not usually cleaned once and forgotten, but need repeated caretaking.

Forgiveness is not overlooking wrongs, or making them right. It's just the releasing of the energy you have repressed within and continue to invest.

Forgiveness is not an act of surrender, but an act of creation.

Stages Of Forgiveness

1. **Recognize the poison pill within.** The first step in problem resolution is always recognizing the problem and its elements—you included.

2. **Deconstruct the programming you have created piece by piece.** Determine the decisions about life you've made, like "I'm not good enough", or "All men/people can't be trusted," etc,. Look over every piece, every element. Forgive it and release it. Good riddance, for it creates an acrimonious environment.

3. **Rebuild your belief system with conscious awareness of what you need to create in your life.** You've already done this in ways that do not support your essence, so discover what does. It's a journey; don't be hard on yourself for not knowing. Use focused intention; don't stop the journey no matter how many "detours" you've found yourself taking. Recognize and get back on track.

4. **Re-energize yourself, taking back the energy you have invested in resentments.** Watch the vitality flow again. Self-forgiveness is the critical element at this point.

5. **Get the lead out.** Become agile and strong at detaching from any further habitual investments in negative issues. This will evolve into a powerful state of gracefulness.
6. **Command positive attention, shine brightly.** This is the opposite of demanding attention.
7. **Build the muscle, get a life.** Take up a hobby, learn something new, love something, and find joy in the process.
8. **Learn to dance.** If he won't, find someone who will. Life is a dance, so start dancing. Infect all around with it. Tell him the coach potato dance is no longer in vogue. Nor is the solo or "constantly out with friends" dance.
9. **Develop patience and compassion.** Remember your training that held you back and realize others have similarly been trained. They are stuck too. Help them and ask for their help.
10. **Welcome your intentionality (the masculine).** This is the final and key step to maturation of the feminine. She becomes whole, holy, by paradoxically being the unlimited, multidirectional being that is her feminine, while her masculine spark, her intentionality, focuses her and makes it come to fruition. The important awareness is to use this inner element consciously, in service to the "all," of which you are a part.

Falling Together

I remember hearing the phrase, "We just 'fell apart'," as if by magic, apathy, being too busy, lazy, or simply just not being suited anymore for each other. I thought that it was funny that we didn't have the opposite possibility. I am not talking of falling in love, though this could suffice as an opposite. But usually this is something that happens in the beginning of a relationship, whereas falling apart occurs at the relationship's end.

So why can't we fall together? Could this be the same as re-falling in love? I consider the word *falling* to indicate: by way of accident, chance, fate, or luck. In other words, nothing that we've actively created, or at least influenced. This seems to be the consensus about relationships in general. "God only knows." There is no focus, no clarity, only a foggy often-depressing unknown.

Most relationships fall out of love at some point. Often it is just the illusions and projections of what we wanted the other person to be that falls away. Some relationships fall back together by chance, or by the "stars."

If you are satisfied with your outcome, that's great. If not, then it is up to you to take focused intentional action. No one, including your partner, is able to do this for you. So decide if the investment is what you want.

Remember as you grumble about your partner, he doesn't know how to do this either, otherwise he would have already attempted. So, forget asking him to be responsible for it. Naturally, as you create action, you can and should invite him with all your heart to join in. But if you are reading this, and you're aware how it fits your situation, then you have a leg up on him. Use it to create something wonderful, not something vengeful or superior.

Sometimes we fall out of love because we change. Those who are sensitive enough to notice their own changing needs and their partner's can change their attitude along with it. If both partners are able to do this, then love may remain.

The failure to notice our own changing needs or our partner's is always at the root of falling out of love. The biggest hurdle is that we often haven't a clue as to our deepest needs, being so focused on what we have been taught to desire. Diamonds may be "a girl's best friend," but they don't keep you warm at night. Possessiveness and casualness are opposites that destroy relationships equally. Wholeness is destroyed. Love and wholeness are inextricable pieces of the relationship pie.

Be aware. Feel your awareness. Direct your feelings and awareness

with a conscious, soul-level, yet relaxed, intention. Go through your day as you would, but hold in the back of your mind the intention. This is a powerful creative force, yet might look from the outside to be nothing more than wishful thinking. It is how we create the results of falling with intention in love, or whatever we wish to create. The power behind the soul's intentions is a force that moves mountains. Are you calling to yourself that force, or leaving it up to chance?

One way we receive gifts from spirit is by being given opportunities to act with intention. Acting with intention may not require physical actions. Just focusing our intention creates an effect that will influence the outcome. This can be as simple as changing our demeanor or our reaction to certain events. Then the mountain can move.

Now, imagine if we actually took action on these intentions, courageously. What would that create? What does it take to act with intention, and how do we kick start this ability or regain it if it has atrophied? It is all about our focus, both of heart and mind, or lack thereof. We must remain aware, or we run the risk of missing an opportunity. Focusing requires sensing, hearing, and following your inner guidance, both emotional and mental. So why don't we just do this?

Constructs

Our constructs are what block the easy transition, making it anywhere from difficult to excruciating. Constructs are our *constructed realities;* dreamlike waking states that we live in day-to-day. These fantasies are egocentric programming and contain many differing elements including: pain, pleasure, arrogance, fear, justifications, insecurities, must do's, or must not do's, etc. Love is not part of constructs, even if we think it is.

These constructs are forms of usually non-conscious imaging that were created by us to define life and create a safe way of handling existence. They may have little or nothing to do with reality. Yes, that

means while operating your "vehicle of life" in this altered state you are driving under the influence—of a construct. To understand this state, we need to understand the trance state.

Hypnosis is the intentional induction of a trance state. Deep prayer and meditation are inductions of a trance by you. When you get to your refrigerator and forget why you went there, you are in a self-induce trance state. Trances are normal and most people are in one eighty times a day. Your constructs are complex, deep-rooted, self-created illusions that you may visit momentarily, or for long periods. They may only be split second trances into never-never land, or long journeys that appear lucid, life-like. They are always playing in the background like elevator music. Beware of the power of subliminal messages contained in pleasant background noise—your own noise.

Your imaginings actually hinder your life. Work on telling yourself the truth, which is admitting to your underlying stories. Find friends that support your creative life; friends who will tell you the truth and want you to do the same for them. This is the part that requires commitment and continual work. The benefits far outweigh the costs.

"A Woman's Prerogative"

This is a colloquial saying which implies an understanding of, and justification for, changes of mind, or shifts in attitude—at the drop of a hat. These choices are usually influenced by emotional desires, mood swings, or perceived needs. They are all elements of one's constructs; even the permission to react at whim without consequences is an element of your construct. It's what allows you to make your shifts; it creates the prerogative. Constructs are egocentric by nature. Unreality will eventual lose its appeal, and then what? Most will just create another construct!

I am not saying that changing one's mind is wrong, but the whimsically created changes are. Abandoning this behavior is a part of maturing.

CHAPTER 18

Father

What is a father to a woman? He is her first love and her first model of masculinity. He is the quintessential hero, protector, provider, knower of everything, and the law. Or at least he is till mother has her say, or he shows up as an imperfect male, or she grows away from him.

He can demonstrate all the wonderful qualities of a male, or the worst. Usually he combines both sides in his demonstration, and she gets to sort them out.

Whatever fears a girl has about life, hopefully she always can go to Daddy. He is usually the answer, at least when young, especially regarding questions about survival and neediness. When he is present and unavailable or not in the scene, she will be challenged by these fears being manifest. Then she will seek someone who can save her from her loneliness and fears. Security and safety are, according to most studies, the primary concerns and desires in a relationship for women. Women will trade themselves for this. It is all about Daddy and how he related to Mother and other women.

Personal Stories

I have interviewed a number of women for this chapter regarding what a father means to a daughter and what effects he has on her life, both good and bad. Here are their stories (their names have been changed for privacy reasons):

Women—The Goddesses Of Wisdom

Nancy K.—Thirties

Nancy has a father she says she now adores. She is a teacher of special needs children. However, she did remember that when she was younger, she wished him dead, hating him. She was embarrassed to say this about him. "You shouldn't talk about your dad that way." She didn't know why she felt this way. But she was "very angry at the world and herself, and always felt frustrated."

She described her father as never wanting to be bothered or inconvenienced by her as a child. She couldn't disturb him when he was reading the paper or watching a game. She felt unloved and unwanted. Underlying this, she realized as we talked, was that she felt unworthy. This is the feeling that underlies codependency.

She spoke of her many failed relationships with men whom she called "unavailable." Her current relationship is, as we discussed it, a mix of codependency and love. She likes him and is struggling to fix him, get him to open up and love her, so they can get married and raise a family.

What she remembered of childhood was Mom and Dad fighting a lot. He was also very controlling; he was a pilot and had been in the military. He liked order and structure, which he was taught. This is the patriarchal role model, which effectively creates insensitivity, the disconnection from feelings. She said, "All I ever wanted to hear was 'I love you and am proud of you,' from my father." She never heard it in her youth. She and her dad did learn to communicate in her twenties.

She spoke of how Dad didn't like crowds. He would walk ahead of the family, alone. She would run up to him, and she learned to walk fast to keep up with him. I told her his behavior was passive-aggressive, and its intent was to create a pattern where others had to chase him, showing that he was in command. This was one of the behavior patterns that initiated codependency; she was rescuing her dad.

When he needed her, she felt connected to him, getting her needs filled by giving to him. This is the codependent pattern of struggling to

feel love. I feel alone and unloved (unworthy), but if I give to you, I feel connected and needed. Therefore, I don't feel so alone and just maybe you'd at least appreciate, if not love me. If this happens, then I am worthy.

She said men, she had decided, are selfish. She acknowledged that the nice unselfish men she met she "dumped." The men she chooses are "non-emotional, not emotive, and blow [her] off." Her views of men are that "men are the providers of food, shelter, money, necessities, and material wants."

We concluded in our discussion that she was not too happy about her own views of life and Self being codependent. She realized how enmeshed in the struggle for love she was, which prevents her from attaining love. She sees how clearly she goes looking for the struggle, finds the appropriate partner and commences the dance of codependency, repeatedly. This, she sees now, is clearly by choice with roots stretching back to childhood conditioning. It is not men's fault, as she has believed, but what she has expected and looked for.

Lisa D.—Thirties

Lisa, who is in retail management, was a daddy's girl, the oldest of her siblings. She believes she was conceived prior to marriage, and though already engaged, her mom was only sixteen at the time. Her father was more than a decade older, and his first marriage had ended childless. He wanted children. Lisa grew up a tomboy; sometimes she camped and fished with dad. These were the happy times for her. Today she might attend a make-up party, but would never throw one.

In her family, her manic-depressive mom was dominant, and the world revolved around her. Lisa and her siblings saw Dad treated as Mom's accessory and her bank. Vacations were spent with Mom and Her family; Dad was usually not there. The kids resented not having Dad there and blamed Mom for it. Mom acted out often, creating chaos, and life was definitely all about her. Dad tried not to rock the boat, was

depressive, but tried to create stability. Dad's actions were codependent. He enabled Mom.

In Lisa's family, there were never any consequences for misbehaviors, or any real guidance given. From this she said she never learned proper money management, as Dad or someone always just bought everything she wanted, and Mom spent incessantly. Lisa is now teaching herself proper money habits, but her younger siblings are constantly getting in trouble and being rescued by Mom with Dad's money.

Lisa says Dad is a "push-over, indifferent, and clueless." He was always "busy." He came from "nothing" and wanted his kids to have what he didn't: everything—all material. He knew no boundaries in his giving, which didn't teach the children boundaries. This spoiled the children. Children need boundaries desperately. Being a part of parenting that is highly critical for the child's development, it is an expression of love. I love you enough to discipline you and teach you boundaries. These are not the fun parts of parenting, so they're more often than not left out of the equation.

In her present relationship, Lisa is "quiet, passive, and doesn't want to rock the boat." That is her family's trait. Her sister is in a violently abusive relationship, but no one will speak of it. This only enables it by covering it up. Her father will never address any issues, including the chaos created by her mother.

Today, Lisa looks for the order and structure in her relationship and life that was not created by a strong father. She gets anxious at the first sign of disorder or chaos. The unknown is anxiety riddled for her. She resents the lack of structure, never being taught to prioritize, and the damage of being spoiled. This is the consequence of the lack of consequences, the lack of parenting.

Father

Natasha R. — Fifties

Natasha is an artist and graphic designer. Her late father was an alcoholic, and her mother did not know at first. When Natasha was ten, Mother and Father divorced.

He was quiet when sober, a voracious reader. He was the manager of a grocery store. As a youth, Father was a lifeguard, a diver, and an athlete. He worked on the movie *Thunderball* as an underwater consultant, and to Natasha, he was bigger than life. He encouraged adventurism and the arts, and told her always to try new things. She didn't experience any dad-daughter activities, didn't do things with him, nor talk about life. He was a non-parent and had no clue about parenting.

Her father didn't like himself, but Natasha didn't see that as a child. She did, however, experience this from a distance. As children, she and her sister always felt deep loneliness, detachment, outsiderness, but didn't understand why. Naturally, both had internalized these feelings. Her sister turned to alcohol; Natasha uses art. She found this answer for herself.

Her first marriage was to an Asian man who she was "rescuing." In fact, rescuing was a pattern in her three marriages. There was no real connection ever established with any of them: the second a pothead, and the third an alcoholic. She was trying to save Dad and codependently hoping to win their love.

Never successful in love, she is only now realizing what underlying beliefs are driving her choices. Her growth has come from her painful breakups that made her question her core beliefs.

Mary C. — Fifties

Mary is an executive. As a girl, she experienced her father mostly as the enforcer of authority, discipline, and perfectionism. He expected her to be the best at academics and personal poise and was critical when she

didn't live up to his ideals. A recurring theme of those years of her life was her mother's exasperated expression, "You and your father!" This meant that who continually butted heads in a battle of egos and control.

Father and daughter argued often, and there were times that they barely spoke to each other. Mary internalized the criticism for many, many years. Only later did she realize that he was imposing the same hard line on her that his own father had laid on him.

Finally, in her thirties, their relationship improved radically. Ironically, they have both aged into different roles: she's much more analytical, and he's become softer and more compassionate. Now, they're close, loving and appreciative of one another.

Kimberly L. — Sixties

Kimberly is a psychotherapist who remembers her father as a good man, very stable, and a great provider. He was financially giving. Her mother always slept in late, and she remembers her dad getting up early every morning, getting fresh baked goods, and returning early enough to make wonderful creative breakfasts for her and her sister. She felt safe with him. "Intellectually loved" is how she describes the way she felt.

Like many men, he showed his love with material things and by doing things for her. She also felt he was uncommunicative and undemonstrative, and since he worked long hours as a pharmacist, his work naturally kept him away long hours from the family. He also used TV as an escape: when he returned home, he would withdraw to watch the tube. She was not allowed to disturb him, except during the commercials. Even during parties at the family home, he would eat and then withdraw upstairs to the TV. Her family and their friends just accepted that this was the way he was. He was "there, but not there."

Her father was "devoted" to her mother—read that as codependently enmeshed with him. Mother had carte blanche, with no limits or material

boundaries, but Mom constantly criticized him. Her mom once told Kimberly that she wanted a divorce, so Kimberly replied to this after years of hearing her complaining, "Why don't you divorce him?" To this she received a smack across the face. Her mother was cruel to her she felt, and she resented her father not protecting her from her "cruel" mother's rampages. Neither of her parents could connect with her or each other.

Kimberly believes men should be good, generous providers. She likes lower middleclass working men, the bad boy types who have a wild side. She doesn't like educated men. Since Dad was too busy with TV to answer her questions, or give her the attention she needed, she acknowledges that she can be "overly demanding" in her relationships with men and can have a sarcastic edge.

Her choices in men are clearly the opposite side of the same coin. We think by choosing someone who is the opposite of what we didn't like in our first model of masculinity (our fathers), we will get away from that energy. What we don't see is that we are just choosing people who are the same inside, but express their conditioning in opposite ways. Then we ask ourselves, "How did I get here? I thought I was choosing something different."

What attracted us was the struggling for the love from someone who couldn't love us any differently because of their own conditioning. Their ways of handling their conditioning are different, and this fools us into believing they are different. But we find ourselves still struggling to be loved.

Chapter 19

Loving Struggle?

Life feels like a struggle sometimes, doesn't it? But why are you struggling? What is the struggle about? We've made the answer complicated and confusing with our ego's wants and desires. It's especially difficult because much of what we think we want is diametrically opposed to our other wants and, most importantly, what we truly need. It all boils down to the struggle for love.

Okay, with that defined it should be easy. However, there is an underlying question regarding our struggles. Why is there a struggle to begin with, and what is the missing link in getting the love and fulfillment we need?

We are the so-called missing links. We create the struggle. We've all been hurt. This is pretty much unavoidable. It may be a key to growth, but it is not one we look forward to.

In his poem, *Crazy Jane Talks With The Bishop*, William Butler Yeats speaks of life being torn apart to evolve:

> *A woman can be proud and stiff*
> *When on love intent;*
> *But Love has pitched his mansion in*
> *The place of excrement;*
> *For nothing can be sole or whole*
> *That has not been rent.*

In fact, knowing that pain is part of growth, we tend to avoid it. This is the natural and instinctive defense against being hurt. We defensively put our heads in the sand and create shields for our hearts. These are actually prisons. They keep us from giving and receiving love, resulting in the starving of our hearts and souls.

We want love, seek it out, but when we find it, we push it away, often without knowing we are doing so. Our partner sees us pulling away and becomes defensive. However, since we don't see our own causative actions, we think it is they who are pulling away, and subsequently, we pull back further from them, making it worse. Confused yet?

We want love and fear being hurt by it simultaneously, so we bury our heads in the sand like the ostrich, forgetting that our derrieres are exposed. You can see the push-pull cycle created here by us, not them. Fear creates resistance to love. Love would end the struggle, but what fun would that be?

The experience of this struggle can feel like our hearts are being torn out. Naturally, we want to defend ourselves against this at all cost. The truth is, our inner essences can never be destroyed, lessened, or diminished. Life may feel like a ride on a roller coaster, but this too shall pass.

We will feel pain, but our inner essence is never lessened. When a new pain or sadness occurs, it activates any reservoir of buried pain. This tapping into our past pain exacerbates the present pain, and it can appear like a mountain instead of a molehill.

Our past pain is what fuels the struggle. Of course, we don't see this, and we conveniently blame, project responsibility for our situations on others. Then, if we continue unaware with our self-destructive behaviors, we make it worse: effectively attempting to quench our fires with gasoline.

We do this zealously. Why? Because we've become addicted to struggling to put out our inner fires to end our pain, so we create more pain unconsciously to fuel the fires. Many people are effectively *addicted to pain*. The pain has become all too familiar and, in a perverse way, safe. It replaces fulfillment with a distracting drama, like a soap opera.

Loving Struggle?

A very serious question that needs asking is: "Are you willing to give up your addiction to the struggle and pain?" I believe most think they want to. But making it so is *easier said than done*. What is this struggle we are caught up in, and how can we break free from it?

Codependency

The people we attract into our lives often have much the same wounds as our own. We just don't recognize this. We think that if we can somehow heal their wounds, then maybe ours will be healed too.

The cycle of struggling for love, while defending against it or precluding it, is called codependency. A Codependent Personality consists of a dysfunctional relationship with oneself, characterized by *living through*, or for, another person(s) and includes attempts to *control others, blame others*, and/or a perceived sense of *victimhood*.

Codependency involves attempts to "fix" others and intense anxiety surrounding intimacy. A perspective exists like, "I have no idea who I am; I need others to tell me this." Further, the codependent may be asked to open his or her heart as a mature being. Dream on; that is an illusion in the mind of another codependent. Many begin relationships with this as a foundation. This dysfunction will often create intense struggles with life, love, jobs, and so on.

Our outer struggles reflect the inner struggles that the codependent is involved in. A codependent will often resist and/or sabotage the very things they covet. This keeps them in the "game," which distilled is the struggle to not feel the pain stemming from the painful struggle to love one's Self.

Codependency is an addiction, plain and simple. And all addictions are a distraction from feeling something that the addict can't or won't deal with.

Codependency is the addiction to struggle and drama, all for the purpose of distracting us from an undesirable feeling. Addiction's roots are found in compulsive distractions from feelings. Whether it is alcohol, drugs, smoking, eating, sex, work, exercise, or relationships, all of these can become addictions. Even religion and spirituality can be addictions.

What delineates an addiction is simply what things/activities are used for. If the purpose is to remain distracted, not confronting something within, this distraction becomes an unhealthy habitual compulsion. Eating is an excellent example. We all need to eat, so how could it be bad? Eating to nourish the body is perfectly fine. If, on the other hand, one overeats or does the opposite and starves oneself to cover some feeling they cannot cope with, then the normal necessary activity of eating becomes an addiction.

One can meditate/pray too much also. Using meditation/prayer to not feel something unpleasant is an addiction. They may perceive the world as undesirable, so distract by bypassing the undesirable, and praying too much. At this level, meditation/prayer is the addiction.

Sex is definitely an addiction, especially for men. Men are taught that the only way they can fill their inner voids is with sex, so they sexualize their real needs. Of course, this won't work in the long run, so, like a good addict, they go hunting for their next fix. Been there, done that, and women don't help this because they get the attention they are addicted to; two addicts feeding each other's addictions.

In codependency, the struggle itself becomes the distraction from "unlovability." This contains feelings like: unworthy to be loved, abandonment, loneliness, and not feeling loved. The invisible drug that distracts us from these feelings is "struggle." When in the state of struggle, which is a "fight or flight" scenario, we are actually in a self-induced trance and pumping adrenaline and endorphins, which heighten the trance. When in a trance, our sensitivity to pain is lessened: the very purpose of addiction.

Loving Struggle?

Periods of calmness for a codependent would be viewed as destabilizing, for their addictive norm is struggle. They need another fix. So they create havoc to feel safe, as they are most comfortable when struggling. Ever seen or experienced a person that chaos and dissension follows?

Dysfunctional families are the breeding grounds of codependency. Partners and children of codependents, alcoholics, and drug addicts are the most affected. Most chemical dependency treatment programs now offer treatment for codependency. Some avenues for treatment are: CODA (Codependents Anonymous), often associated with Alcoholics Anonymous and Narcotics Anonymous, and a spiritual counselor; all can be helpful. Of course, enlisting the assistance of a good therapist would be ideal.

Breaking free of these self-induced trance states is of paramount importance to one's growth and happiness. Don't put this off; end the struggle. We all deserve to love and be loved!

People who allow a part of Self to be given up in order to meet the wants, desires, and projection of their mate's constructs do great damage not only to themselves, which is obvious, but to their mates. They deny their mates becoming, through suffering, more conscious persons. As discussed earlier, the enabler controls the addict by making it better, preventing them from receiving the feedback of rejection. Their mates may poison the relationship with their not unjustified, but unconscious resentments. They know inside they are wrong and need the scolding. Neither will understand the situation, but the finger of blame will wag rampant. A difficult heartbreak for both is inevitable. This is a lose-lose scenario.

Codependent Indicators

Here is a list of concepts that can help you identify characteristically codependent behaviors[17]:

17 Adapted from www.recoveryresources.org.

1. One's good feelings stem from being liked by others or receiving approval from them. Others' struggles affect your serenity.
2. One's attention is focused on solving others' problems, or relieving their pain. This bolsters your self-esteem.
3. One's attention is focused outside of Self, on protecting others or manipulating others to do things "your way."
4. One's own hobbies/interests are put to one side. One's time is spent sharing the hobbies/interests of others.
5. One's clothing and personal appearance are dictated by others' desires, and the individual feels that certain others are a reflection of one.
6. The behavior of others is dictated by one's desires, and one feels that others are a reflection of one.
7. One is neither aware of how one feels nor aware of how others feel.
8. One is not aware of what one wants. One asks what others want, leaving one out entirely.
9. One is not aware of life, is not conscious; one assumes and operates as if on autopilot.
10. The dreams one has for the future are inseparably linked to others.'
11. One's fear of rejection determines what one says or does.
12. One's fear of others' anger determines what one says or does.
13. One uses "giving" as a way of feeling secure in relationships.
14. One's social circle significantly diminishes as one becomes involved with one's partner.
15. One puts one's values aside in order to connect with others.
16. One values others' opinions and ways of doing things more than one's own.

Loving Struggle?

17. The quality of one's life is based on the quality of others' lives.
18. One feels others validate one's own existence.

To understand codependency further, let's look at how we learn. We learn, especially when young, through a process called "mirroring." We see things in others, such as our parents, and mimic these behaviors.

This is the *first stage* of our personal education. Our learning comes from this mirroring of others and is, for the most part, an activity that is unrelated to the ego Self. At this early stage, we have no experiences on which to base our egos.

As we mature we transition to the *second stage*, where we begin to use our own individual consciousness and decision process. This is the creation of our egos—us as individuals in the world. We mirror less and less and make choices from our own inner beliefs and desires. This is the egocentric stage of life. Much of the world operates in this stage.

The *third stage* is the balancing of the ego's needs with our outer-world needs. This is a healthy, altruistic stage, and it begins our release from egocentricity.

This heralds the possibility of moving onto the *fourth* and *final stage:* learning through connection to the inner Self, which is firmly rooted in its universal connection. This is individuation[18] of the whole being, the soul.

Codependency is a malfunctioning of the transition from the first stage to the second. We get derailed on our path and continue to mirror others in a desperate need to find inner peace from these outer sources. We live in the illusion of victimhood and the lack of "something." This illusion, or struggle, is the addiction. We construct a reality, a construct, to enable our addictions, so we interact with reality through illusions.

18 Individuation: forming a distinct entity, or individuality differing from the universally accepted or collective norm; differentiation.

The Way Out

It is up to you to make change happen, first and foremost within. The reason why many don't choose this is because shining our light into the dark appears at first to intensify the darkness of these heretofore unlit areas. But it really is only creating a greater degree of contrast. At first this may appear harsh, making the dark darker. But it is only illuminating what is there and may take a little while for your inner eyes to adjust to your newly bright room. Fear not, it will become easier.

Do like Hansel and Gretel did, follow your breadcrumbs, your intuition. Call upon your intuitive abilities, dismantle the negative self-talk that creates the blocks in your path and waylays you. You will know what to do and can handle what you find. In fact, in looking back, the issues will probably seem much smaller.

Part of this recoiling from looking within stems from becoming conscious of the pain our actions cause others, then making new choices. Wisdom includes being conscious, knowing deep things about others, the natural world, and ourselves. This is the awareness of the shadow.

We delude ourselves by pretending we love without illusions, while not letting go of them. This is advancement without truth. Like industry polluting the earth in the name of advancement. We hope our chosen surrogates will fulfill us. But they can't, and we don't want to invest the necessary coinage, emotional gut to make it so.

Our shadows includes:

- What is not beautiful, the pig we put lipstick on attempting to disguise
- Our secret hunger to be loved
- The misuses of love
- Dereliction of duty
- Lack of loyalty and devotion
- Inadequacies
- Misunderstandings

Loving Struggle?

- Lies
- Infantile fairytales
- Cycles of Birth-Life-Death
- And, for women, menses

All these are parts of the shadow; you cannot exclude them try as you may. But you can mature and incorporate them instead of rejecting them. Then you can draw from their energy, their inspiration, and regenerative essence.

Innocence

Innocence is the healer and is related to grace. Lovers who experience this grace are surrendered to these forces; those with faith trust the profound power of innocence. This does not indicate blindness, nor any lack of wisdom. In fact, wisdom is innocent. Any confusion about what innocence is arises from thinking innocence is ignorance. Nothing could be farther from the truth. It needs no protective garb, or created illusions. It understands, sees, but doesn't judge, though it does discern clearly, without bias. It takes nothing personally.

Innocence is like a waveform. It rides the ups and down of all things without resistance. It knows resistance comes from bias and judgment.

Wariness at innocence is not justified and comes from being wounded previously. Both parties can act touchy, overly sensitive, or worse still, disinterested, notwithstanding that they actually feel different. These are defensive postures and masks, lies we perpetrate on others and ourselves in the hopes of staving off harm.

We're afraid of being taken for a ride, being played for the fool. Can you hear the melody? "Everybody plays the fool, sometimes…" Well not me! Oh yes, you too, sorry. No one likes it, but lies are everywhere and the trickster energy looks to take advantage where it can.

Wisdom and innocence know it is not about them, they pick up the pieces and move on, find fulfillment elsewhere. The thieves don't ever find it; that is their sentence. That's unfortunate.

Sometime we trade wisdom for control, mistakenly thinking this will "fix it." Control stifles life force and turns everyone into hollow apparitions. Control is used to create safety, but winds up strangling life force. Sometimes one must just leap. Wisdom includes faith and innocence, but not ignorance or illusion. Wisdom precludes codependency. And it allows for love.

Chapter 20

This Thing Called Love

"How do I love thee? Let me count the ways..." What is this thing we call *love?* Do you know? If you're eighteen, you may think you know, but maybe all that is a lusty illusion, a fairytale. Or maybe with age we become jaded. *He loves me, he loves me not...* Often in counting or measuring these ways we create standards—benchmarks to judge the amount of love—like flowers (how many, how frequently, and what their color represents) or number of diamond rings; after all, diamonds are a "girl's best friend" aren't they? How many phone calls received is also weighed, and there are a myriad of other measurement benchmarks.

I met a woman a number of years back whom I fell in love with; she said she felt the same. Weeks into our relationship came Saint Valentine's Day. I brought her a dozen roses (smart man, aye?). These were a deep yellow, and their center burst forth with shades of orange. They were the most beautiful roses I had ever seen. I brought them to her at her work. She looked at them and said, "Oh... yellow." This was not a thrilled response.

Taken aback, I asked her if she didn't like yellow. She said, "No, yellow is nice, and they are beautiful... BUT yellow means you're *not sure.*" Still reeling, I asked her what she was talking about. It seems every woman knows, having read it in some authoritative supermarket tabloid or mini-book, that red means love and yellow means not sure. The other colors supposedly mean something also. Where had I been? For such a smart guy, I can be quite an idiot I guess.

Or maybe not. Perhaps women have digested ideas that have nothing to do with reality. But, if women are really from Venus (or another galaxy) as John Gray propounds in *Men are from Mars, Women are from Venus*, then I had better learn their language. I can't argue with that. But what if they're not from another galaxy? What if women, the feminine, are the opposite side of the same coin as men? What if they are actually from the planet Earth? What then? What can I, as a mere man, make of their... thinking?

I prefer not to hold the belief that all women are out of their minds, but I can't say I haven't thought it. *How arrogant of her to tell me what I meant.* And this was all based on a source of the highest authority contained within the mini books or tabloids, proffered by publishers who will say ANYTHING to sell their wares. Well, what do I know?

I knew that I felt hurt, angry, and was simply dumbfounded. How could this intelligent woman I was in love with say such a thing?

In the Indian chakra energy system, yellow is the color of the third, or solar plexus chakra. It's the center of personal power—or its opposite based in negative beliefs that causes such feelings as powerlessness, helplessness, and weakness. Derived from the negative side is the colloquial term "yellow-bellied coward." So yellow could mean a powerful love, or could mean afraid of commitment, helpless, weak—unsure. However, for a source to propose as if fact only the negative side of something's meaning, or for that matter, for a woman to assume an intention meant unsure without verifying what was meant, is unreasonable. FYI: I was powerfully sure.

Further, red is the color of the root, or first, Chakra, which is our grounding, our connection to earth, security. Some women think of security as love, but it's not. The fourth, or heart, chakra's color is green; this is the seat of the soul—and love. Green roses anyone???

This Thing Called Love

Benchmarks

Well, it seems that not only didn't I fully understand Venusian, I did not understand women's rating system either. You see, women's masculine abilities are always operating, but without conscious command, or even just an awareness of this part of themselves, as is usually the case, this masculine part can take over.

Her masculine essence definitely will not sit still. He will find something to focus on, something to create structure with. He doesn't feel comfortable with feminine abilities that don't need to focus their multi-directional awareness. This appears to him as chaos, so he creates within her, like the magic of a fairytale, a rating system with standards to measure the life out of love!

You can just see a woman's masculine essence chomping at the bit to get a hold of something like this. And since she is mostly unaware of him, he gets free reign over her non conscious awareness. Then he takes over! The feminine becomes the co-pilot; the masculine has become the pilot. This would be fine if she was a male. It spells disaster when she is a female.

Organize, structure, pigeonhole... oh boy! Remember the dwarfs in *Sleeping Beauty?* "Hi ho, hi ho, it's off to work we go!" The masculine has information, facts to work with (dubious, but that's not his concern), and a great landscape filled with ideas that he can corral, brand, and slaughter. Then he can cut them up into nice prepackaged pieces, in a well-organized fashion. However organized, these slaughtered beasts, these ideas, are now dead. But they're neatly cut into nice pieces. That's his job; don't blame him.

Without him there can be no wisdom coming from women. That is, without her myriad of emotions focused with conscious intent there is no wisdom, just chaotic emotions. Like a gun or testosterone, this driving force needs to be guided, directed, put to good use, or it can wind up

being used for inappropriate things. On whom does the responsibility fall to guide him? The feminine, of course.

Men simply cannot know love—they will never be The Gods of Love—without their feminine. In this arena, they look for women to be their teachers and inspirations, and men's benchmark is sex. You're not surprised at this are you?

Of course, they must find their inspirations mainly from within, but their inner feminine is presently disallowed, and this training makes feelings difficult for men. So here we have women allowing their masculine energy to organize love. Well after all, they sure demonstrate love, compassion, and empathy in everyday life, right?

Responsibility is not always a pleasant task. And women love the attention they get from men, while they receive the treasures they trade for sex, right? But what do they give up? Ah, responsibility, a mental concept that's not in high demand in the emotional arena. What? You don't have time to deal with it, you have a nail appointment, I understand dear. (This sarcasm may be over-the-top, but it's not unimaginable is it?)

Love will not be measured; it will not be pigeonholed. Any attempts to do this slice it up into little lifeless pieces. Love is holy; it's an expression of the soul. It's expressed in masculine and feminine ways, in many splendored ways. However, if you, as a woman, see only a limited number of measured masculine ways, why you simply have forgotten your limitless feminine. Get it back.

So What Is Love?

Ah, that often misunderstood, much sought-after commodity—love—the human race's ultimate desire and goal. But what is it? A philosopher once said, "The nature of love cannot be defined."[19] More precisely, it can't be classified using our masculine thinking processes.

19 The *Bakti Sutras* by Narda.

This Thing Called Love

Love is actually much more than an emotion or a thought. I will attempt a clarification by describing some of love's attributes, though it is much like explaining God. Some things are simply indescribable with the limitations of human language and understanding.

Love is compassionate, empathic, and considerate. Love is caring, passionate, enduring. It is selfless, unconditional, respectful, and trusting, but not blind. It's accepting, surrendering, open, and vulnerable. Love never wants ownership, nor does it desire to cause harm. Sometimes love can be experienced as gentle, while other times dynamic and powerful. Love is the divine breath that flows through all things, specifically our souls. How it is then expressed after being filtered by our unique filters is another matter.

Feeling empty is another way to identify love—by its lack. I have known this emptiness intimately, and I can't say I liked it. I codependently struggled to find love in the outer world. And just when I thought I'd found it, it would elude me. I took this personally, blaming love and God, which only made matters worse. Love and God would not be shamed into submission by my blaming.

Finally, I identified the cause of my emptiness. I was "looking for love in all the wrong places," living without my heart and soul balanced with my mind, living the patriarchal way. Yet, at the same time, my emotions were all over the spectrum. That was my feminine aspect that I was not fully conscious of kicking up hell. I had to become conscious of her. It takes continued awareness to command her, or she will create havoc. I have seen myself become moody, irritable, demanding, and, dare I say it, unreasonable and reactive. Ever see that in a man?

Women do the opposite; they live in their emotions without a conscious balance with the masculine aspects, which can cause havoc as mentioned previously.

Properly balance these aspects to the best of your abilities, but beware of succumbing to your inner opposites. This requires intention and conscious effort to create and maintain. You will encounter difficult times, or be hurt; that is the human condition. Don't let your inner *him* protect you by building impenetrable walls, or worse, impenetrable rules that weigh the life out of every drop of life.

Though you may not have realized it or been old enough to understand your decisions, you are the one who has placed your masculine in the dungeon. Or he may have escaped and is creating mischief while attempting to take control. No one does that to you, no one has that power—you do it.

Get command of him within you, or he will run rampant. Use his gifts to intentionally focus your whole being. But beware of his masculinizing of your feminine: his ordering and structuring every last emotion and action, till they become stale and emotionless, like men have been taught to do.

This is a process called masculinization, and especially in the West, encouraged by the feminist movement, women have imprisoned the feminine. This is not to say that feminism does not have positive aspects, only to be aware of the negative ones also.

Free the prisoner, allow her to love and be loved. A common saying is, "It's a jungle out there." This certainly feels true when you have lost your path.

For your love to flow freely, use this visualization:

1. Visualize a jungle.

2. Call upon your masculine to create tools to cut through this jungle.

3. Let your feminine decide where to start and in what direction to go.

4. Then have him cut a path through the jungle.

5. Have him stop occasionally and take a look around. Do you like

what you are seeing? Is it right for you?

6. Verify that the direction the path he is forging is still correct.
7. Make decisions and tell him where he needs to be directing his energy. Direct him in his cherished work, his service to you.
8. Thank him for his good work, acknowledging his importance.

Can you see the wisdom in this? It's resultant is love.

This is part of the interactive adventure called "life." You are here to forge a path of wisdom. Wisdom is inseparable from your masculine, but becomes heartless mental dictates without your feminine. Wisdom is an active process of your whole self. He or she can't do it. The whole is always greater than the sum of the parts. Wisdom is not based in feelings or thoughts. It is like harnessing a tiny atom, creating huge energy. Whether to power things, or blow them up, will be a test of your wisdom. Otherwise, it is reverse alchemy where we turn gold (wisdom) into dull lead; it is inert, stale, and full of stagnant dictates and doctrines—a book of rules.

This is the secret of feminine life. Wisdom is its core; a lot of the rest is illusion, and wisdom is the only thing that can save us. This is why, when we fail to be wise, we either create chaos or destruction. Yet, we mistakenly project responsibility for these results onto others, men especially. They are just the catalysts, the ones that call forth our expressions of wisdom. But we want it our way, may not be willing to put forth the *effort,* nor take the *risks* to exercise intentional heart-centered wisdom. Life then loses its luster.

Often, this is how relationships die too. The necessary ingredient was mistakenly restricted, dishonored, or given over to him to carry the burden, as women have been conditioned to do. Wisdom is derived from our divine essence: the Self that is directly connected to wisdom's source. It only stops when we don't consciously focus our abilities, while allowing

our emotions free reign. This can be like giving a kid free reign in a candy shop, or worse, allowing them to play with matches in the home, or hay barn.

"Behind every great man is a great woman" helping him to see the correct direction, wisdom applied. Apply this to yourselves.

You have limited control over your outer men, but a great deal of love-based command. Yet all command within, the unlimited resource—wisdom. It is set in motion through women's selfless service, their unlimited ability to see in all directions at once, a defuse awareness that must be focused with the intention and courage of your inner masculine. This becomes your expression of love-based wisdom.

We may have an intense experience of feelings with a particular person, but it is not this person that creates the feeling. It is our love flowing from within us and through us that is the essence of the experience of love. We try to hold onto it (control) and often find it dissipates into thin air as we try to corral it. This is because love cannot be contained, only experienced. If you are a controlling personality, your masculine has taken over, and this will fly in the face of your wisdom, no matter how much makeup you apply.

No one can take the experience of love from us, or diminish it. Others may awaken it, and that is fine. But what they awaken is only the dormant love that flows from our connection to source. Often we project our belief of the external nature of love onto another person. They become the responsible party. They are our "love," but they are not. They are the igniter of our love, not its source. We may feel their love for us, and their love ignites ours. The point is it is ours and our connection to a greater love. This is great news because it allows us to feel fulfilled from within and to love others more, and it is our feeling nature that connects us with it. Love is of the domain of the soul, not the mind.

Is there such a thing called unconditional love? Absolutely yes! However, love is so confused with intense emotions, bartered needs, loneliness, insecurities, and fear that it has become indistinguishable from them.

This Thing Called Love

This is not love, but the illusion of love. Illusions are short-lived and finite; love is not. Love is not the glittery or shallow outer displays many have adopted. Love is often confused with strong passions and addiction to the senses. Love has become contaminated with ideas that have nothing to do with love.

So, how do we come to understand this thing called love? How often do we go looking for it in all the "wrong places"—outer places, that is?

Love is within, and it is about our relationship toward all things, including ourselves. When we "look for it," it is a limited attempt only within the outer realm of life—the outside; we are actually denying ourselves, for it resides within. This is what eludes us. Looking for God is to deny God. Because God is everything. Stop denying and start being what you are, loving wisdom's embodiment.

Love Is All Around Us, Isn't It?

Love is all around, yet our experiences of it become so contaminated by or own beliefs, expectations, and assumptions that true direct experience, without our filters, is difficult at best. Life seems to work so diligently to disprove every belief, assumption, or expectation that we can easily think that love is a sleight of hand, prestidigitation (quick fingers) or *léger de main* (French for "lightness of hand".) Love transforms right in front of our eyes seemingly by some secret magician into a heart-rending, blood sucking monster.

"She said love, Lord above, now you're trying to trick me in love," bellowed Tina Turner in Paul Rodgers' *All Right Now*. Falling in love can seem like a trap, solitary confinement in a gilded cage, then the bars tarnish, and we realize it's a prison.

Our illusions of love, mostly proven false, occur with the idea that love is permanent. Divorces demonstrate this, as does love between parents and their children, and of course, lovers being true to each other.

Even the marriage vows contain the sweet line, "Until death do you part." Love looks ugly, more like hate, when we stare these concepts straight in their faces.

Why is this? Our projections are the cause. Men project their illusionary visions of what a perfect mate will be onto their loves, often based on conditioning interrelated with mother. Women do the reverse with husbands based on their experiences with father. This is all an aspect of the greatest of illusions—that of our being able to control love. That's like thinking we control God. "Men make plans; God laughs."

You control nothing; give up this idea, this pursuit. It drains your energy and is guaranteed to fail. Yet, I know this pursuit too. And yes, I failed, tried again to do it right, better, find the right formula, etc., to no avail. So I stopped—mostly. What's left? Nothing? No, something was left, but what—love? Am I now only trying to trick myself in love?

I found that the less control I attempted to exert, the more I could feel this love, but there was no one there to love. What I was and still am discovering is that as I found the fleeting moments of stillness, when I stopped telling God what was to be done, love was all around; transient in nature, it will not be bridled or saddled, but will come to love.

Here was the secret I found: the only command I had over love was allowing my love, with all its vulnerability (YECH!), fleeting nature, and uncontrollability. This was absolutely not what I had previously thought about love. After all, I was told that I would only have to fight the good fight, slay a few dragons, and the princess would give me her kingdom (love). I wanted that! Damn those fairytales, they really do a number on us.

What was left was unlearning the nonsense we all were taught, and learning to allow myself to allow love. That's it. No control, no demands, and I had to forget temper tantrums, withdrawing, womanizing, and all the costumes I had tried on, but were unfulfilling.

Love happens by grace.

This Thing Called Love

Remember, that in order for Grace to grace us with love, we must not erect barriers, blocks streams, poison our wells with one-sided beliefs, and we must not harden our hearts. Okay, with all that said, I know I have done all of the above and more. The good news is one can make new choices, apologize for damage done, and create the space for love. Often we have forgotten how to do this. We have choked off the flow, but think it was another's doing. This makes us convenient victims. We also then don't have to take responsibility for the situation we find our lives in.

Be aware that often the person who despairs at their mate's inability to understand her, needs to recognize that she has probably not only failed to communicate what she means, but probably failed to tell herself. More than likely, self-confusion, not really knowing who we are, is the root issue. This is a common situation in our world. Even our governments have lost sight of whom they represent. We simply don't want to invest the considerable energy and capital needed to really do the right thing and to learn what that is in the first place.

We are all still works in progress, and our old programming is still continually reinforced by conditioned beliefs and our culture at large. Continue to release these old beliefs, which magically reappear in life, over-and-over, again and again.

Will the old conditioning ever disappear completely? I don't know, and it doesn't matter. Perhaps this is only another of life's paradoxes. After all, the all-encompassing, overpowering romantic love as we know it is not necessarily wrong. But when it replaces the rest of reality, it becomes toxic and harmful.

Psychology will say that our failed loves were just projections. No, I do not argue that there were projections ongoing, but love is real, even when combined with the chaos of projections. We must honor our love, not lessen the humanness of our experience by writing it off as just projection, "a bit of undigested beef," as Ebenezer Scrooge said in *A Christmas Carol*.

I personally reject the debunkers of love and the undermining of grace. That is not to say that what these naysayers have said is completely without merit, only just a part of the picture. True, the Titanic sunk because it hit an iceberg. But there were so many contributing factors, from design flaws to going too fast to business pressures, etc. All factors in the equation must be considered and any one of them could have changed the outcome. The same is true of our relationships. They contain unreal projections and expectations and valid real love. Love is and was present; what we did with it is another thing.

Mothers

Mothers are often targets of blame. They are surely not innocent nor as guilty as they are made out to be. Women are conduits of love; it flows through them like mothers' milk. They need to give it lest if festers in their breasts.

This loving flow is intended for their mates, as well as their children. However, what is she to do if her man refuses to accept it? Why would he anyway? Perhaps, he distrusts love, fears it and the vulnerability that comes with it. Men are supposed to be invulnerable supermen after all, aren't they? Perhaps, he acts arrogant and aloof, or is just too busy to accept or even see her love. He may confuse this love with his mother's milk, which he has rightfully outgrown.

Mother becomes desperate, pouring out all her love on her children and anyone who will accept it. They wind up drowning in the flood. This is a problem of parenting, and the spouse is part of the equation. He needs to create a balanced flow of what he married for, so he can feel fulfilled, his offspring are not overfed and all will be well. Ignoring this aspect of balanced give-and-take is like jumping off the seesaw. All is not right.

Mother can also do the opposite, becoming an absentee mother, too busy with work and Self to be a loving parent/spouse. The nanny or schools, daycare, etc. become the surrogate mother. These are not

inherently wrong or bad, only they do not replace parents, who come home too tired to be loving, guiding, and disciplining attentive parents. And what of the mate?

Also, many of us try to live out though our children the lives we failed to live. Whether through dictates or over feeding, we are actually attempting to control them with our needs. Years of resentment will follow, not to mention the hindrance of our children's discovery of their purpose. The "sins of the father being visited upon the children to the fourth generation" shows how long the damage continues.

The real failure is failing to be conscious to the best of our abilities. Most are not even concerned with this, or aware of the possibility. That is society and religion's failure. Indoctrination is simply easier. It makes the masses more controllable.

Our children also relink us grown-ups, who have become overly rooted in our islands of consciousness, to the unconsciousness that all children come from. Out of the mouths of babes comes great wisdom. But as adults, we have both terra firma and the ocean of unconsciousness from which to draw.

Vulnerability

Love can be frightening to men and women. It seemingly relieves all of us of our senses, at least temporarily, and we feel vulnerable. Nobody particularly likes feeling vulnerable. For men, this is aggravated by a conditioning which says that vulnerability is not permitted; they are supposed to be the "rock." Is there any wonder, with this understanding, why men avoid relationships and commitment?

Women confuse men's resistance to commitment with their projected beliefs that men only want to be free to have unbridled sex. To men, being vulnerable means the possible loss of oneself. This is a terrifying prospect. They fear that when vulnerable, their women will use this to somehow

extort them into "rolling over and playing dead," being subservient, like a dog. Real love would never want this, but many believe or fear that it will.

Then there is the question is it real love, or just someone to keep her from being alone? Men's deepest fear is of being abandoned by love, and from personal experience I can say this can be deeply painful. Being powerfully vulnerable is what is needed—yes, another paradox. Who knew?

Love causes an awakening that allows us to lose our illusions about life. This can be viewed as frightening, especially if we are unaware we have other options.

For a man who has been taught to deny his own feelings for most of his life, the reintroduction of feelings must be done patiently and gently, with a great deal of open communication and understanding.

Men are conditioned to be warriors, which includes the directives to reject feelings. Men fight and die in wars to protect their families, and they hope for women's love in return. Women must understand this, so they can forgive them for not being the complete, feeling being so many women desire.

Yes, they abuse their power and sometimes you—and this must change. However, *you must stop nagging, deriding, and complaining.* This not only prevents relating to a man, it has the effect of closing him down, as he hears these complaints as saying he is wrong. This is the cracking of the emasculating whip of shame, creating the previously discussed shame cycles.

Women must find another way to reach men. Hey, what about love? The Neanderthal can learn, but women must remember that he is what your Inner Neanderthal desires. Yes, no matter how much make up you put on it, women have one too. Honor him, be his partner, and guide him when necessary. You can reject his misbehaviors, but never make him wrong. You destroy his self-esteem, which lessens him and his ability to

be what you want; this may be your intention based in stockpiled anger. But in so doing you make that part of you that you recognize and judge in him wrong. You shoot yourself in the foot.

Most women want their men to be their "rock," their hero and protector; reinforcing the quandary men feel. They are being asked to become a "feeling rock." Men have no clue how to be both, as this seems contradictory to logic, an oxymoron; but like being "powerfully vulnerable," it really is a paradox. However, it is *easier said than done*. Not that it is inherently difficult, just that the understanding needed to enact it has been conditioned out of us to the point that we don't see the existence of any options. Women, you can help create this understanding.

Eros Reconnected

Eros has been connected with sexual love. This is not the indiscriminate type, but the connected type of sexual intimacy. There is no self-esteem, intimacy, connection, or fulfillment without integrity. This is being totally honest with yourself, no less others.

Your level of self-esteem is directly proportional to the degree you live in the truth. Not your created truth, but the truth, the whole truth, so help you God. You know what this is, but may not be comfortable with it. Damn comfort and security. These are the offerings of the trickster. Don't be fooled, lulled into complacency as so many are.

Eros demands nothing less then all: not a blind offering, but one based in your wisdom and love. Only then can he trust enough to give you what your heart desires—all of him. Yes, I know men have their own work to do. Don't use this to hold back, use it wisely to help create the sacred dance. Invite him to do the same.

I ask all women collectively to awaken. You must let go of focusing on outer looks. Then, you can focus on interrelating on the deepest spiritual levels, especially with men. Perhaps you can guide men on this. We men

need your wisdom and guidance. But guide us to find what it is as a man, not to mimic a woman. Your withholding of yourself based on egocentric anger and blame backfires.

Take courage women; be on the inside what you have been trying to create on the outside. Realize the nature of the self-imposed trap most women succumb to: wanting to be adored as a goddess, wanting attention at all cost, even at the cost of your soul. Stop blaming and projecting your needs and wants on men, but most importantly, forgive us. Remember, men manifest, women motivate. It has been long said, "Behind every great man is a great woman." This doesn't mean you can't manifest, just that it is the masculine energy that does this. Just as a man's feminine aspect is the part that guides and motivates men. This is expressed in the outer world.

Women, what do your present behaviors motivate? Your anger, blame, and judgment of men is clear. What do you think this anger, blame, and judgment motivates us to be? Do you think it motivates us to become our compassionate, loving, divine essence? Of course not, but many women hold men in the lowest of esteems, while seeing themselves as innocent victims.

"If a man was in the wilderness, miles from anyone, especially from any women, and he spoke... would he still be wrong?" I have told this "joke" for years, and interestingly, almost every woman who's heard it emphatically responds, "Yes!" This joke illustrates the stockpiles of stored and collective hatred and resentment of men, called *misandry*.

The title of my first book, *Men—The Gods of Love*, overwhelmingly received the following response from women: "They all think they're gods of love," accompanied by laughter at this preposterous, idiotic idea. Even the review in the *Boca Raton News* (see www.davideigen.com/get/news/book-reviews/) started off with this premise. It followed with an apology from the woman writer and a good review, but shows this reaction clearly.

Our thoughts are very powerful, especially those from our inner realms (sub or unconscious). Women's collective hate and distrust has

powerful and continual negative effects they are often unaware of. If you are motivated from this inner place with resentments, what do you think your results will be? This is the Socratic Law of Causality, known today as the "Law of Cause and Effect."

In computer lingo it is called GIGO—Garbage In, Garbage Out. Poor programming will always yield a program that doesn't perform well.

I beg of the collective feminine to awaken to its wisdom and strength, to its inner longing to interrelate, healed of hate and blame. I ask you to forgive men for their foibles and actions based in their programming. Then forgive yourselves for any deeply hurtful thoughts and actions; for some it has been being willing to destroy everything when enraged, including your own families. "Hell hath no fury like a woman scorned!" And forgive yourself for selling yourself, bartering your essence, like it was a currency.

This is true about all men and women's interactions; we all need mutual forgiveness of each other "for we know what we do!" Start looking in the mirror, not to check your hair or make-up, but to see yourselves, how you have perceived men, and what your underlying beliefs show. Then, review in what light you hold your inner masculine energy. What you believe about the outside, so shall it be about the inside.

Also realize it is God we must forgive. For when we hold all men or all women as wrong, then deep inside we are blaming God. Remember, forgiveness is about letting go of blame and resentment. It is also about letting go of arrogance and becoming humble. Then we can all truly evolve into the divine beings we are.

It is said that God has sent nothing but angels, even when twisted and contorted. To see the angel within others you must first see it within yourself. To do this will require absolute honesty, being willing to see the twistedness within. And there is no doubt about it, you have some. This is more difficult for women because men's twistedness is so outward, physical, and direct (of course, that's why men manifest.) Women, on the other hand, exhibit their twistedness in more clandestine, subtle ways.

Women—The Goddesses Of Wisdom

By women making men out as wrong, it allows for and justifies revenge (all manners of cruelty) against them. "Where is my John Wayne," asked Paula Cole in her song, *Where have all the cowboys gone?* Ladies, you drove them off, and in the process drove off your connection to your inner male, judging him as wrong. The formula is: damaging the outer male equals demeaning the inner. Do you really want all men on one side of the planet and women on the other? If you even slightly, jokingly thought yes, then it is your deeply buried resentment of men, your *misandry* rearing its ugly head. In order to survive, we must find how to coexist. There are no innocents.

I humbly speak from my deepest essence and say to all women, speaking for all men, "We forgive you, we love you, and ask you to forgive us." Help us; guide us back into our hearts by returning to yours! We need you. You need us. Together we can create the greatest of wholes. We will then know what wholeness is. We are grateful for you and all we have learned and experienced, but we don't always feel this way, that's true. We know the same holds true for you. Perhaps, we can learn who we really are and change the out-of-sync dance we do into something wonderful.

"Gratitude is not only the greatest of virtues, but the parent of all others."—Cicero

The current situation between men and women stems from each sex being unaware of their own inner opposites, possessed by them and rejecting them at the same time. Wisdom dictates conscious awareness and positive relatedness to our opposites.

We all long for union, peace, contentment... yet it is times of strife in which we grow the most. I hold that our future will include our abilities to interrelate and create true connection, rooted in our connections with our inner opposites. This is the paradox of living.

A Little Homework

Saving Private Ryan, the title of a 1998 movie directed by Steven Spielberg and starring Tom Hanks, is something that I recommend all women view. Why? To understand what men know about their lives and what being a man includes. Feelings are difficult for warriors. Yet, women desire this and resent it if they don't get what they want in the manner they desire. Perhaps a better understanding of what goes on within men would help women's understanding of men? Fasten your seatbelts and watch the movie.

Chapter 21

Divine Feminine

The union of the feeling spiritual Self with the rational physical being produces the divine feminine: born again, not religiously, but really as a being that has one foot on both sides of the great divide. She bridges the sides of the divide, unifying that which once seemed irreconcilable, certainly for any human-made bridge. Only a female engineer could create the span necessary to accomplish this feat. She is the feminine aspect that doesn't see limitations, only unlimited possibilities, and she builds with intentionality.

How does she bridge a "great divide?" Simply by a change in perception, the divide is no longer great, only something to be stepped over like a small creek. She can make this happen. The structure of her bridge includes restructuring of perceptions. How can you do this? Would this be nothing but another illusion?

The divine feminine knows that the *original separation* from love was an illusion. It gave us the opportunity to experience who we were not, but thought we were. In fact many staked their lives on their incorrect perception. She knows that union is the proper state.

Why does air rush into an area of low pressure? So it can equalize the imbalance. You can see this in the weather, areas of high pressure seeking to equalize by filling areas of low pressure. Our winds are the physical manifestation of this process. This is a natural process and she, the divine feminine, understands this. All that is needed is the correct perception

to accomplish what manmade machines are not capable of, in and of themselves.

This divine feminine was called the Medial Woman by the late Jungian psychologist Toni Wolff, who referred to this type of woman as a bridge between both worlds.

The eastern cultures know that without Shakti (the divine feminine), Shiva (the divine masculine) withers into a shriveled-up corpse, unable to stand erect. She is the life force, the energy that animates the male, which animates action in the world. Shiva is also the force that initiates all actions including Shakti's. It is circular in nature, both being necessary for each other at the same time, animating each other in a differing manner in order for life to continue.

This is the paradoxical nature of life: two seemingly different items being correct and necessary at the same time. Imbalances are destructive and flatten-out the circle into either a more linear (masculine) form or more chaotic non-directional (feminine) form. Both must co-exist for harmony to occur and the natural wisdom to be revealed.

Learning to order and structure with intention, adding these masculine qualities to the feminine, gives foresight and the clarity not just to see, a woman's natural ability, but to see how to express this vision into the physical plain, to make it so. This is bringing spirit into matter. Women must relearn what has been conditioned out of them and bring back the instinctual. And they must remember to encourage their daughters to retain and use what is inherently natural.

One can change one's belief system (thinking and feeling), which creates limiting perceptions and thereby causes projections. These projections of incorrect perceptions effectively devalue one's self-esteem. Change them to correct and balanced perceptions, and you will see your old projected behaviors fall by the wayside, impotent, as they were illusions.

Purpose

A woman may stay in a situation that is empty, unfulfilling, and loveless. She may repeat these empty and unfulfilling patterns in a life of drudgery and duty, perhaps thinking as a reward she is building a great spiritual treasure. She is buying her way into heaven in exchange for her soul. Many religions teach this idea, and it is great for controlling the "flock."

By example she teaches her children how not to get their needs met by continual unsatisfactory sacrifices. Childcare surely requires dedication, but the habitual living through and defining one's Self through one's sacrifices is a poor shadow for a real life. This is a learned behavior. You get to have a life, and part of it will be in service to life. Life includes you.

Children As Purpose

Many women think that they will be unfulfilled, or less of a woman, without a child. Raising a child is the highest calling in my opinion. Yet, so many women nowadays go off to work and leave the kids in daycare. Women have been "liberated" by the feminist movement and told that they don't have to focus on caring for their children: they should "have their own lives and take back their power."

The movement sees childcare as limiting and entrapping women in the web of male dominance, making women powerless. Of course, men had the money and power, and some abused it, but women didn't see the daily grind that was draining and unfulfilling that men experienced. They do now and should soon, I hope, be awakening to the damage parentless children experience.

Interestingly, I don't see a lot of women not wearing bras after the movement burned them. Perhaps the bra burning was just a metaphor? Perhaps seeing child rearing as demeaning is too? Perhaps it is a sacred opportunity?

Women—The Goddesses Of Wisdom

This belief about child rearing is playing out in women having children without fathers—intentionally. I met a woman who decided after a divorce to have a child in her forties. She had a son. She was impregnated with the sperm of an anonymous donor. I wonder what she tells her son who will learn of the thing called "father" and learn that he has none, just a sperm donor. What will he think of the value of masculinity and of himself?

I've spoken with many women about this and most called her actions selfish. One man I spoke with, who was raised by a single mother, said his mother did a great job, but that he had wished he had a father. So what was she thinking?

Without question this was an egocentric decision, but what would drive this? She believed she would feel "complete" if she had a child. She needed to have a child to be a complete woman.

This has nothing to do with child rearing and everything to do with using a child as a "fix" for a lack of self-worth. And she will not suffer the questioning, "Why don't you have children," or the blank stares that childless woman often experience. These influences have a great impact on the decision process. I acknowledge the animal drive to procreate; the biological imperative is a strong force.

These compelling reasons are simply not enough justification to bring a child into this world. There must not only be reason applied to this decision, but consideration for the child as well.

Remember, a child's father and mother are their first models of masculinity and femininity. To deny them that consciously, by choice, is abusive. Sometimes it is unavoidable, and you make do the best you can. Men are not always cooperative either, are they? But if you cannot create a healthy relationship with a partner, then these are your issues to be ironed out prior to bringing in another being to our overpopulated planet. And you will teach the child your issues, infecting them so to speak.

All of the women's magazines (prior to the women's movement), psychologists, and counselors would tell women the solution to their depressions, marriage issues, etc. was to have a child. This has been shown to be untrue. The issues still weren't addressed, only a new distraction offered. This created a new socially acceptable illusion. Fake-it-till-you-make-it thinking. This isn't working, but neither is the masculine declaration, "I am woman, hear me roar." There is little wisdom in any of these attempts to evolve.

Children are a part of life, but also not our sole purpose in life. They can be and are important parts of life certainly. They are our creations biologically, and we have great influence on them mentally and emotionally, but they are not *ours*. Our guidance and child-rearing skills, or lack of, are what steers their development. But they are their own beings. Get a life—before you give it. And then be prepared to serve, just as men must in a masculine way.

Women As Intermediaries

As recent time has unfolded and women have increasingly penetrated every field of society, we don't see a more balanced society, we see a more tormented one. Partly this is true because during times of change, no matter how positive the future looks, an almost palatable uneasiness is created: the unknown, which is viewed with anxiety.

Women naturally bring in their feminine outlook, which has always concerned itself with their relationships, their men, and their children.

The Jungian analyst Irene Claremont De Castillejo offered this in her book *Knowing Women*, "Women do not readily bother about [the plight of children around the world] or the horror of concentration camps unless they actually see them. Women have permeated man's world, but, instead of regenerating it, they seem to have contaminated it with their own pettiness of outlook, with the sublime indifference of a tree which

is concerned with its own growth, and its acorns, caring nothing, for it knows nothing, of the forest as a whole."

Egocentric perceptions and actions are the result of a feminine infusion that is not matured, unbalanced before being infused. Even if you held the belief that the tree knows intuitively of the forest, it still will not uproot itself to do anything. Women can fit this model, but can uproot themselves if they so choose. It's all a matter of the desire to do so, and the perception that they can.

Dr. Castillejo went on to say in *Knowing Women*, "Many women have forgotten, in the modern emphasis on career and economic independence, that woman has a role to play towards man which is inherent in her nature... her role [beyond the obvious] has always been to be a mediator to man of his own creative inspirations, a channel whereby the riches of unconsciousness can flow to him more easily than if she were not there."

Young men today are more unsure about who they are, but this is not the case with young women. Women inherently seem to know who they are, or are at least more comfortable with their own place. Not so for men for whom internal change without a clearly defined end point is destabilizing and anxiety riddled.

Women are excited about their possibilities found within their enlarged world. They continue to be wives and mothers, yet compete successfully in a man's world. They fail to recognize the precarious ground upon which men stand. They view men as indestructible, able to handle everything. An example of this thinking would be, "After all, Daddy was a MAN and nothing could deter him."

Hardly! But women never saw this in Daddy; they only bought into their macho father act: the acts they were conditioned to perform for their women, their work, the military, peers, etc. A father tries to create stability and safety for his children. That doesn't mean his world is safe or stable. If he doesn't teach her what the world is really like, she will grow

up expecting this. There will be a rude awakening that need not be, if she is shown reality, including dad's weaknesses and feelings.

In her egocentricity, she also failed to notice how a man needs a woman to believe in him, to recognize his uniqueness and appreciate it. He does not want to be a bit part actor in her fantasy, where he is the prince and he takes out the garbage, mows the lawn, brings home money, and walks the dog. He wants something more: to be loved, honored and appreciated, not just for what he does; he wants to be seen. Yet, often has no clue what to do to create this.

Have you ever heard a man say, "She just doesn't understand me?" He is really saying, "I don't feel seen." While this is an issue of the as yet undefined male, it is also the result of a women not even looking. Men don't need attention, only women do.

Most men don't feel like women even care to notice; they are too busy with a thousand and one other things. He needs to be trusted and valued. He also needs for his woman to express herself, her deepest parts, not the surface things or the nagging, but to share whom she is. Most of the women I have worked with all thought they did this. Then, after some guided trips into their inner territories realized they didn't; they were holding back the secrets women supposedly have.

What a man wants is to be acknowledged and seen, but what he gets are conditioned responses, or princess clichés, not expressions of the inner goddess. Most women are unaware of how much they talk in slogans, while adopting masculine principles without flexibility.

To be a mediator to the masculine, either outer male or her inner masculine, requires consciousness on a woman's part. This consciousness is developed in silence. Then true communion can happen.

Women have allowed their inner masculine to overpower their femininity, having given up their feminine command. Yet, women are still housewives and mothers, and they want security, material comfort, and status quo for their families and those generations to come. Women

have become the hub society revolves around; they are the consumers and the ones with the purchasing power. However, women's newfound achievements, her assumption of her power, are of little avail if they deprive a man of her fundamental role of being his partner, helping him find himself, so he can be the leader he is. She must be The Goddess of Wisdom if he is to be The God of Love. Both are needed and feed each other.

It is like two dancers whirling around a dance floor. How beautiful they look, and yet both have different but equally important roles of honoring and supporting each other unconditionally in partnership. You can see this displayed in the best of dancers. Yet there are millions who prefer "freestyle" dancing even with spouses. What does this say for there interconnectedness?

For a woman to fulfill her part, she must remain connected to her inner wellspring of unconscious Kundalini energy. She then must apply reason to focus its outpouring. Her partner starts off as the presenting component, the giver/leader, she as the receiving vessel, then she pours [presents] her inner wellspring on him, and he becomes the receiver. He takes this and presents, and the cycle continues, if both remain conscious and in service to each other.

Carl G. Jung has said, "In the same way that the anima gives relationship and relatedness to a man's consciousness, the animus gives to woman's consciousness a capacity for reflection, deliberation, and self-knowledge."[20] The genders nourish each other.

The animus is a woman's ability to separate, not unite; which is why if she is trying to create a relationship, she had better be aware of and keep this analytical part at bay, or he will wreck it with his impersonal, collective character.

It is all about balance, give and take, interconnectedness made manifest. Spirit then has shown up in matter.

20 *The Bakti Sutras* by Narda.

"From your own center, you may view the ever-widening concentric rings of reality, which begin with your personal reality and extend to include the reality of others and the physical universe. This center will be found in stillness, and there, truth will be revealed. This principle is valid subjectively, objectively, and collectively, for it is the nature of truth to clarify through unity. Polarity is actually an illusion. As long as you are convinced that it is real, you will believe all other illusions and miss the truth of existence."[21]

Polarity is the great divide. Find the unity, first within, then with your partner, and then in the outer world, the whole outer world. You are at cause; you are unity.

21 *Ibid*, Vol. 9, ii, Par. 33.

Chapter 22

The Sacred Offering

You inherently know what I speak of. Stop fighting it and allow it. Remember your wisdom. Find you, be you, and help him to be him.

It is through a woman that a man finds his soul. Through man, a woman finds her abilities to express her soul, so she can know herself and men can know her. He really wants to know her; he needs to know her, but in not understanding her chaos, fears knowing her at the same time. The chaos is the immature feminine, unable to communicate her vastness.

Mutual service to each other without betraying one's inner essence is the paradox at the center of relationship. It must be treated as an art form, not a book of rules. The only path one can take to create this is to create it within. We can't know with any certainty what is within another or if it changes. We have zero control over that. But command of ourselves, becoming conscious, is within our grasp.

This creates wholeness of being, and only from this point can we hope to create whole relationships. But this is not easy, and we all think, or at least hope, that life owes us a rose garden, don't we? Hold the thorns please. The equation is simple: add one part consciousness and one part willingness to serve as a base of love and wisdom, and you may just create wholeness, a sacred wedding cake. But please don't try to shove it down anyone's throat as is "customary."

The willingness to serve is a key element for the presence of love. Unwillingness to serve shuts out the flow of love. Yet, the loveless will blame their condition on others. It is our egocentric demands, petty possessiveness, and stupid jealousies that transform generous service into something burdensome.

The guise of indifference, coolness, objectivity, is a weapon used by many. It indicates a lack of dedicated service. These will poison the wellspring from which love leaps. Indifference is the negation of love. Anger is not; it means something is amiss, and the angry party doesn't like it. Communicate and find out what is at the base of the anger. But be aware, you may not want to hear about your own ugliness. Be willing; it is part of bringing the shadow into the light of awareness.

Also be aware that what brings two together, or keeps them together, may be lust, or duty, or greed as in bartering, or a false giving up of Self (it's always false); but these elements aren't love.

With regular patterns of parenting and relationship and our instinct to guide us, we create a model that is workable. Our consciousness will help us become aware of what might misguide us too. Giving tender understanding does not always heal. Sometimes it is necessary to stand firm and allow the sufferer to beat their heads against a wall until they hammer out their own salvation. But don't stand in judgment—just stand firm.

The powerful life-changing technique of talking to a person's unconscious self, the real loving self, plants a seed that will grow and percolate. If it falls on fertile ground, the results will be rapid and abundant. If not, if may take years, or lifetimes. Still, cast your seeds.

In the West, we are taught to distrust instinct, and we worship the god of force-based reason, held together by a colossal egocentric desire for power. These teachings create structures of conformity, in order to march lock-step as directed. And the life force drains out like it did to the old Roman empire. Obedience to our instinctual essence, our

The Sacred Offering

universal innate intelligence, is the key to undoing the destruction these structures cause.

Wisdom allows you to respect and understand yourself, others, and life's laws. It allows you to stand above the betrayals and disappointments of life. It is the conversion of your experience into higher understanding.

In the Old Testament, The Book of Proverbs (8:1-4), King Solomon exclaims: "Doth not wisdom [call out]? and understanding put forth **her** voice? [On the heights along the way, **she** takes **her** stand.]", (8:6-9) "Unto you, O men, I call: and my voice is to the sons of man. O ye simple, understand wisdom: and ye fools, be ye of understanding heart." (9:1-2) "Wisdom hath [built] **her** house..."[22]

SHE is wisdom; she is you.

22 Pennyroyal Caxton Bible.

Bibliography

Claremont De Castillejo, Irene. *Knowing Woman.*
 Boston, Massachusetts: Shambhala Publications, Inc. 1973.

Diamant, Anita. *The Red Tent.*
 New York, New York: Picador, 1997.

Estes, Clarissa Pinkola, Ph.D. *Women Who Run With the Wolves.*
 New York, New York: Ballantine Books, 1992.

Ferrier, Loretta, Ph.D. *Dance of the Selves: Uniting the Male and Female Within.*
 New York, New York: Simon & Schuster, 1992.

Greene, Glenda. *Love Without End.* 10th Anniversary Edition.
 Sedona, Arizona: Spiritis Publishing, 2002.

Golomb, Elan, Ph.D. *Trapped in the Mirror: Adult Children of Narcissists in Their Struggle for Self.*
 New York, New York: HarperCollins Publishers Inc., 1992.

Hillman, James. A Blue Fire. *Contribution by Thomas Moore.*
 New York, New York: HarperCollins Publishers Inc., 1989.

Hopcke, Robert H. *A Guided Tour to the Collected Works of C. G. Jung.*
 Boston, Massachusetts: Shambhala Publications, 1999.

Horney, Karen, M.D. *The Neurotic Personality of Our Time.*
 New York, New York: W. W. Norton & Company, 1937, renewed 1964.

Johnson, Robert A.
He: Understanding Masculine Psychology.
New York, New York: HarperCollins Publishers Inc., 1989.

She: Understanding Feminine Psychology.
New York, New York: HarperCollins Publishers Inc. 1989.

We: Understanding the Psychology of Romantic Love.
New York, New York: Harper & Row, Publishers, 1983.

Owning Your Own Shadow: Understanding the Dark Side of the Psyche. New York, New York: HarperCollins Publishers Inc., 1991.

Ecstasy: Understanding the Psychology of Joy.
New York, New York: HarperCollins Publishers Inc., 1987.

Von Franz, Marie-Louise, Ph.D. *The Problem of the Puer Aeternus.*
Toronto, Canada: Inner City Books, 2000.

Woodman, Marion. *Dancing in the Flames.*
Boston, Massachusetts: Shambhala Publications, 1997.